THE NEW
PHOTOGRAPHY
MANUAL

THE NEW
PHOTOGRAPHY
MANUAL

BY **STEVE BAVISTER**, **LEE FROST**,
ROD LAWTON, AND **MAREK CZARNECKI**

THE **COMPLETE GUIDE** TO **FILM**
AND **DIGITAL CAMERAS** AND **TECHNIQUES**

CHRONICLE BOOKS
SAN FRANCISCO

First published in the United States of America in 2007
by Chronicle Books LLC.
First published in the United Kingdom in 2007
by HarperCollins Publishers.

Library of Congress Cataloging-in-Publication Data available.

ISBN-10: 0-8118-6050-7
ISBN-13: 978-0-8118-6050-5

Manufactured in Great Britain.
Created by Focus Publishing, Sevenoaks, Kent, UK
Project Manager: Guy Croton
Editor: Vicky Hales-Dutton
Designers: Diarmuid Moloney; Guy Croton
Indexer: Caroline Watson

10 9 8 7 6 5 4 3 2 1

Chronicle Books LLC
680 Second Street
San Francisco, California 94107

www.chroniclebooks.com

Contents

Introduction

Photography means different things to different people. For some it is a way of capturing memories—of having a lasting reminder of special moments. For others it is a way of expressing themselves artistically. For a fortunate few, it is a rewarding way of earning a living. But for many it is simply one of the most fascinating hobbies there is to be enjoyed—a delicious blend of art and science that can be practiced on its own or combined with other pastimes.

Equipment matters

One of the secrets of success is choosing the right camera. Most of us now have one built into our cell phone—and increasingly, as digital resolution improves, the quality of images produced is perfectly acceptable at relatively small degrees of enlargement. However, camera phones are extremely limited. While it is convenient to have them immediately at hand, so you can take pictures as and when the opportunity arises, they lack the versatility of dedicated cameras.

For this reason, those who are serious about taking good pictures tend to spend as much as they can afford on equipment, rather than making do with what they have already. At the very least, you need a compact camera with a decent zoom lens, and ideally a Single Lens Reflex camera with a collection of interchangeable lenses and other accessories.

While you can tackle most popular subjects successfully with a compact camera, the tool of choice for serious photographers is an SLR, onto which you can fit everything from wide-angle lenses to open up perspective, and get more into the frame, to telephoto lenses that enable you to pull in distant subjects and compress perspective. Most also give more control over exposure, allowing you to control the shutter speed and aperture.

While some photographers still use film, the majority have now switched to digital. The advantages are obvious: the quality is fantastic, you can see your pictures immediately after you have taken them, and once you have bought the camera plus removable storage card—which can be used many times over—the running costs are minimal. Of course, you will need computer equipment to enjoy your photography to the

Start them young! Photography appeals to people of all ages, and because modern cameras are so easy to use, it is possible to get great results from the very beginning.

OPPOSITE: Digital technology has changed both the way that we think about photography and the way that we use cameras.

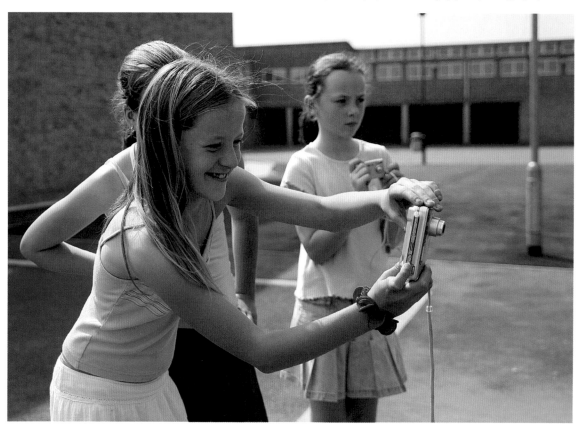

Being able to review pictures immediately after they have been taken makes digital photography an extremely sociable activity.

full, but since most households now own a PC or Macintosh anyway, this is rarely a problem. Software to enhance images is bundled with most cameras or is readily available at a reasonable price. If you want prints to put in an album or frame, these can be ordered from photo labs at minimal cost, or you might prefer to invest in an inkjet printer and produce them at home.

If you prefer using film, or have a significant investment in film cameras, one option is to continue shooting in the traditional way and scan either the negatives, transparencies, or prints. This, however, can be extremely time-consuming, and since digital SLR bodies are now available that are compatible with most systems, it makes sense in most instances to make the transition to the latest technology.

This book assumes, therefore, that most readers are shooting digitally, and either using a compact camera with a zoom lens or an SLR with a range of lenses. In Chapter Two we consider in detail the opportunities offered by different lenses and lens settings, not only in terms of the subjects that can be taken successfully, but also with regard to the effects that can be produced. It is this variety and versatility that makes photography so endlessly fascinating. Adding a range of accessories, such as tripods and strobes, increases your options yet further.

Developing your technique

Equipment, though, will only take you so far. Ultimately it is developing your technique that will determine how good your pictures are. And that comes to down to a number of key photographic skills: control over exposure; accurate focusing; effective composition; and powerful use of lighting.

Once you have mastered the different exposure "modes," you will be able to put the right amount of light on the sensor or film in your camera in the most creative way—varying the shutter speed and aperture according to what you are seeking to express. You will also learn to recognize the kinds of situations in which exposure meters are most likely to be misled and get things wrong—and then what you can do about it.

Focusing, too, can sometimes be awkward. It is fair to say that modern, advanced focusing systems work well most of the time; however, if you are not careful, they will sometimes focus on the wrong part of the subject. Consequently, you need to know when to override automatic operation in your camera and take control yourself.

OPPOSITE: Want to take pictures at night? No problem. Most cameras these days feature settings that allow you to capture the scene, no matter what the prevailing conditions are like.

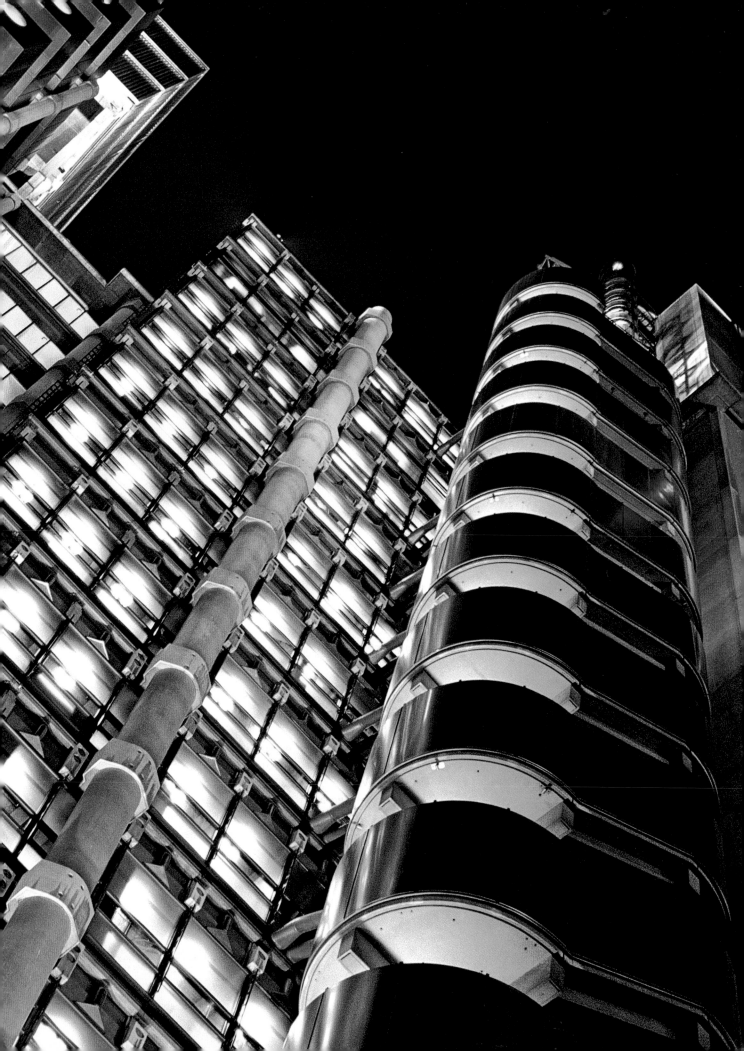

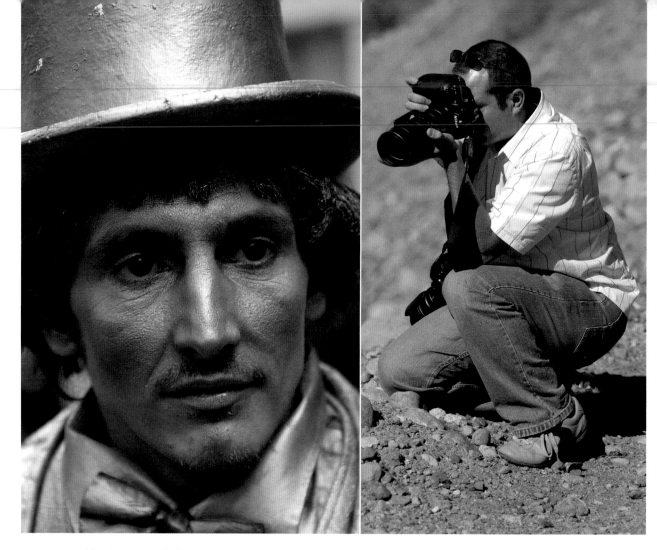

Biting sharpness and phenomenal detail are the characteristics of the high-resolution digital cameras now available. Here, the fine hairs of the goatee and the pores on the face of this street performer are clearly visible.

Single Lens Reflex (SLR) cameras are the first choice for professionals and enthusiasts because of the sheer versatility that they offer and the quality of results they deliver. They are now as good as the best film cameras.

Effective composition is at the heart of successful photography. Faced with a particular subject, there are dozens of different ways in which the elements could be arranged in the frame. Of course, much of this is down to personal taste and choice—after all, it's your picture! However, if you follow a few simple rules— such as using frames, dynamic diagonals, and lead-in lines—your picture-taking will improve immeasurably. Color, too, is vitally important, and the way you blend tones can make or break an image.

As you become a more experienced photographer, you will also need to learn how to make the most of the many moods and nuances of daylight. Once you understand how light changes from dawn to dusk, from season to season, and according to the weather, you will be able to match the right light to the right subject. Quality of light is more important than quantity of light, and some of the best pictures are taken when ambient levels are low or at night. This requires excellent technique to avoid problems with camera-shake and exposure.

Developing an eye for a picture

Ultimately, becoming a good photographer is a matter of learning to *make* pictures rather than just take them. No matter what subject you like to shoot, you should always be looking for ways of improving what you find already there, not just accepting things as they are. Follow the advice given in Chapter Four: exploring original and eye-catching ways of capturing your subject will help your images stand out from the crowd.

The most popular subjects for photography are people, landscapes, children, architecture, and travel, and in Chapter Five we explore them fully, along with other subjects including sports and action, pets, close-ups, documentary, and nudes. As you learn specific techniques that are particularly effective in each area, so you will produce even better pictures.

For those who would like to go further, in Chapter Six we examine the challenges of taking pictures in the studio, and consider ways of making money from photography—perhaps even the potential for going freelance or turning professional.

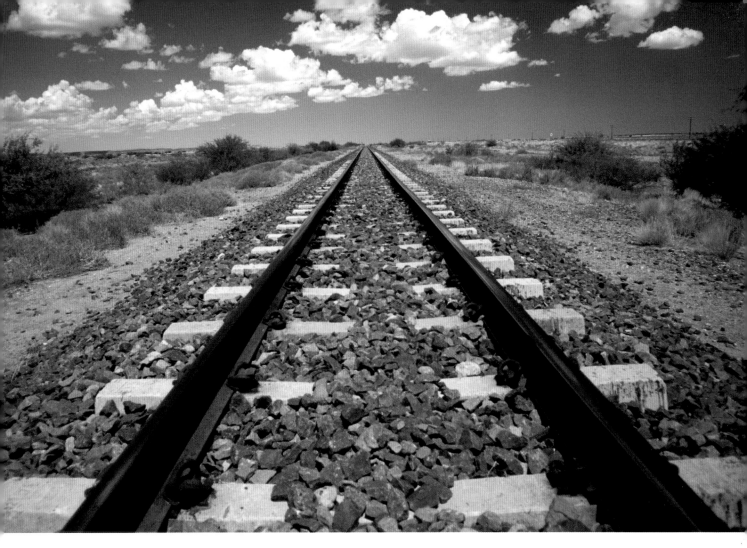

Creative use of lenses and composition makes it possible to turn a mundane scene into a picture with lots of impact. Here, the railroad tracks disappearing into the distance combined with the fluffy white clouds on a blue sky create a memorable image.

Enhance and manipulate

Capturing your subject, though, is only the beginning. Once you have transferred the image to your computer, a whole world of creativity opens up. You can improve color, exposure, and composition, or selectively lighten and darken specific areas. Unwanted elements can be completely removed. Images can be combined, filters added to creative effect, pictures transformed into black and white or toned. All these options are explored in Chapter Seven to get your creative juices flowing.

Looking forward

Photography has been in existence for over 160 years, and it is still as exciting and as interesting as it ever was. *The New Photography Manual* has been designed so that you can either read it from the front to the back or browse each of the sections as you prefer—to find the information you need to become a better photographer.

We have sought not only to give you clear, practical advice but also to include inspirational, powerful pictures as a spur to your creativity.

Enjoy your photography!

chapter 1

Getting Into Photography

Everybody takes pictures—and virtually everyone now shoots digitally. The medium offers many advantages, and it is easy to see why digital has replaced film. For a start you can view your pictures immediately, which means that you can check you have captured exactly what you wanted before moving on. Digital images are also incredibly accessible when you transfer them from the camera. You can view them right away on a computer or television, and then print them out on your own inkjet or at one of the many instant-print outlets. Best of all, once you have your digital camera and removable card, taking pictures is more or less free.

The Changing Nature of Photography

These days, getting started in photography generally means getting started in *digital* photography. Although film dominated the medium for decades and digital imaging is a quite recent phenomenon, relatively few people now buy or use film cameras.

The early days of photography

The first permanent photograph was produced way back in 1826 by the French inventor Nicéphore Niépce—and incredibly it involved an eight-hour-long exposure! From this starting point, for all of the 19th and for most of the 20th century, taking photographs was a chemical process. Light-sensitive materials were exposed to light, developed in a darkroom, enlarged to the size required, and then fixed so that the image was permanent and would not fade. Since then the equipment and processes used have become ever more sophisticated— but the principles have basically remained the same.

The rise of digital photography

Over the last decade, however, we have witnessed a fundamental change in how we take pictures. "Wet," chemical photographic processes have been replaced

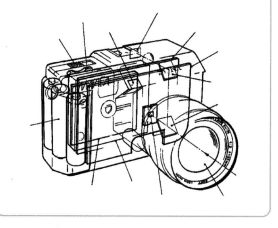

Sony announced its Mavica digital camera in August 1981, but it was not until the late 1990s that production models were available in the stores. Technically the first Mavica was not a digital camera but a video camera, from which freeze-frame images were taken. Later models recorded onto floppy disks and then CDs, which made them extremely popular.

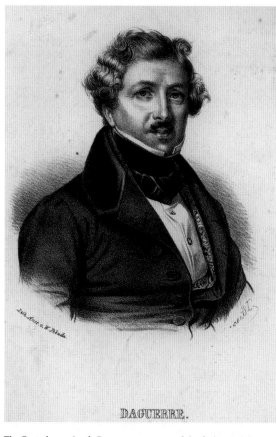

The Frenchman Louis Daguerre was one of the fathers of photography. Having experimented for several years, he announced his patented Daguerreotype process in 1839.

by "dry," digital processes, revolutionizing every aspect of photography. The processes pioneered by Niépce and Daguerre have been dramatically superseded.

You might be surprised to learn that the first digital camera, the Sony Mavica, was announced as long ago as 1981, but it was not until 1990, when Kodak unveiled the DCS 100, that digital cameras became commercially available. Initially sales were slow, because the prices of digital equipment were high and the quality of output was low. However, as prices have tumbled and quality has improved, sales of digital cameras have skyrocketed. These days not many people buy cameras that use film—sadly they have gone the way of the slide rule, the Betamax video recorder, and the vinyl record. Digital is now the norm. In fact, some leading manufacturers have completely discontinued film models, and are focusing exclusively on digital.

So, when you first get started in photography, it makes sense to buy and use digital equipment, for all the reasons we gave in our introduction: economy, quality, and immediacy.

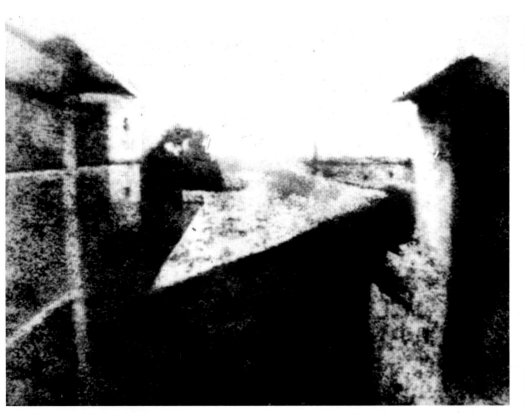

The first photograph ever taken—an eight-hour-long exposure of a French country house by the inventor Nicéphore Niépce, who captured this image in 1826.

The picture below, taken using a shutter speed of 1/500sec on a digital SLR camera, shows just how far photography has come since the early 19th century.

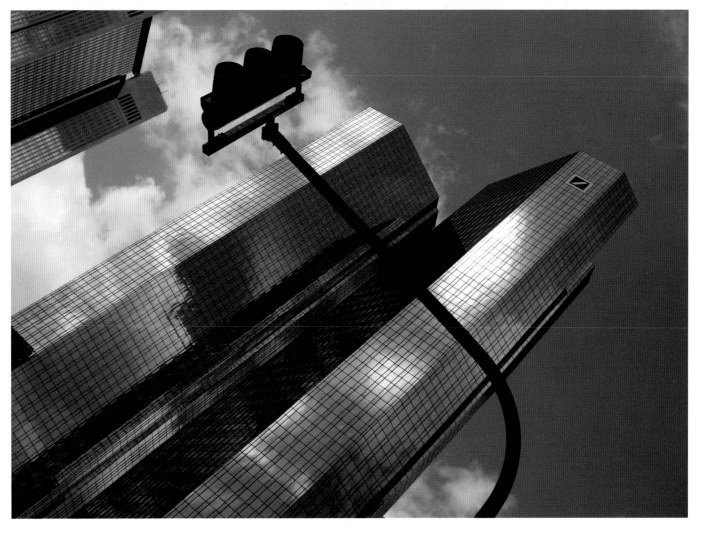

Digital Compact Cameras

Digital compact cameras are small, portable, and inexpensive. They are easy to use for beginners as well as being ideal "go anyplace" cameras for more experienced photographers.

Megapixel ratings

The "megapixel" rating typically found on digital compacts is a rough guide to the picture quality you can expect, although this is not as important now as it was when digital imaging technology was first emerging. This is because these days digital photography has advanced so much that just about any camera will take a reasonable image, regardless of the number of megapixels that it advertises. Five megapixels will give you excellent 6" x 4" prints and good enlargements up to 7" x 5" or even 10" x 8". If you regularly want to print at larger sizes, go for a higher-resolution camera with 7–10 megapixels.

Zoom ranges

How long a zoom range do you want? Basic digital cameras usually have a "3x" zoom range. In other words, this means that at the maximum telephoto setting you get a 3x magnification compared to the wide-angle setting. If you want to shoot subjects which are farther away, you need a longer zoom range. Some compact cameras have zoom ranges up to 6x, but if you want more (10x or 12x), you should look for a "superzoom" camera, although these are generally bulkier and heavier.

Tips for basic usage

Most compact digital cameras are designed for simple snapshot operation, and control the shutter speed and aperture automatically. If you want to control these manually, you will need to look for cameras with "PASM" (Program AE, Aperture-priority, Shutter-priority, and Manual) modes.

Check the battery life of your compact. Some cameras may take as few as 100–150 shots on a single charge, which is not always enough for a full day's shooting. Aim for a battery life of 200 shots or more.

Once you have purchased your digital camera, there are a couple of tips you can use in order to take better shots.

Firstly, use the LCD to compose shots when you can, rather than the camera's optical viewfinder (if it has one). Optical viewfinders are good in bright light, when the LCD can become hard to see, but they do not give an accurate indication of the precise area that the camera will photograph.

Shutter lag

You will also notice that compact digital cameras suffer from "shutter lag," in which case you press the shutter release, but the shutter does not fire straight away. When shutter lag occurs it will typically take the camera around half a second to focus first and this can make it difficult to time your shots accurately.

To get around the problem, line up your shot first and then half-press the shutter button. The camera will focus and the focus will remain "locked" while the button remains half-pressed. Now wait for exactly the right moment to take the shot, then press the button the rest of the way until it is fully depressed. The shot will be taken instantly, without any shutter lag.

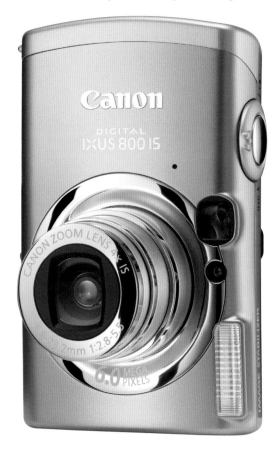

Digital compact cameras come in a variety of shapes and sizes. Choose one that will fit in a pocket or purse and you will have it ready at hand whenever you want to take a picture.

OPPOSITE: Small, handy digital compact cameras are ideal for capturing impromptu moments and everyday events. Many treasured images are originally taken as the most casual of snaps.

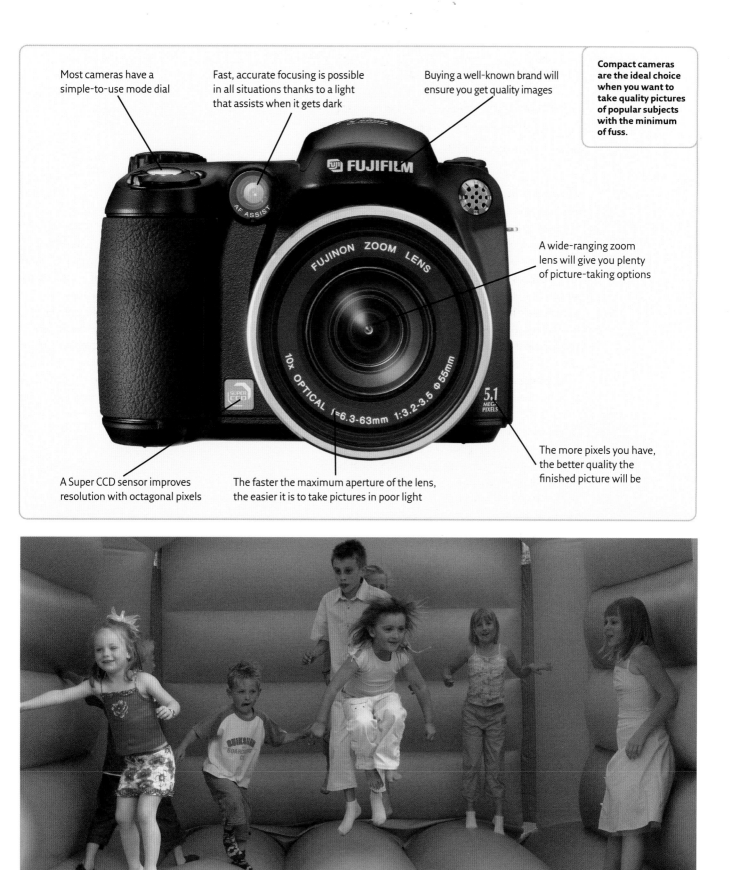

Most cameras have a simple-to-use mode dial

Fast, accurate focusing is possible in all situations thanks to a light that assists when it gets dark

Buying a well-known brand will ensure you get quality images

Compact cameras are the ideal choice when you want to take quality pictures of popular subjects with the minimum of fuss.

A wide-ranging zoom lens will give you plenty of picture-taking options

A Super CCD sensor improves resolution with octagonal pixels

The faster the maximum aperture of the lens, the easier it is to take pictures in poor light

The more pixels you have, the better quality the finished picture will be

Digital SLR Cameras

Digital SLRs are bulkier and more expensive than compact digital cameras, but they have larger sensors, which give better picture quality, and more advanced photographic controls.

What is an "SLR"?

The acronym SLR stands for "Single Lens Reflex." When you use an SLR, the picture is composed and taken through the camera's single lens. "Reflex" refers to the mirror which is used to reflect the image up into the viewfinder until the moment the shutter is released. The mirror flips up out of the way and the image then passes to the sensor at the back of the camera.

Low-cost digital SLRs have 6–10 megapixel sensors which can yield very good results, but it is worth paying a little extra for a camera with more pixels. The difference in fine detail is visible.

Lenses, kits, and accessories

You can use different lenses on a digital SLR and manufacturers sell them in "body-only" form, in which case you have to buy a lens separately, or as a camera "kit," when a general-purpose zoom lens is included. If you already own compatible lenses, it might make sense to buy the body on its own. However, if this is your first digital SLR, you should get a kit with a lens included. This will be much cheaper than buying the body and the lens separately.

Canon, Nikon, Olympus, Pentax, Samsung, Panasonic, and Sony all make digital SLRs. Canon and Nikon have the widest ranges, which include professional models. It is important to understand that each maker uses its own unique lens mount. You cannot use a Canon lens on a Nikon body, or a Panasonic lens on an Olympus body. When you choose an SLR you should think about the lenses, bodies, and accessories you might want in the future, and which maker has the best range.

Professional SLRs

There may appear to be little difference in features between an inexpensive SLR and a more expensive professional model, but you will find that professional SLRs are much more solidly built, with metal instead

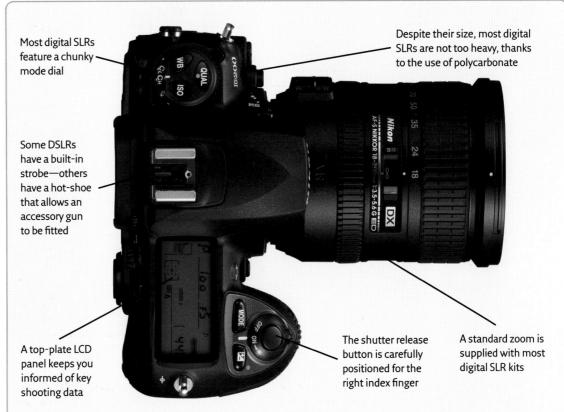

Most digital SLRs feature a chunky mode dial

Despite their size, most digital SLRs are not too heavy, thanks to the use of polycarbonate

Some DSLRs have a built-in strobe—others have a hot-shoe that allows an accessory gun to be fitted

A top-plate LCD panel keeps you informed of key shooting data

The shutter release button is carefully positioned for the right index finger

A standard zoom is supplied with most digital SLR kits

PAGES 20–21: These days it is possible to take great images that can be blown up to very large sizes on an affordable digital SLR.

of plastic bodies, will last longer, and will withstand rougher handling. They are quicker to use and adjust once you have gained some experience, and they may offer faster continuous-shooting speeds also, which could be important for wildlife or sports photography.

The benefits of SLRs

Digital SLRs are as easy to use as compact digital cameras. All have "point-and-shoot" fully automatic modes, so beginners can explore the more advanced options at their own pace.

Having said that, it may be necessary to modify your shooting technique a little if you are used to a compact digital camera. This is because digital SLRs have much less depth-of-field (near-to-far sharpness) than compacts, so when you graduate to an SLR you will need to come to grips with lens apertures and how these affect depth-of-field.

Finally, because the pictures are sharper than those from compacts (and digital SLR users will be expecting more from their photos anyway), it is a good idea to invest in a tripod to help avoid camera-shake in low light and to aid careful composition whenever time and space permit.

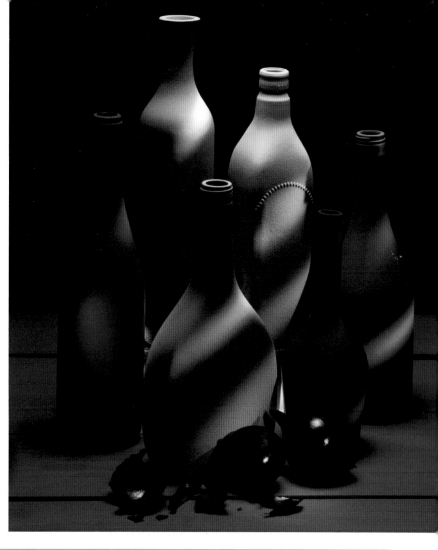

While digital compacts are fine for snapshots, a digital SLR is required if you want to create more advanced images such as this stunning still-life study.

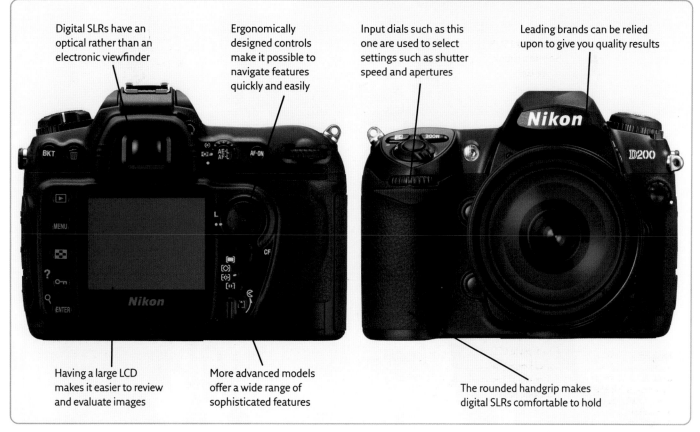

Digital SLRs have an optical rather than an electronic viewfinder

Ergonomically designed controls make it possible to navigate features quickly and easily

Input dials such as this one are used to select settings such as shutter speed and apertures

Leading brands can be relied upon to give you quality results

Having a large LCD makes it easier to review and evaluate images

More advanced models offer a wide range of sophisticated features

The rounded handgrip makes digital SLRs comfortable to hold

Digital SLR Cameras

Digital SLRs are superior to digital compact cameras in a number of respects. The larger sensor area produces better image definition and less digital "noise" (random speckling, like film grain).

Other advantages of digital SLRs

SLRs have a different viewing system, also. With the exception of a couple of models from Olympus and Panasonic, the design of a digital SLR makes it impossible for the sensor to feed a live image to the LCD display on the back. This means that you have to compose shots using the optical viewfinder. However, the viewfinders on digital SLRs are greatly superior to those on compact cameras and show you the view through the camera lens itself. Consequently, what you see in the viewfinder is exactly what the camera will photograph.

Digital SLRs have faster focusing systems than compact cameras, despite the fact that their lenses are physically larger and heavier. There is still some shutter lag, but it is usually far less. What's more, you can switch to manual focusing, and the size and sharpness of the viewfinder image means that you can easily see when your subject is in or out of focus.

Digital SLRs offer manual photographic controls which are frequently missing on compact digital cameras. You have control over both the shutter speed

BUILDING A SYSTEM

The enduring popularity of Single-Lens Reflex cameras can be attributed to many different factors, but the most important is undoubtedly their enormous versatility. Buying an SLR gives you the beating heart of a system that can be expanded almost infinitely, to cover a virtually unlimited range of picture-taking opportunities. In fact, it is no exaggeration to say that if you can think of a picture you can probably take it with a reflex camera.

However, with such a bewildering range of equipment on the market, how do you know which to buy? Mistakes can be expensive, so you really need to get it right the first time. The most crucial thing is to think carefully about what kind of pictures you like to shoot, and choose your accessories accordingly. Certainly you will need at least two lenses—possibly more, depending upon your interests. As well as adding a strobe, tripod, and bag, you may want some close-up accessories, an infrared remote control, or filters. Building a photographic system is never finished. There is always something new to buy and something new to learn.

HANDLING AN SLR

Digital SLRs are much bigger and heavier than digital compact cameras, which means you cannot just slip one into a pocket or a purse—you need to make a conscious, deliberate decision to carry one around with you, especially if you want to have the option of using more than one lens, or fitting an external flash. In that case, you will need to pack everything into a bag. Unless you have extremely small hands you will find that SLRs, despite their size and weight, handle extremely well. Most SLRs have chunky handgrips that make them comfortable to use. In fact, some people find them less fiddly than compact cameras, because there is more room for your fingers.

used and the lens aperture, and this is important for many creative effects. Digital compact cameras are easy to use but ultimately limiting. SLRs offer the potential to take your photography much further.

Greater versatility

Part of this potential comes from the fact that you can use different lenses. Digital SLRs are often supplied with a "kit" lens which covers a useful everyday zoom range from wide-angle to medium telephoto. However, additionally you can acquire ultrawide-angle lenses and longer telephoto lenses in order to extend the range of subjects and conditions that you can work with.

Some camera makers offer "twin lens kits." In this case, you get a general-purpose zoom and a telephoto zoom. These can represent very good value.

SLR makers also supply external strobes which can be attached to the camera's accessory shoe and which provide more powerful and more versatile lighting than the built-in flash. Manufacturers' SLR "systems" include not just lenses and strobes, but also remote controls, battery grips, underwater housings, and more.

One further advantage of digital SLRs is that they enable you to shoot "RAW" files as well as conventional JPEG images. RAW files contain the data captured by the sensor and have not been processed into images by the camera. You carry out the RAW file processing (conversion) on your computer later on. RAW files are like "digital negatives"—they contain extra image data which can often be used to produce superior pictures.

Single-Lens Reflex (SLR) cameras are technologically advanced pieces of equipment capable, with the right lens or accessory, of taking virtually any picture you could imagine.

Other Digital Cameras

Many photographers want a wider zooming range or more photographic control than an ordinary compact digital camera can provide. At the same time, they do not want the size and weight of a digital SLR.

Bridge cameras

A "bridge" (or "prosumer") camera may be the answer. These offer many of the advanced controls of digital SLRs but in a smaller and less expensive body with a fixed lens. This lens may offer a very wide zoom range, perfect for photographers who want a single, "all-in-one" camera. Additionally, because the lens is fixed, the interior is sealed, and bridge cameras are immune to a problem that can affect digital SLRs—dust spots on the sensor.

This type of photographic equipment does have its downside, however. Bridge cameras use electronic viewfinders which are not as clear and sharp as the optical viewfinders in digital SLRs. Furthermore, bridge camera sensors are much smaller—the same size as those in compact digital cameras—so you cannot expect the image quality to be as good as that you would get when using an SLR.

Other alternatives

Camera phones are becoming more popular, but the picture quality has yet to reach the standard you would expect from even a basic digital camera, despite the fact that many now have similar numbers of megapixels. This is because the sensors in camera

The cameras built into mobile phones are increasingly capable of delivering images of acceptable quality. However, they lack the resolution and versatility of dedicated compact and SLR cameras.

phones are of a lower quality, as are the lenses, and most are fit only for undemanding snapshot use.

You can also take still photographs with digital camcorders. Again, though, if you go this route the picture quality will be quite low, even with camcorders that boast good megapixel ratings. This is a good option only if you want to shoot a mixture of video and still shots without having to carry both a camcorder and a still camera. However, if you are interested in still photography for its own sake, a camcorder will soon prove too limiting.

Finally, there are interesting hybrid cameras which are essentially still digital cameras adapted to shooting movies as well, saving them directly onto memory cards rather than tape, DVD, or hard disk. These devices are smaller than traditional camcorders. Bear in mind also that digital compact cameras have movie modes which are excellent for short video "snapshots" and, in many cases, longer high-quality movies.

Most camcorders offer the option of capturing still images, but their resolution is relatively low and unsatisfactory.

Most images from a camcorder are only 1-2Mb or so in size, which means that the quality is a long way short of what you get from a digital camera.

Images taken with a cell phone look fine when reproduced reasonably small, but as soon as you enlarge them they appear "soft," and lacking in sharpness.

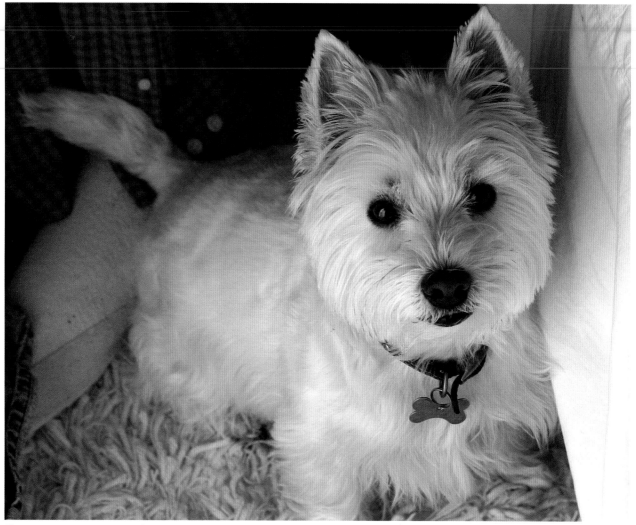

Since most cameras now capture images at high resolution—even as a JPEG this picture of a dog was 2.2Mb—you will need plenty of removable storage.

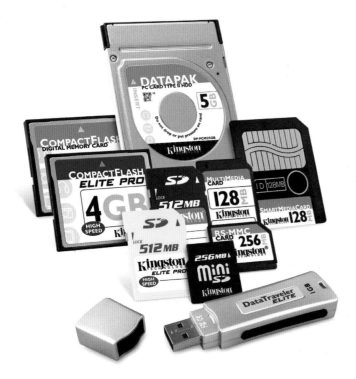

Removable storage comes in a bewildering range of types and capacities. For most photographers, though, it is not an issue—you simply buy the type your camera uses.

TRANSFERRING IMAGES

There are two main ways of transferring photos from your camera to your computer. One is to use a "card reader" (see the sidebar on the facing page) and the other is to connect the camera to the computer by cable. Most cameras use a USB connection, now universal among computers. Some professional models may also offer FireWire, a connection used by Apple Mac computers. It may also be possible to transfer photos "wirelessly" or, in the case of camera phones, using Bluetooth. Wireless transfer can sometimes be slower and less reliable than cable transfer, and technically problematic.

Capture and Transfer

Whereas cameras used to store photographs on film, digital cameras store them as electronic files on memory cards. This is known as image "capture." In order to be able to do anything meaningful with your digital images, you also need to be able to transfer them.

Some cameras may come with fixed internal memory as well, but this is usually enough for only a limited number of shots. All cameras have memory card slots. Compact digital cameras with internal memory do not come supplied with memory cards. Compact cameras without internal memory will usually be supplied with a low-capacity card just to get you started. Digital SLRs are sold without memory cards.

Memory cards

Memory cards come in several different types. These are SD (Secure Digital), CompactFlash, xD Picture Card, and Memory Stick. There is also an older "SmartMedia" format which is no longer in use.

All these types offer broadly similar value for money and performance, so you do not need to choose a camera based on the type of memory card it uses, unless you already have a stock of memory cards or you already have another camera and you want to keep on using the same cards.

Memory cards vary in storage capacity. This is measured in megabytes (Mb) in the same way as computer storage. You will typically get 16Mb or 32Mb supplied with the camera, but this is not sufficient for longer photographic assignments. Each digital photo will take up around 2–4Mb of space and, if you use a digital SLR to shoot RAW files, these can take up 5–25Mb, depending on the camera.

You should consider buying a 256Mb card at the very least, since this will be enough for around 100 shots with an average compact digital camera. However, 512Mb and even 1Gb (1000Mb) cards are also comparatively inexpensive, and let you take many more shots.

Some memory cards are marked with a speed rating (for example "40x"). This describes the speed at which the card can store the image data supplied by the camera. However, the processing hardware in the camera is usually the main bottleneck. High-speed cards can offer better continuous-shooting performance or longer movie sequences in some instances, but in most cameras the advantages of "fast" cards are minimal.

Many card readers can now read as many as 15 different card types. All you have to do is slot the card into the reader and it appears as a hard drive on the desktop, allowing you to access the images. This is arguably the most convenient method of transferring images from the camera to the computer.

One of the easiest ways of getting images from your camera to your computer is by using a card reader.

USING A CARD READER

Card readers are small devices that plug into a computer's USB port. You insert your memory card into a slot and it shows up on the computer as an external storage device, so that you can simply drag the photos across into a folder on your computer. You need to make sure that you get a memory card reader that takes the type of card your camera uses, although many card readers include slots for all types.

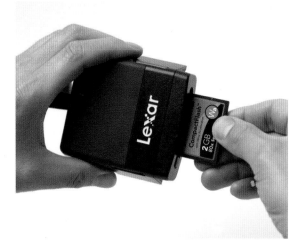

Computers

It is possible to print your photos without a computer with specially designed printers, but a computer is essential for storing and browsing growing photo collections and for editing, enhancing, and sharing your images.

If you already have a computer you need to find out whether it is suitable for digital photography. This also applies if you are about to buy a new computer or replace an old one. The main considerations are the processor speed, the memory (RAM), and the storage capacity (hard disk size).

PC or Mac?

Firstly, though, there is an even more basic decision to be taken. Most computer buyers go for PC machines running Microsoft Windows, but while Apple Macintosh computers—"Macs"—are in a minority, sales are still strong and they have certain advantages for this kind of work.

All Macs come with a program called iPhoto which is extremely good at organizing, cataloging, and enhancing your photos. PCs do not offer an equivalent, although your digital camera may come supplied with similar software. The iMac, iBook, and MacBook models come with very good monitors, also, which is an important consideration for photographers.

Like most contemporary technology, computers are evolving very rapidly. The specifications of even the most humble machines are improving on an almost daily basis. As with anything else in photography, buy the best one you can afford.

However, while all cameras and printers work with Macs as well as PCs, there is less choice of software for the Mac, although certain top image editing programs such as Adobe Photoshop and Elements are available for both PC and Mac.

The performance of any computer will be governed largely by its processor speed. This is a complicated and constantly changing technical area with many competing chip "families" and variants. To generalize, though, any medium-priced computer is likely to have an adequate processor for digital photography. Even budget models will work well enough, though you may find some tasks taking just a little longer.

RAM and storage capacity

It is more important to make sure the computer you buy has enough RAM (Random Access Memory). This is the computer's "thinking space." These days most models are supplied with 512Mb of RAM, which is just about enough, though 1Gb is better. Avoid computers which offer only 256Mb of RAM.

Digital images can take up a lot of space, especially as your collection grows. Hard disk size is measured in Gb (gigabytes—1Gb equals 1,000Mb). A collection of 10,000 photos could easily take up 20Gb of space, and this will increase if you save lots of edited versions and photographic projects. For this reason, an 80Gb hard disk is really a minimum requirement and 160Gb or more is better.

An Apple Macintosh computer can make a very good choice for editing digital photography. These machines feature the special image organizing software iPhoto, and are robust and easy to use.

THE ADVANTAGES OF USING A LAPTOP

Laptop computers can make excellent alternatives to desktop computers. Apart from their obvious advantages, such as being very compact, easy to pack away, and available to work anywhere, laptops also make great portable storage and display devices for photographers.

If you take your laptop on holiday or on a photo expedition, you can transfer photos from your camera and then erase its memory card to make room for more shots. However, avoid budget laptops. You will need at least 512Mb of RAM (1Gb is better) and an 80Gb or larger hard disk for adequate image storage.

Keep in mind that the displays on laptops are often a weak point. They are frequently low-cost screens which, although they generally offer good color, often have poor viewing angles. In the worst cases, the top of the screen can appear darker than the bottom.

USEFUL COMPUTER ACCESSORIES

- **Printer**
 For best results choose a photo printer. These produce excellent quality. Many models have built-in memory card readers so that you can print photos without a computer.

- **Scanner**
 You need a scanner if you have a collection of old prints that you want to turn into digital images. Inexpensive "flatbed" scanners will do a great job, and many models come with adaptors for slides and negatives as a matter of course these days.

- **Card reader**
 A card reader will make it easier to transfer digital photos to your computer because you only need the memory card, not the camera itself (or the cable for connecting it).

- **Monitor calibrator**
 Modern LCD displays are very good, but they are not always set up for accurate color. Monitor calibration kits can help ensure that the colors you see on the screen will match those produced in prints of your digital photographs.

Software

Broadly speaking, you need two types of software for digital photography: software for organizing and browsing your photos, and software for editing and enhancing them. Sometimes a single program will do both. Even then, though, these jobs are usually split into two distinct areas within the program.

In the past, the job of keeping images organized has been largely overlooked as users concentrate on the more glamorous aspects of image enhancement and manipulation. However, software publishers and photographers are now realizing the growing importance of image organization and this now forms a key part of most digital photography applications.

Image organizing software

Digital photography software can come from a number of different sources. Most digital cameras are supplied with programs to get you started. Nikon cameras come with PictureProject, for example, which provides basic image organizing and enhancement tools. Kodak provides similar EasyShare software with its cameras, while HP cameras come with ImageZone.

Google's free Picasa 2 application is a very interesting alternative. It is exceptionally fast at finding and browsing digital photos, and incorporates editing tools which are both easy to use and highly effective. If you are on a budget, this is probably the best option to start with.

Even basic image organizing programs such as those described above will make a big difference to

the way you manage your photographs, though serious or professional photographers may eventually need to move up to a professional cataloging application offering greater versatility.

Similarly, while the image editing tools in the programs that come bundled with cameras are adequate for fixing everyday photo errors, if you want to experiment with more advanced digital effects you will need to buy a more sophisticated image editing program. The best advice is to stick with the software provided until it becomes obvious that it can no longer do what you want. By then it will be clearer exactly what you do need.

Dedicated image editing software

There are many separate image editing programs to choose from. The most famous (and the most powerful) is Adobe Photoshop, but it is expensive, complicated, and has features which many digital photographers will simply never use.

Adobe Photoshop Elements is very much cheaper, easier to use, and equipped with most of the tools photographers will need. It comes with photo organizing software which is better than that you get free with the camera, also. Other notable programs in this price bracket include Corel Paint Shop Pro and Ulead PhotoImpact.

"Photoshop" has almost become a generic name for imaging software, but it is expensive and more sophisticated than many amateurs need— and there are several alternatives that are more economical and just as effective.

Digital cameras come bundled with software that enables
images to be downloaded from the camera to the computer.
In most programs—the Fuji Finepix Viewer was used here
to review shots from a trip in a hot-air balloon—pictures are
displayed as thumbnails and can be browsed, opened up,
and improved as necessary.

Printers

Looking at pictures on a computer screen still isn't quite the same as holding an actual print in your hand. For this reason, most digital photographers will want a home printer at some time.

Photo printers

Most photo printers use "inkjet" technology. Tiny nozzles on a moving print head squirt dots of ink on to the paper as it passes through the printer. The dots are so small that they merge to form the appearance of a smooth-toned image. Some smaller printers designed for 6" x 4" snapshots alone use "dye-sublimation" technology. In this case, the inks are supplied on a ribbon the same width as the paper. The inks are heated into a gas and permeate the upper layers of the paper.

There is little difference between the two types in terms of picture quality. Inkjet prints may prove fractionally sharper, but dye-sublimation prints are dry as they emerge and are therefore physically a little more resilient.

These postcard-sized printers are inexpensive and very popular. Many contain built-in memory card readers so that you can print digital photos without a computer. The makers have adopted fixed-price "photo packs" containing enough ink and paper for a specified number of prints, so that you can easily work out what the costs are per print.

Some photo-quality printers are so small and compact that you can even take them away with you—allowing you to print out your vacation pictures before you get home.

THE MORE INKS THE BETTER?

Everyday inkjet printers use four inks: cyan, magenta, yellow, and black. Photo printers typically use six, introducing extra "light cyan" and "light magenta" inks. The greater number of inks reduces the faint "dottiness" that ordinary printers can sometimes produce when printing photos.

Some more sophisticated models may use as many as eight or even nine inks. These are designed to extend the color range, or "gamut," that the printer can produce. These extra inks can improve the print quality, but they also make printers expensive and complex to maintain. However, advances in inkjet printing technology are allowing manufacturers to move back to simpler systems, and many photo printers now produce superb print quality with just four inks.

Larger printers

Larger letter-paper-size printers are more versatile. With a couple of rare exceptions, these all use inkjet technology. Many letter-size photo printers include memory card slots, and almost all of them produce excellent print quality every bit as good as that you would expect from a commercial photo laboratory.

If you are interested in exhibiting your work, or you want to enter competitions at a local camera club, or you simply want to hang big pictures on your wall, you should consider a tabloid-paper-size printer. Perhaps surprisingly, these typically cost more than twice as much as an equivalent letter-size model.

Printer manufacturers quote a variety of specifications, but these don't necessarily help you to identify the best performers. Resolution figures (in "dpi"—dots per inch) are now so high that they have little practical bearing on the print definition. Ink droplet sizes are now microscopic and, in reality, also have little actual bearing on print quality. Real-world tests in magazines are always a good guide, and they will also be up to date with the latest models and technologies.

The quality you get from modern inkjet printers is absolutely amazing—offering rich colors and plenty of detail. If you choose the right kind of paper, your prints will last for decades, if not centuries, without fading away.

PRINT LONGEVITY

In the early days of inkjet photo prints, rapid fading of images was a problem. Manufacturers have invested heavily in research, and most now quote a print life expectancy in decades or "generations." The important thing to note, however, is that manufacturers have not yet agreed on a standard set of test conditions and, obviously, they rely on "accelerated aging" processes to estimate print deterioration.

Nevertheless, prints do now last much longer than they used to, and quite probably as long as traditional photographic prints kept in the same conditions. However, it is essential to use the printer makers' own papers and inks, because these have been specially tuned and matched to provide this longevity.

Desktop printers are relatively affordable—and will print letters and other documents as well as images. Letter-paper size is sufficient for most photographers, but if you can afford it, go for a tabloid-paper-size model.

Storage

When you take a digital photo it is stored by the camera on a memory card. Memory cards have limited capacity and are best treated as purely temporary storage until you have the opportunity to transfer the photos to your computer.

The hard disk inside a computer has a much higher capacity and is perfectly suited to long-term storage of your growing photo collection. A 256Mb memory card may store around 100 good-quality photos, but an 80Gb hard disk, which is quite modest by today's standards, could store as many as 30,000.

These figures assume that each photograph takes up around 2.5Mb of space. This is a typical size for photos taken in the commonly used JPEG format. However, if you own a digital SLR and prefer to shoot RAW files, the file sizes will be much larger—anywhere from 5–25Mb, depending on the camera model. Edited versions of your files may also take up a lot more space than the original JPEG photos.

Virtual reality and the need to "back up"

Finding space to store your digital photos is not the only issue you need to be aware of. Unlike film, where you always have the original negative to fall back on, digital photos have no physical form. The electronic file on your computer is all you have. If the computer's hard disk should fail, or if the computer is stolen or damaged, you will lose all your photographs.

This is why it is important to have a system for "backing up" these files. This simply means keeping a copy of your photos on another storage device, preferably in another location, just in case something should happen to your computer.

There are different ways of doing this. Some photographers find the simplest method is to save their photos on CD or DVD as they go along. This is easiest if you have a routine. For example, your routine might be to first copy the photos from the camera to your computer, then copy them from the computer onto CD, then delete them from the camera.

Alternatively, you can use a plug-in ("external") hard disk drive and special backup software to maintain an up-to-date copy of your photo collection. This will serve as a generally reliable and relatively safe archive.

For photographers on the move, or for those who are ultra-cautious about protecting their images, hard-wearing, "rugged" external drives are now widely available.

If you don't need to access images regularly, a CD/DVD writer is a great medium for archiving images—whether it is built-in or connected externally to your computer.

The high capacities now available on USB "pen" drives make them ideal for transferring and storing images.

Take great care of your images, and archive them carefully, if you want to safeguard your memories for the future.

External hard drives are relatively inexpensive and can provide extra capacity once the drive built into your computer is full. Alternatively, they can be used as backup archives as a precaution should the built-in drive ever fail.

STORING IMAGES WHEN ON LOCATION

Storage can become a problem if you are away from your computer for any length of time, perhaps on vacation or on a business trip. It is no longer possible to transfer pictures to your computer and erase your memory card to make room for more. The simplest solution is to buy a larger memory card because prices have fallen considerably and even high-capacity cards of 1Gb and more are now inexpensive. Alternatively, you could invest in a portable storage device. These contain hard disks for bulk storage, but are battery-powered and have memory card slots so that transferring photos to the hard disk is easy. Finally, many stores have photo labs which can transfer pictures from your memory cards to a CD.

Film-based Cameras

Digital cameras now easily outsell film cameras, but some photographers still prefer to use film because it offers advantages in some specific circumstances. Film cameras come in a number of types which are aimed at different kinds of photographers.

35mm and instant cameras

Film cameras are categorized by "format"—the size and type of film used. The most popular type is 35mm film. There are many 35mm compact cameras and SLRs on the second-hand market, but they have largely disappeared from the dealers' shelves and the manufacturers' catalogs as digital compacts and SLRs have taken over, offering very similar levels of picture quality.

However, 35mm "single use" cameras remain popular. They cost little more than a roll of 35mm film, and they are ideal for school excursions or other projects where the camera may be damaged or lost.

Instant cameras can also be useful. The prints they produce are small and comparatively expensive, but the ability to produce a print on the spot has both novelty and practical value.

Medium- and large-format film cameras

"Medium-format" film cameras use larger film which comes on rolls. The larger film area produces much better quality than 35mm film, ideal for commercial or advertising work. Nevertheless, medium-format cameras have largely died out, also, as professional digital SLRs can now achieve similar levels of quality.

"Large-format" cameras use single sheets of film usually measuring 5" x 4", though some cameras may use sheets as large as 10" x 8". These produce superb picture quality and are used for calendars, posters, and other large-scale displays. These cameras are still popular among landscape photographers due to the fact that although they are slow to set up, they are comparatively light—and no digital camera can yet match the level of quality of a large-format film camera.

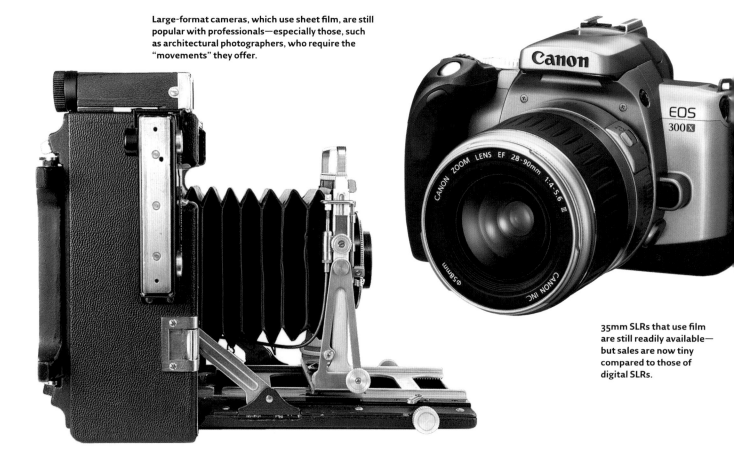

Large-format cameras, which use sheet film, are still popular with professionals—especially those, such as architectural photographers, who require the "movements" they offer.

35mm SLRs that use film are still readily available—but sales are now tiny compared to those of digital SLRs.

Why film cameras remain popular

Few studio-based professional photographers now use film cameras because the ability to check digital images on the spot and the low running costs (the only cost is printing the pictures you select) are impossible to ignore. Why spend a fortune on films and processing, as in the past, when digital image quality is—in the main—just as good and the whole business of getting pictures into a finished form is so much quicker and easier with a digital camera? Another consideration is that professional photographers' clients are increasingly unwilling to accept the additional material costs that come with traditional film photography.

Having said all that, many amateur photographers and artists are currently rediscovering film photography. This is chiefly because film produces images with subtly different characteristics, and the longer chemical processes involved in developing films and producing prints encourage a more deliberate and considered approach to picture taking.

While makers have largely abandoned the production of film cameras, there are many millions of such cameras still in use. They are widely available on the second-hand market and many should continue to function for decades to come.

A BRIEF HISTORY OF FILM

1826: Joseph Nicéphore Niépce records the first permanent image.

1829: Sir John F.W. Herschel coins the term "photography" (*photos* [light], *graphein* [to draw]).

1834: Henry Fox Talbot creates permanent negative images from which prints can be made.

1839: Louis Daguerre invents the Daguerreotype process.

1900: The Kodak Brownie box roll-film camera arrives.

1907: The French Lumière brothers invent the first commercial color film—"Autochrome."

1914: Oscar Barnack, working for Leitz, develops the first 35mm camera.

1936: The arrival of Kodachrome color film.

1963: Polaroid invents the first instant color film.

1981: Sony reveals its "Mavica" digital camera.

Medium-format cameras use special 120/220 roll film, which produces a negative/ transparency that is 2.7x the area of 35mm.

Millions of people around the world own 35mm compact cameras, so many are still in use.

Choosing and Using Film

"Negative" film is used to make prints. "Positive" film, which is more commonly called "slide" or "transparency" film, is designed to be viewed directly or displayed on a screen using a projector.

Negative film

There are printing processes for making prints out of positive film, but they are less convenient than using negative film in the first place.

Color negative film is the obvious choice for people using film cameras who want to be able to get their films developed and prints made at a photo laboratory. Although film camera production has now all but ceased, there are many millions of film cameras still in use and it seems likely that photo labs will continue to offer traditional developing and printing services to cater to them for some time to come.

Black-and-white negative film has traditionally been the realm of more dedicated enthusiasts rather than everyday snappers. This situation, and the fact that black-and-white film is chemically much simpler than color, has led most black-and-white photographers to develop their own films. The makers sell the chemicals needed to develop your own films at home at the kitchen sink. However, you will need a darkroom in order to produce black-and-white prints.

Alternatively, you could follow the route adopted by many photographers and scan in your negatives and then produce prints digitally using your computer and an inkjet printer.

Color transparency film

Color transparency film was for many years considered the "professional" color film, because it produced better picture quality than color negative film. Today, Fujifilm's Velvia transparency film enjoys a cult following among those who believe no other film (or digital camera, for that matter) can match the intensity and richness of its colors. Before it was supplanted in professional photographers' affections by Velvia, Kodachrome enjoyed a similar reputation.

ISO ratings

Films come in different sensitivities, or "ISO" ratings. High ISO films have more "grain" (random speckling) and are not as sharp as low ISO films. As a general rule, you should choose a high ISO film when you are shooting in low light and a low ISO film whenever picture quality is crucial.

Special films

There are some special-interest films which can produce effects that are difficult to achieve in any other way. One of the most interesting is "infrared" film, which captures the heat given off by objects as well as the light that they reflect. Kodak's High-Speed Infrared black-and-white film is a well-known example. It reproduces blue skies as near-black, but vegetation and human faces have a strange, ethereal glow.

Kodak's High-Speed Infrared black-and-white film features a special emulsion that is sensitive to red light which our eyes cannot perceive. It produces images in which the foliage seems to glow.

OPPOSITE: Film may have been eclipsed and largely superseded by digital, but it is still capable of producing pictures of superb quality.

All About Scanners

A scanner is used to convert a photograph into a digital image file on your computer. The photograph may be a print, a negative, or a slide, though in order to scan negatives and slides you need a scanner with a transparency adaptor or a special film scanner.

Flatbed scanners

Most scanners are of the "flatbed" variety. You lay the item you want to scan face-down on a glass plate, close the lid, and then operate the scanner from your computer. The glass plate, or "platen," is usually a little larger than U.S. letter size. Larger tabloid-paper-size scanners are available, but they are specialist items and considerably more expensive.

Flatbed scanners are designed for all kinds of printed material. They can be used to scan articles in magazines, letters, and business documents as well as photographs. However, there is some quality loss during the scanning process, however good the scanner, and photo prints themselves are often imperfect, so it is better, where possible, to scan the original negative rather than a print.

Flatbed scanners with transparency adaptors can do this, but the quality will not be as high as you will get from a dedicated film scanner. These are more expensive than standard flatbed scanners and can only scan 35mm slides and negatives. You can also buy medium-format film scanners, but these are many times more expensive and are impractical for amateur photographers.

DPI (Dots Per Inch)

Manufacturers will quote the scanner resolution in dpi (dots per inch). Typically, even an inexpensive scanner will have a resolution of 2400dpi. This is way beyond

the level of detail you are likely to find in any item you might want to scan. In practice, the optical and mechanical quality of the scanner will be far more important than the resolution figure.

High resolutions are useful only when scanning film directly. Here, you need a resolution of 2700dpi or more to capture all the detail in the photograph. However, even though many flatbed scanners offer higher resolutions than this, their optical and mechanical components prove the limiting factor, not the resolution. You can usually expect to get sharper pictures from a film scanner than from a flatbed scanner with a transparency adaptor, whatever the quoted resolution figures.

All the major photo equipment makers produce scanners, so there is a wide choice of models on the market.

OPPOSITE: Scanners offer a quick and easy way of digitizing your existing collection of prints.

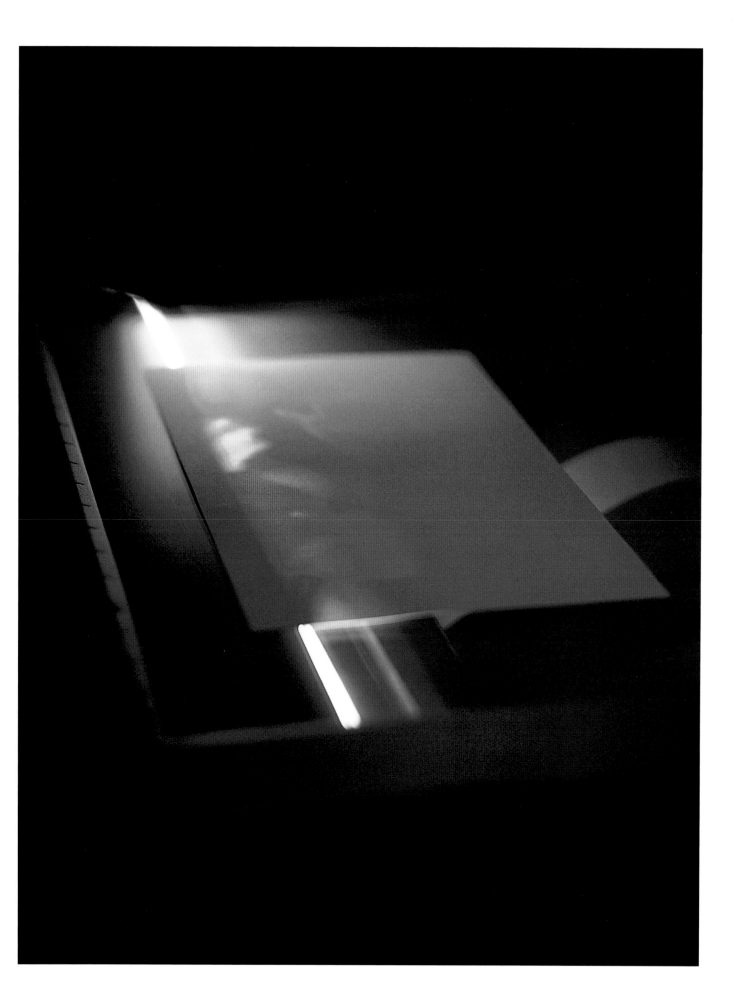

Using a Scanner

Whether you are using a flatbed scanner or a film scanner, the scanning process is much the same. The first step is to place the photographic print on the scanning platen or, if you are scanning film, place the film in the holder provided.

Preview scans
Once your item is on the platen or in the film holder, you can then carry out a "preview" scan or "prescan." This scans the image quickly, but at a lower resolution than the final scan. Its purpose is to display the image on the computer screen so that you can make the necessary adjustments before the full scan is carried out.

Cropping
First of all, you will want to "crop" the scan or, in other words, remove any borders or empty space around the photo. Some scanners can "auto-crop" your photos, but to get exactly what you want, do it yourself.

Color settings
Next, you should confirm the color settings. Many flatbed scanners will attempt to detect the type of item you are scanning as a "document," "text," or "photo." It is always a good idea to check that the scanner has identified the type correctly and is not about to save your photo in the wrong format.

When you first "open" your scanner on the computer using your scanning software—here it is Epson Twain Pro—you are offered a whole range of settings in the initial dialog box.

CORRECTING DEFECTS IN SCANS

35mm slides and negatives are very small and have to be magnified considerably to produce prints. This also magnifies any dust or hairs on the negative and this can easily spoil the image. You can use a blower brush or compressed air to try to dislodge any debris from the film before you scan it, but while this can help, it seldom eliminates dust entirely.

However, scanner makers have found a solution. Some scanners can identify dust particles, which stand proud of the film surface, using a special infrared scan. Once the scanner knows the location of these particles it can fill in the defects during the main scan to produce spotless images. "Digital ICE" technology is the best-known example of this.

Image adjustment settings
Now check the image adjustment settings. Most scanners have an "auto-adjustment" option which measures the light values during the preview scan and adjusts the image brightness, contrast, and colors automatically. These automatic adjustments will often be correct, but you may sometimes need to make adjustments manually if your photo looks too dark, too light, or the wrong color.

Resolution and output size
The next step is to check the scanning resolution and output size options. This can often be the cause of much confusion. The simplest solution is generally to leave the output image size the same as the original's (or set the "scaling" to 100 percent) and then choose a resolution figure appropriate to the item that you are scanning. A figure of 300dpi or 600dpi is usually plenty for scanning prints, and 2700dpi or 4000dpi will suffice when scanning slides or negatives.

Image formats
Finally, you will need to choose the format of your scanned image file. The JPEG format produces the smallest files and is usually the most efficient option. If you set the "quality" to "high" there will be a negligible loss in quality compared to other formats.

ABOVE, LEFT AND RIGHT: Got a collection of vintage photographs that are past their best? Why not scan them in and use an imaging program to breathe new life into them. The results may surprise you.

When you scan a print or other object, it is always a good idea to make a "preview" scan before undertaking the final version. This way, you can ensure that your image is correctly positioned on the platen, that all your basic settings are correct, and that any changes you might want to make are dealt with before final scanning.

The Future of Photography

Experience has shown that trying to predict the future is fraught with problems. It is all too easy to get things laughably wrong. There are two types of change: evolution and revolution. Evolution is easier to anticipate. You start from where you are now and simply project forward. But progress is rarely linear and logical. Which of us at the turn of the century would have anticipated that within five years virtually every cell phone would incorporate a digital camera?

Pixel count

One thing we can be reasonably sure of in the future of photography is that camera pixel count will continue to rise—though how much benefit that will be to anyone other than the professional photographer is another matter entirely. The resolution currently available on even inexpensive models of digital camera is more than sufficient to produce quality images that will satisfy most amateurs, whether they want to view them on screen or make prints. Not many photographers often enlarge their pictures beyond letter size, and that is easily achievable at the resolutions available today. However, that factor alone will not stop the pixel count from rising—even though bigger files mean longer processing times and require more storage capacity.

Increased capacity

Higher resolutions will inevitably lead to an increase in the capacity of removable memory cards. Already you can buy cards that are capable of storing hundreds of quality images—enough for a whole year of picture taking for some photographers. One day, though, it might be possible to store an entire lifetime's pictures on just one card. Doing so, however, without downloading or archiving them, would be a huge risk. Prudent photographers sensibly prefer to use several lower-capacity cards just in case a card gets corrupted—which, happily, does not happen very often.

Screen size

Large screens on cameras will become the norm in the future, and the larger the better. Screens allow you to compose images more effectively, review them more accurately, and share your images with others more easily just after you have taken them. The limiting factor will be the size of the camera itself—which will surely remain as diminutive as possible.

Live preview on SLRs

Being able to see the subject "live" on the LCD monitor has been the norm for many years—but for a long time SLR cameras only showed the image electronically after it had been taken. Pictures were still taken using the tried-and-tested reflex viewing system. In time all cameras will have live viewing, including SLRs, and it will seem perverse to have anything else.

Convergence

It seems likely that the various electronic items we use will gradually converge. Who wants to carry around lots of different gadgets? We are seeing this happen already, with phones featuring not only cameras but also music, e-mail, games, the Internet, diary, and the capacity to play live and recorded video. Even so, it is likely to be some time before the SLR, used by most photo enthusiasts, goes the way of the dinosaur.

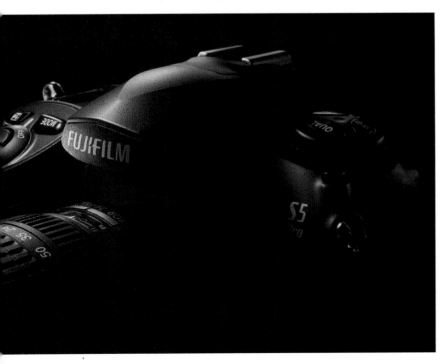

The pixel count of SLRs will continue to rise, with super-high resolution becoming the standard. This Fujifilm S5 Pro is one of the models that is currently setting the standard.

The larger the screen, the better—the only limit is the size of the camera to which the screen is attached.

SLRs with "live" LCD displays are likely to become the norm in coming years. Offering a very high quality of image on the screen, these give the most lifelike "reads" of images before you take them.

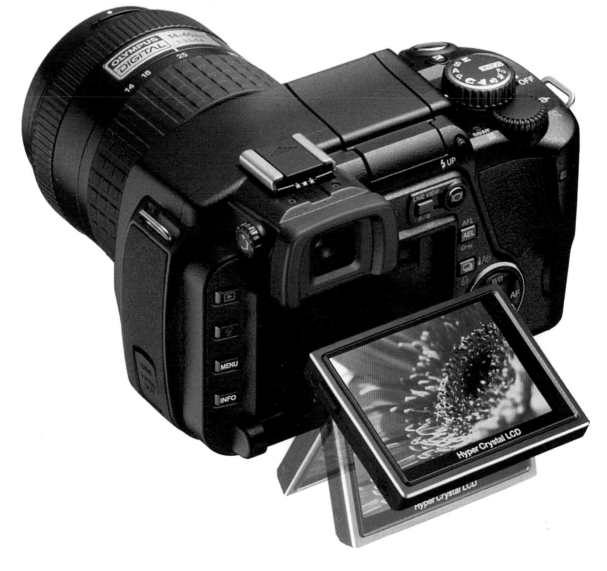

chapter 2

Lenses and Accessories

It is the enormous range of lenses and accessories on the market that makes photography so creative and so enjoyable. Compact digital cameras now generally have a zoom lens with a decent angle, from wide-angle to telephoto—making it possible to tackle most popular subjects successfully. Step up to SLR ownership and there are no limits to what can be achieved photographically. Lenses and accessories are available to meet every possible need—from capturing distant subjects such as wildlife and sports to revealing the splendor of vast interiors or panoramic vistas. If you can imagine it, you can take it.

Understanding Lenses

Single-lens reflex cameras enable you to change lenses to achieve a variety of effects. The camera's standard lens will give an angle of view roughly similar to that we perceive with the naked eye; a wide-angle lens enables you to get more into the frame, while a telephoto magnifies distant objects.

There are other lens properties to take into account, apart from their focal length, including the maximum aperture. The larger the maximum aperture, the more light the lens can gather. This is useful in poor light or whenever you want shallow depth-of-field in your photographs, perhaps for throwing backgrounds out of focus, or for creating a similar effect.

Zoom lenses
In modern cameras, zoom lenses have largely taken over from lenses with fixed focal lengths ("prime" lenses). The versatility of zooms means that you do not have to carry around a number of different prime lenses, or keep changing lenses for different subjects.

However, zoom lenses do have a couple of intrinsic disadvantages. One is that their maximum apertures are lower than those of prime lenses. Whereas a 50mm prime lens might have a maximum aperture of f/1.8, a typical "standard zoom" might have a maximum aperture of f/4 at this focal length.

Lens mounts
Each digital SLR brand uses a different lens mount. A Nikon lens, for example, will not fit a Canon camera. However, you do not have to buy lenses made by your camera's maker. Independent companies such as Sigma, for example, make lenses which can be supplied in different mounts according to the brand of camera you are using. These lenses are just as serviceable as those supplied by leading camera firms.

Independent lenses versus marque lenses
Lenses made by independent companies are generally much cheaper than those offered by the camera maker. The optical performance is often very good and it may be difficult to see the difference in image quality between photographs taken using a good-quality independent lens and those taken on a more expensive "marque" lens.

Having said that, when you buy a lens you are not just paying for image quality. Marque lenses may be better made than those from independent companies and are consequently more likely to withstand years of hard use. Their design and finish will be consistent with other lenses in the same range, and with the camera bodies which they are designed to accompany, and the lens range may include more sophisticated and specialized lenses that you cannot get elsewhere.

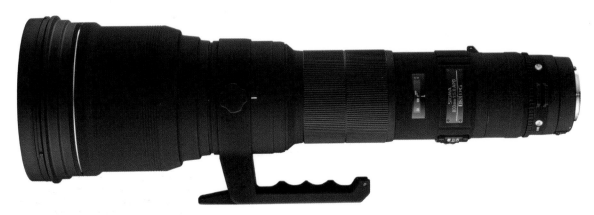

If you want to make much impact on subjects such as birds and motorsports, you will need a super-telephoto lens like this Sigma 800mm f/5.6.

Fisheye lenses have such a wide angle of view that you have to be careful not to get your feet in the picture.

Photographers who favor subjects like architecture and landscape should consider investing in a wide-angle zoom.

Fast-aperture telephoto lenses are bulky, heavy, and expensive—but ideal if you want to capture subjects such as sports and action.

For general use, nothing beats a telephoto zoom with a range around 70–300mm.

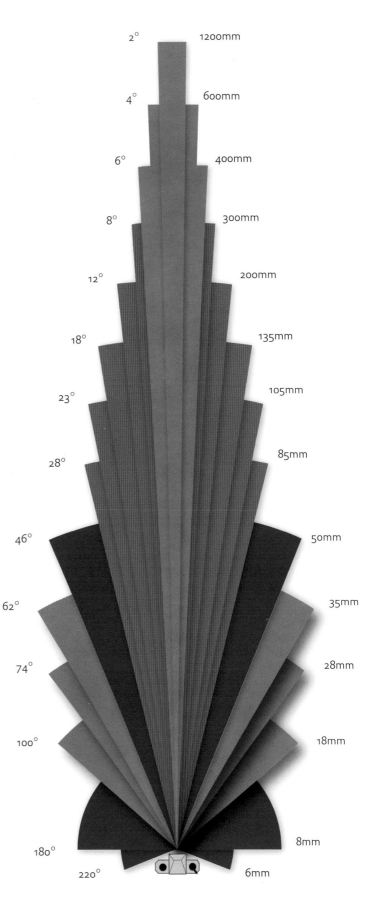

As the focal length of a lens increases, so its angle-of-view narrows. Wide-angle lenses take in lots of the scene because they have a large angle-of-view. With super-telephoto lenses the angle is reduced to just a few degrees, and little of the scene is included.

Standard Lenses

Digital cameras may be sold in "body-only" form, but this option will normally only appeal to buyers who already have compatible lenses. Most buyers will choose a camera kit that includes both the body and a standard lens.

Although most new cameras come with zoom lenses fitted these days, until fairly recently film cameras were supplied with only a fixed focal length lens. A typical standard lens has a focal length of 50mm or thereabouts, and is designed for general-purpose photography. Its angle of view closely matches that of the human eye, although some photographers feel that a 45mm lens is closer to the ideal. With a lens like this, the framing and perspective of shots looks natural, and this type has a large maximum aperture of f/1.8 or f/1.4. This makes it especially useful for shooting in low light or where you want shallow depth-of-field.

50mm standard lenses are light and compact, but some makers have produced shorter "pancake" lenses for photographers who want their camera and lens to be slimmer still. These have a focal length of around 40mm and a smaller maximum aperture of f/2.8, but their optical quality is usually excellent. They are more expensive, but for many photographers they are also more useful as standard lenses.

Standard zoom lenses

The zoom lenses that are a standard feature of most cameras sold today offer greater flexibility than the fixed focal-length lenses of the past, covering a range of focal lengths from wide-angle through to telephoto.

On a film camera, the usual standard zoom has a focal range of 28–90mm. On a digital SLR it is usually 18–55mm, which gives a comparable angle of view. You can use a 28–90mm film lens on a digital SLR, but the focal range is not ideal, because it does not provide proper wide-angle coverage on the smaller sensor.

Zoom ranges are sometimes quoted as a factor—for example, "3x," "4x," or "5x." This figure indicates the change in magnification across the zoom range. A 28–90mm zoom offers a 3.2x zoom range, for example, while a 28–135mm is a 4.8x zoom.

Zoom lenses with a longer focal range are more desirable, but they are also more expensive and much heavier. A lighter, inexpensive lens may be more useful on a camera that is going to be carried around all day.

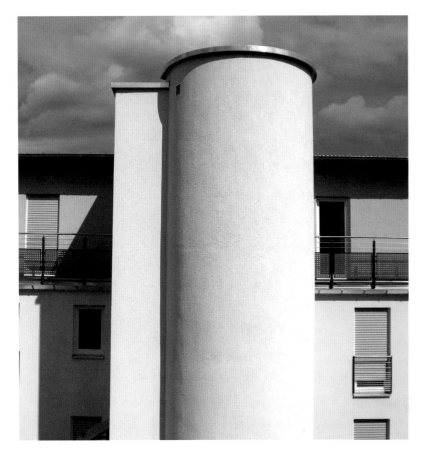

USES FOR STANDARD LENSES

- Standard prime lenses are good for full-length portraits, because you stand far enough away to prevent distortion but not so far away that you run out of space when working in small rooms.

- The large maximum aperture of a standard prime lens will make it ideal for taking pictures at parties and celebrations where you don't want to use flash, which could disturb the subjects.

- A standard 28–90mm zoom lens (or its digital equivalent) is perfect for everyday photography, because it is compact and light and you will seldom need focal lengths outside this range.

- Standard zooms are perfect for travel photography as well, in situations where there is often little time to change lenses or viewpoints. For this kind of work, a slightly longer zoom range (28–135mm, for example) can be an advantage.

Whenever possible you should photograph buildings from a distance and keep the camera square—to ensure the sides of the building appear upright. A standard zoom gives just the right perspective.

OPPOSITE BOTTOM: Pictures taken with standard lenses look very natural, because the angle-of-view is similar to that of the human eye.

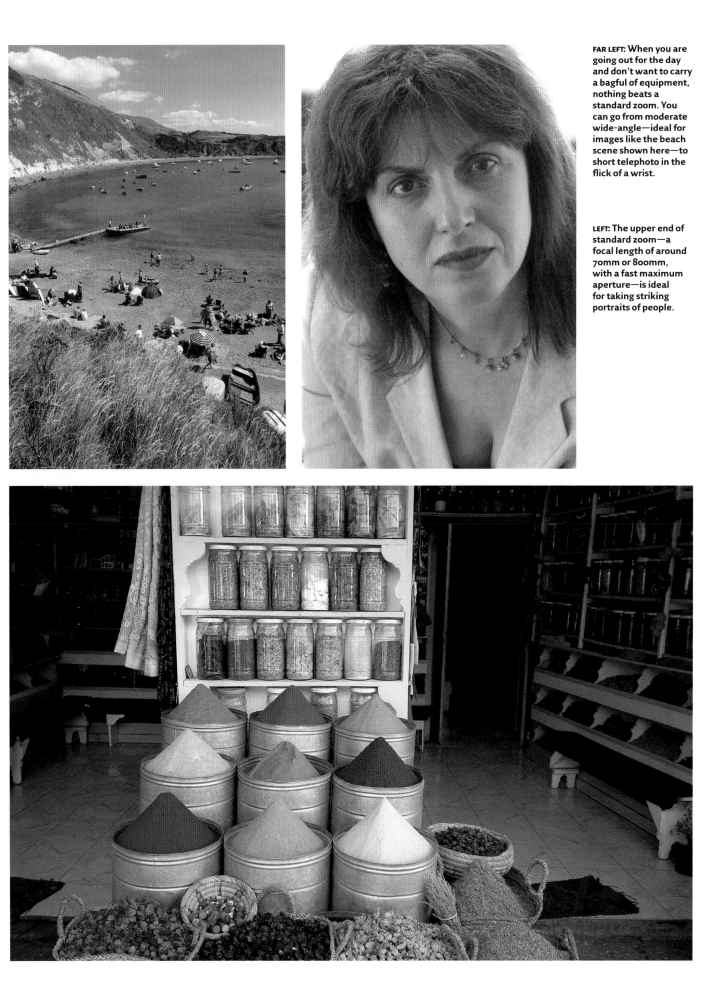

FAR LEFT: When you are going out for the day and don't want to carry a bagful of equipment, nothing beats a standard zoom. You can go from moderate wide-angle—ideal for images like the beach scene shown here—to short telephoto in the flick of a wrist.

LEFT: The upper end of standard zoom—a focal length of around 70mm or 80omm, with a fast maximum aperture—is ideal for taking striking portraits of people.

Wide-Angle Lenses

A wide-angle lens enables you to get more into the frame of your image. At the same time it makes objects seem smaller and farther away. A wide-angle lens has an obvious, practical value if you are trying to photograph a sweeping landscape or if you are taking pictures in confined spaces.

The term "wide-angle" covers a range of focal lengths. On a 35mm film camera, a 35mm lens would be considered a modest wide-angle and a 28mm lens a proper wide-angle. 20mm lenses are "super-wides," and considerably more expensive.

The standard zooms supplied with modern cameras usually have a minimum focal length of 28mm, which is probably as wide as you will usually need to go.

Just as there are super-wide fixed focal-length lenses, so there are wide-angle zooms, which cover similar focal lengths, such as 16–40mm on a 35mm camera, or a 10–20mm lens on a digital SLR.

These lenses are bulkier and more expensive than standard zooms.

In common with most special equipment, wide-angle lenses have both advantages and disadvantages. Their most obvious advantage is that they enable you to get more into your picture. They also offer more depth-of-field than lenses of longer focal lengths at a given aperture, so that it is easier to get both close-up and distant subjects sharp at the same time.

Wide-angle lenses are great for architectural photography—especially when there is not much room to maneuver. Framing one building inside another gives a great sense of depth.

WIDE-ANGLE PERSPECTIVE

Wide-angle lenses have a profound effect on perspective. This is not because of their inherent optical properties—the explanation is, in fact, much simpler. Wide-angle lenses make objects appear smaller, with the result that you move closer to fill the frame. The fact of doing this exaggerates the difference in size between nearby objects and those farther away. In turn, this produces the "keystoning" effect which is often seen when tall buildings have been photographed from their base. However, this exaggeration of perspective can have creative uses, as well. The dramatic size differences between close and distant objects produce a strong feeling of three-dimensional depth and compositional "movement" in images taken in this way.

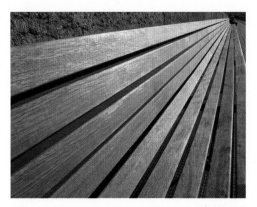

With a wide-angle lens at your disposal it is possible to create pictures from virtually nothing. By getting in close to the bench and setting a small aperture of f/16, here the photographer was able to lead the eye dramatically to the figure in the distance.

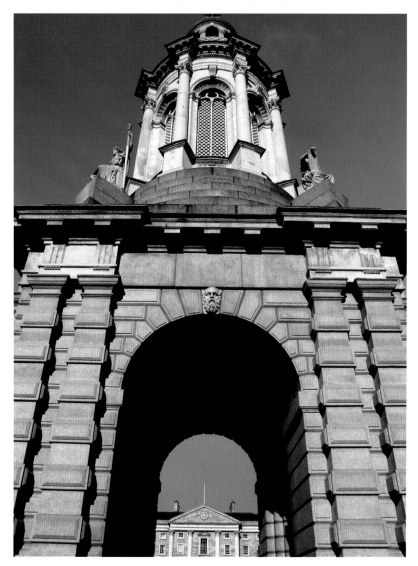

Many photographers automatically reach for a wide-angle lens when they come across a view like this—and with good reason. When you want to capture the spirit of a landscape, for the best effect you need the open perspective a wide-angle provides.

Image distortion

One downside of wide-angle lenses is that they can introduce distortion. This distortion manifests itself in two different ways. The most obvious is perspective distortion, in which the walls of tall buildings, for example, appear to converge, or objects at the edge of the frame appear to be toppling inward. This undesirable effect is called "converging verticals," or "keystoning." It is not a fault in the lens, but simply a reflection of the fact that you tend to stand closer to your subject with a wide-angle lens, and this means that you tilt the camera more to take in tall objects. If possible, you should compose your shots in such a way that the camera can be kept level.

The wide-angle setting of zoom lenses can often cause another unwanted effect known as "barrel distortion" to occur in images as well. In this case, the center of the image appears to bulge outward, and straight lines become bowed. This is one of the compromises inherent in zoom lens design.

USES FOR WIDE-ANGLE LENSES

- Huge, sweeping landscapes can only be captured with a wide-angle lens. With longer focal lengths you are restricted to picking out interesting details.

- Domestic interiors can be quite cramped, making photography difficult. A wide-angle lens will make a room look larger and enables you to get more people into the shot.

- Landmarks and tourist attractions are often hemmed in by other buildings, leaving you no room to stand back to take the picture unless you have a wide-angle lens.

- The big differences in size between close and distant objects enable you to produce surreal compositions in which everyday objects take on a monumental and dramatic appearance.

Telephoto Lenses

Like telescopes or binoculars, telephoto lenses magnify distant objects. They are essential for wildlife photography and for taking good pictures of many sports. Telephoto lenses can also be useful for picking out details in landscapes, or for head-and-shoulders portrait shots.

Like other lenses, telephotos are categorized according to their focal length. On a 35mm film camera, a 100mm lens would be a "short" telephoto, a 200mm lens would be a "medium" telephoto, and a lens of 400mm or longer would be a "long" telephoto.

Due to the magnification factor from their smaller sensor sizes, digital SLRs make telephoto lenses "longer." Fitted to a digital SLR, a 200mm lens would have an equivalent focal length of around 320mm, and a 400mm lens would become a 640mm.

Professional photographers use fixed focal length, or "prime," telephoto lenses. This is because they have wider maximum apertures which enable them to shoot in low light. This is essential for many sports, especially those held indoors under artificial lighting.

Telephoto zoom lenses

Telephoto zooms are more versatile than standard zoom lenses but have smaller maximum apertures. However, their flexibility and lower cost make them better-suited to general-purpose photography.

Most "kit" zooms (those supplied with the camera) have a maximum focal length of between 90 and 105mm, depending on the lens. This is not enough for sports and wildlife photography, and there may be other occasions in your photographic life when a longer lens is desirable or even essential.

Keep in mind that the longer the focal length, the more difficult it will be to get steady shots. Small movements of the camera become magnified with long focal lengths and this causes two problems. Firstly, the

subject will appear to bounce around the frame a lot more and it will be difficult to keep it centered. Secondly, camera-shake can cause blur at shutter speeds which would be "safe" at normal focal lengths.

To find the minimum safe shutter speed, divide 1 by the focal length being used. With a 200mm lens, this gives a shutter speed of 1/200sec. Although most of the time this works, there is no absolute guarantee of sharpness and it may still be possible to see camera-shake at 1/400sec.

Some telephoto lenses have image-stabilization mechanisms which move elements within the lens to counteract any movement during the exposure. These can help you get sharp shots and shutter speeds two to four times slower than normal.

OPPOSITE: Telephoto lenses allow you to pick out details in the distance. This is especially valuable when you can't move any closer to your subject—such as this clock tower—or with subjects like sports and when taking candid portraits of people.

RIGHT: One of the great things about telephoto lenses is that they compress perspective—they make things that are actually some distance apart appear to be closer together. In this picture, the woman's eyes were actually some distance behind the boy in front.

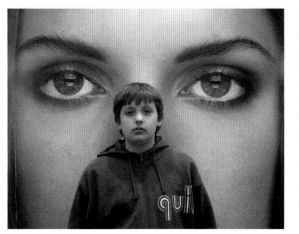

Extreme Lenses

At the extreme limits of optical design are ultrawide and ultralong lenses which can produce dramatic visual effects. However, these are also expensive and challenging to use.

Ultrawide-angle lenses

Ultrawide-angle lenses have focal lengths of 20mm or less. It is difficult to design lenses with good optical performance at these angles, and to make them render straight lines. "Fish-eye" lenses have even shorter focal lengths, but here the battle to reproduce lines as straight has been abandoned, and these lenses produce an almost spherical view of the world—hence the term "fish-eye." It is important to check the specifications of lenses in the 15–20mm range, because some will be genuine wide-angles and some will be fish-eyes.

Ultrawide-angle lenses can be difficult to use for a number of reasons. To avoid dramatically converging verticals (keystoning), it is important to keep the camera level when shooting, and many architectural photographers will use a tripod and a spirit level as they set up their shot to ensure that this is the case.

Another disadvantage of ultrawide-angle lenses is that it may not be possible to use filters with them, either. The front element of the lens may be so curved that it protrudes outward too far, and the angle of view will be so wide that many filter fittings will intrude on the edges of the frame.

Ultralong telephoto lenses

Ultralong telephotos (lenses with focal lengths of 400mm or longer) pose different problems, related to

USES OF EXTREME LENSES

- Due to its scale, architectural photography can be quite a challenge. An ultrawide-angle lens may be the only way to capture the subject in its entirety from the viewpoint available.

- It is very difficult to fully capture the interiors of buildings, whether they are small or large, without an ultrawide-angle lens. Other lenses can only capture sections or details.

- In the case of sports that take place on a large field, such as baseball or soccer, you will need an ultratelephoto lens to fill the frame with individual players.

- At air shows, the public is kept well back from the display areas, so if you want to photograph airplanes in action, an ultratelephoto lens will be essential.

weight and magnification. These lenses are so heavy that it may be impossible to hand-hold them for more than a few seconds. Most photographers mount them on sturdy tripods instead.

A tripod is also necessary to help you keep the subject framed correctly. At these magnifications, the slightest movement is multiplied drastically, so hand-holding the camera is not really a viable option.

TELECONVERTERS

It is possible to increase the focal lengths of lenses with a "teleconverter." These are supplementary lenses which fit between the camera body and the lens and magnify the image by a fixed amount, such as 1.4x, 2x, or 3x. They are a much cheaper alternative to long-range telephoto lenses, but they do have drawbacks. The most serious is that they reduce the maximum aperture of the lens. A 1.4x converter will reduce the aperture by 1 stop, a 2x converter by 2 stops, and a 3x converter by 3 stops. This reduction in the size of aperture increases the risk of camera-shake or subject movement in low light levels.

The dramatic perspective you get from an ultrawide-angle lens makes it easy to produce eye-popping pictures. Getting down low and pointing the camera upward adds to the effect.

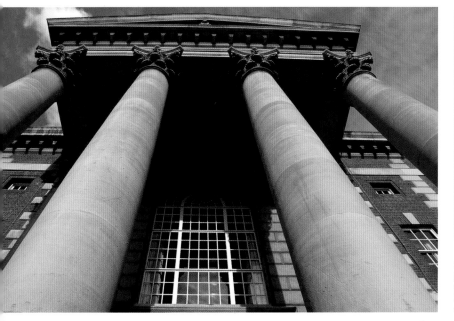

PAGES 58-9: If you want your images to stand out from the crowd, you need to go for impact rather than a realistic record of the subject. Here London's Millennium Wheel and surrounding buildings have been distorted through the use of an extreme wide-angle lens. The result is an unusual and dramatic image.

Long telephoto lenses, with a focal length above 300mm, are essential for pulling in distant subjects such as this bird of prey. Care needs to be taken in using them, though, especially in order to avoid camera-shake. Either set a fast shutter speed of 1/500sec or more, or support the camera in some way.

Special Lenses

Special lenses are available for very specific tasks that ordinary lenses cannot accomplish. There are a variety of different types available, offering applications that are useful to enthusiastic amateur photographers as well as seasoned professionals.

Soft-focus lenses

Professional portrait photographers sometimes use soft-focus lenses with carefully designed optical properties that soften the details of complexions in a much subtler way than simply blurring them. However, as more and more photographers migrate to digital equipment, this type of lens may become less useful. This is because it is possible to experiment with a much wider range of soft-focus effects after you have imported the image into image-editing software such as Adobe Photoshop (see page 222).

Macro lenses

Unlike soft-focus lenses, macro lenses will continue to be important as digital technology continues to transform the photographic medium. These lenses are designed to focus at very close ranges. The term "macro" describes photography in which the image of the subject produced on the film (or the sensor) is the same size or larger than it is in real life. However, it is not just a question of making lenses focus more closely; photography at these distances requires a different optical design if the overall image quality is to remain high.

Macro lenses can also be used for conventional photography, and they produce extremely sharp results even with subjects photographed at normal distances.

Shift lenses

Shift, or "tilt-shift," lenses are designed to tackle the problems of architectural photography. They are also known as "perspective control" (PC) lenses. This is because they offer special movements which enable you to correct the "converging verticals" or "keystoning" effect you get when photographing tall buildings.

With a conventional lens, the camera must be tilted upward to get the building in the frame, and this is what produces the undesirable perspective effect. With a shift lens, the camera is kept level, and the lens is shifted vertically upward on its mount until the building is correctly positioned in the viewfinder.

Shift lenses are expensive, specialized items. This is because the shift controls built into them must be precisely engineered and the lens must produce a much larger "image circle," to prevent the edges of the picture from becoming dark when you apply the shift movements.

Using a special shift or PC lens, you can adjust the perspective so that the sides of a building stand upright rather than converge. In the picture above, a shift lens has not been used and the image has become badly distorted as a result. However, in the picture below the use of a shift lens has ensured the perspective is viewed as it would be naturally by the human eye.

Special macro lenses are not cheap, but they are worth every cent. Using one it is possible to fill the frame with subjects that are extremely small—in the process producing pictures with lots of impact.

Lens Choice and Perspective

Interchangeable camera lenses have obvious advantages. A wide-angle lens will enable you to get more into the frame of your shot while a telephoto will enable you to magnify subjects which are far away.

While different lenses give you more choice, it is important to remember that by changing lenses you are also changing the perspective, the relative sizes of objects in the picture and their spatial relationships. To paraphrase an old photographic saying—why use interchangeable lenses when you can use your feet?

Admittedly, there will be many occasions when you physically cannot move farther away from your subject to "get more in," or you can't move closer to fill the frame, or there is simply no time to experiment with different positions. However, it is important to understand that changing lenses and changing your position have two different effects. While it might be tempting to imagine they achieve the same result, in practice the pictures you get are very different.

This is why it is important to spend time looking at your subject from every possible angle before you actually press the shutter. Walk past it, through it, around it, and behind it, experimenting with different lenses while you do so. Ask yourself questions about exactly what you are trying to accomplish with the shot and then think carefully about which lens in your bag will help you to achieve your objective.

When traveling, it is tempting to take only the typical "tourist" photo—the first thing you see from the steps of the tour bus! There may not be much time to explore your subject, but do make the most of whatever time you have available.

Which to use—wide-angle or telephoto?

In general, wide-angle lenses create a sense of "being there," of putting the viewer right in the center of the photograph. The exaggerated perspective offered by these lenses produces a sensation of involvement on the part of the viewer and adds immediate drama and depth to the image. With wide-angle lenses it is very difficult to find an uncluttered background. Usually, you have to make the background part of the "story" of your image.

Telephoto lenses produce a more distant, detached feeling. They are ideal for drawing your viewer's attention to specific objects, not least because it is much easier to frame shots with a neutral or complementary background.

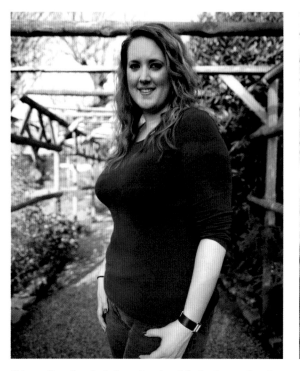

Using a 28mm lens includes quite a lot of the background, and requires the photographer to get extremely close to the subject, distorting proportions unattractively.

A 50mm lens gives a slightly more natural perspective, and reduces the amount of background included, but the effect could still be more attractive.

Using the right length of lens for the effect you want is crucial. Here a 20mm setting was used to give a sense of depth to this shopping mall interior in Dublin, Ireland.

Switching to a "portrait" setting of 100mm helps separate the subject from the background while producing a much more flattering perspective overall.

The use of a 200mm position on a telephoto zoom puts some distance between the photographer and the subject, creating an appealing perspective and reducing the impact of the background.

Using a Zoom Lens

Zoom lenses may be more versatile than prime lenses, but they are also more complicated to use. Additionally, they are prone to certain conditions which you need to take into account.

Potentially one of the most confusing features of zoom lenses is the way that the maximum aperture of most types changes across the zoom range. Only the most expensive "professional" zoom lenses have a fixed maximum aperture right across the zoom range. Usually, the maximum aperture is greatest at the wide-angle end of the range and smallest at the telephoto end. For example, if a lens is described as a 28–105mm f/3.5–5.6, this means that it has a maximum aperture of f/3.5 at 28mm but only f/5.6 at 105mm.

Zoom focal lengths and exposure settings

So what happens when you change the focal length after choosing the exposure settings? For example, you might set the camera to shoot at f3.5 and then zoom in. With modern electronic cameras, the lens will communicate changes in the focal length to the camera body, so that even if you have set an aperture of f/3.5, the camera will automatically update it with the new maximum aperture value as you zoom in, and will adjust the exposure accordingly. However, if you have already zoomed in on your subject before attempting to set the exposure, the camera will limit the maximum aperture you can set to the value available at this zoom setting.

The situation is slightly different with older camera and lens combinations, especially when the lens has an aperture ring. For example, on a 28–70mm f/3.5–4.5 zoom, the f/3.5 setting remains available whatever zoom setting you choose.

Zoom lenses are now the norm, and come in a variety of ranges, sizes, and prices. Offering economy, flexibility, and ease of use, they allow you to frame the picture exactly as you want. As with all photographic equipment, buy the best one you can afford.

EXPLOSION EFFECTS WITH ZOOM LENSES

You can change the zoom setting during the exposure of your image to produce an "explosion" effect, in which the center of the image is comparatively sharp, but the edges appear to be racing out of the frame (see facing page).

To do this, you need to use a shutter speed long enough to give you time to use the zoom control. This might take around a second, so to be sure of a reasonably sharp shot, use a tripod. A strong explosion effect also demands good coordination.

WHICH ZOOM LENS SHOULD YOU BUY?

"Standard" zoom lenses cover all the focal lengths you would normally use. Typically this will be in the range of 28–90mm for a 35mm film camera and 18–55mm for a digital SLR. A 70–300mm zoom is a good choice as a "second" lens since it will give you three times the magnification and most are relatively inexpensive. Wide-angle zooms cost more. A 17–35mm lens will give you dramatically increased angles of view.

Between them, these three zooms cover a focal range wide enough for almost any photographic purpose.

In this case, if you zoom in, all that happens is that less light is passed through the lens and the camera adjusts the exposure automatically. When you are taking photographs in this way, the only difficulties arise if you are setting the exposure manually and not using the camera's meter at all. In these situations you need to make sure that you are using an aperture which is available at the focal length that you have selected, as otherwise your pictures will not be successful.

OPPOSITE: If you zoom the lens while the shutter is open you get a powerful and dramatic "explosion" effect. Experiment with a range of shutter speeds and zoom as smoothly as possible.

Choosing a Strobe

Most cameras now come with built-in strobes, but there are still a number of distinct advantages to fitting an external strobe, even when the camera already has one built in.

External strobes are much more powerful than those which are fitted to cameras as standard items. Their extra power enables you to photograph subjects that are farther away, or to use lower ISOs or smaller lens apertures when you take the shot.

Additionally, many external strobes offer "swivel" and "bounce" movements. Direct flash generates harsh lighting, which might be acceptable when there is no alternative, but which is never very attractive. However, if you can turn the flash and "bounce" it off a nearby wall or ceiling, you will produce a much softer and more natural-looking light in your photograph.

These are two of the most important advantages of external strobes, and to a degree they are related. Keep in mind, though, that "bouncing" flash around a room saps a great deal of the strobe's power, so it is important to choose a powerful model if you intend to use this feature very often.

FLASH POWER VALUES

A strobe's power is quoted as a "Guide Number" ("GN"), usually set at ISO 100. This offers a useful, standardized measurement of flash power, and this number can also be used for exposure calculations. To work out the lens aperture to use, you divide the Guide Number by the subject distance, in meters. If necessary, you can then convert from meters to feet.

A typical built-in flash might have a GN of 12, so for a subject two meters away the aperture should be 12 divided by 2, or f6. If you think that this sounds complicated, the good news is that in practice modern strobes carry out these calculations automatically.

Other operating modes

External strobes may also offer operating modes which are not available with built-in flash. The shutter design of SLR cameras limits the maximum shutter speed at which flash can be used to 1/125sec or thereabouts, depending on the camera. There is a faint risk that some subject movement may show up at these shutter speeds, and the speed is also a limitation if the flash is being used to provide "fill-light" for outdoor portraits. However, using complicated timing techniques, some external strobes offer a "high-speed sync" mode that enables you to shoot at much higher shutter speeds.

Some models of external strobe also offer repeating "strobe" flash for capturing multiple images of a moving object during a single exposure. This can be a very useful feature for whenever you are shooting anything traveling at high speed when the prevailing light levels are poor.

Auxiliary strobes fit on the tops of SLR cameras. They generally deliver far more power and offer a much more attractive light source than integral flashes.

OPPOSITE: Most accessory strobes feature plenty of creative controls that allow you to balance their output with the ambient lighting. Spend some time getting to know your strobe and exactly what it is capable of, and you will soon see the difference in your pictures.

The secret to avoiding red-eye when using flash is to have people looking toward a light as you take the photograph. That way their pupils will close down, reducing the chance of their eyes coming out in ghoulish, red effects.

Modern strobes can be linked up to give controlled exposures, even when taking macro pictures.

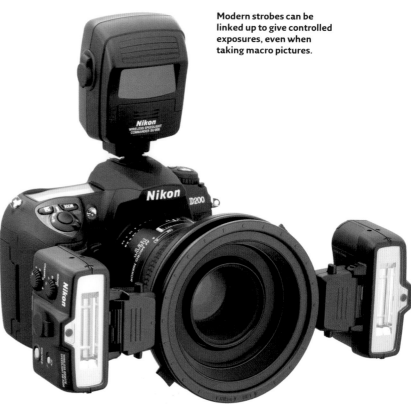

Supports and Releases

You should use a tripod to prevent camera-shake in poor light or when taking photographs with long exposures. However, tripods have other less obvious but equally important uses. They keep the camera locked in a fixed position while you make careful adjustments to the composition and arrangement of objects in the frame, and they leave your hands free for adjusting props, handling accessories, or directing your model.

Tripods

Tripods come with either ball-and-socket heads or pan-and-tilt heads. Those with ball-and-socket heads are the lighter and more compact of the two types, and very much quicker to use. However, they are not very good when you need to make careful adjustments, or if you need to pan the camera to follow a moving subject.

Monopods, clamps, and bean bags

There are alternatives to tripods which are less effective but which offer the advantages of being lighter and less awkward to set up and use. These include monopods (which are essentially one-legged tripods), clamps, and bean bags.

Some clamps are designed to fit within a car window, for example, while others may simply be adaptations of carpentry clamps with a ball-and-socket head. They are often useful, but they do need something of the right thickness to "clamp" on to, such as a table top.

Bean bags are often touted as the perfect portable support, but they do restrict you to specific viewpoints and you may be forced to take shots at ground level or table-top level, for example. This is not always ideal.

Remote releases

There is little point in using any kind of camera support if you then press the shutter release with your finger. This is because doing so will almost certainly jog the camera and will produce visible shake in the image.

Instead, you should use a remote release. These come in two forms. Older cameras, and some current models, have a threaded shutter

A versatile head, which can be adjusted to a range of positions, increases picture-taking flexibility.

A solid, stable tripod is an essential purchase for anyone who is serious about taking quality pictures. Buy the best one you can afford and then upgrade it as and when necessary.

MONOPODS

Monopods do not provide the stability of tripods, but they can help you get sharp shots in difficult conditions. They can be useful in poor lighting indoors, but they are especially useful if you are shooting with telephoto lenses and need the freedom to move quickly from one place to another.

To get the best results, lean forward slightly to put a little weight on the monopod as you hold the camera—but be careful not to apply so much weight that it collapses! This way, your legs and the monopod together act as a makeshift "tripod."

button so that you can screw in the inexpensive and widely available "cable release." You fire the shutter by simply pressing the plunger at the other end of the cable.

Many modern cameras do not have threaded shutter buttons. Instead, you use a wireless remote, which operates digitally without any direct connection to the camera. These must usually be bought separately.

There is an alternative to both of these options, however, which is completely free—the camera's self-timer. The delay on a self-timer lasts long enough for any vibrations you introduce by pressing the shutter button to die down. Of course, this technique only works with subjects which are not moving.

OTHER FORMS OF SUPPORT

If you don't have a tripod, a monopod, or any kind of camera support with you, it is often possible to improvise. Night shots can be taken by resting the camera on a wall or table. To avoid scratching the base of the camera you can place a folded sweater, a table napkin, or a rolled-up coat beneath it. Use the self-timer so that the camera is not jogged when you press the shutter button. You can also hold the camera against vertical surfaces such as walls and door frames, which will help to steady your hand.

Fantastic pictures like this are possible when you anchor your camera to a tripod. As well as enabling you to exploit your camera's creative potential to the fullest, supports also allow you to produce images that are crisp and sharp, with no risk of camera-shake.

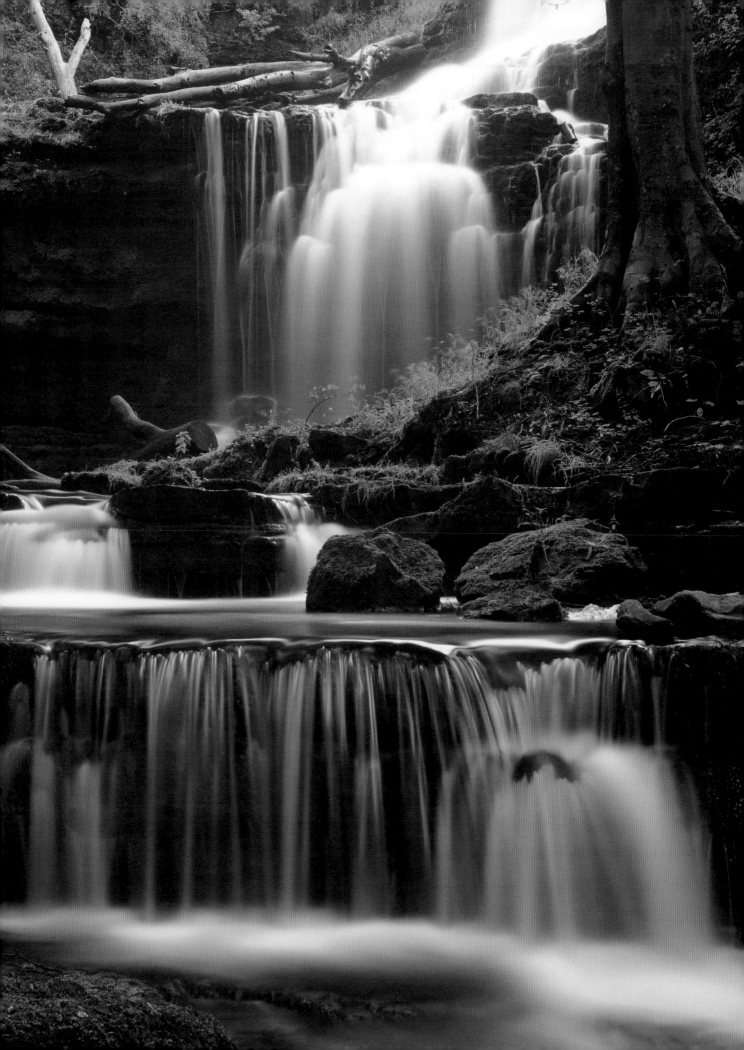

Bags, Filters, and Other Accessories

It is always useful to have a cable or remote release for your camera and a mini table-top tripod. Both will fit into a modest-sized camera bag and will help improve your photography in any number of different situations.

There are other items you should consider taking with you as well as a remote release and a mini-tripod. Modern cameras are increasingly dependent on battery power, especially digital models. Make sure you take a spare set of batteries, since those in high-draining devices like digital cameras will expire without very much warning. If you don't carry spare batteries, at least consider taking the camera's battery charger with you wherever you go.

You will also need spare memory cards, or, if you are using a film camera, spare films.

Do not forget to pack cleaning materials. A blower brush can remove dust from your lenses and viewfinder, while a soft cloth can be used to get rid of smears on lenses and LCD displays. Clean tissues are useful, also—they are often the only means of removing lens smears completely. Try a few different brands first, because unfortunately many types leave faint, oily residues on lenses, which will adversely affect the quality of your images.

Although no longer used as much as they were in the days of film—because so much can be done on the computer—filters are nevertheless still valuable accessories for certain kinds of work.

CAMERA BAGS

It is important to choose a suitable bag for carrying your photographic equipment. Proper photographic bags are more expensive than everyday bags, but they are much better in terms of organizing and protecting your equipment properly.

While most photographic bags have adjustable internal dividers, it is still a good idea to try them out in the shop with your own camera equipment, just to make sure everything fits properly. Many modern cameras, especially digital models, have fat handgrips and extra-deep bodies which may not fit

traditional camera bags, many of which have been designed for older, smaller, and more regular-shaped camera bodies.

Additionally, make sure that there is enough stowage space—not just for any extra lenses and a strobe, but all the other accessories you might want to take with you.

Photographic bags come in three main types: shoulder bags, rucksacks, and waist bags.

- **Shoulder bags** are the most common, and they provide quick access to your equipment while you are on the move. However, they can be uncomfortable over longer stretches, even if you keep swapping shoulders to balance the load.

- **Rucksacks** are much more comfortable to wear, but access to your equipment is more difficult. It is usually necessary to stop and take off the rucksack before you can take any photos. They are a good choice, though, when your subject awaits you at the end of a long hike.

- **Waist bags** are less common, but there are "modular" systems consisting of separate bags for bodies, lenses, and accessories which can usefully be attached to the belt as required.

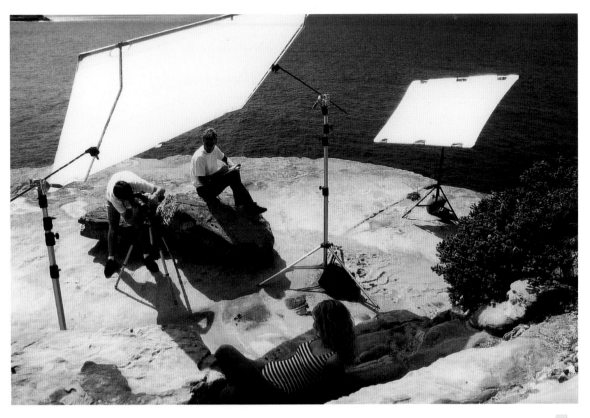

Reflectors are extremely useful accessories that allow you to control the light when shooting on location.

Fitting a neutral UV filter over the lens helps protect the front element from damage and will not adversely affect the quality of your images.

CLOCKWISE FROM TOP LEFT: Special cases are available in which filters can be stored; For the ultimate in protection, choose a hard case—these models are also dustproof and waterproof; Compact cameras are most easily stored in a simple pouch; Enthusiasts will ultimately build a comprehensive system that requires a large holdall with plenty of sections to accommodate; Be sure to choose a bag that will protect your equipment against the elements.

chapter 3

Technicalities and Techniques

The technology in modern cameras makes it easy to take pictures that are sharp and well-exposed most of the time. However, they are not foolproof. You still need to keep your wits about you if you are to be sure that your "once in a lifetime" picture doesn't end up being "the one that got away." Thankfully, all you have to do is master a handful of key techniques to get to the stage where you can guarantee 100 percent success. Once you have learned the principles of exposure, focusing, and flash, you can really let your creative juices flow.

Understanding Exposure

Getting the right amount of light for a correct exposure is like filling an automobile with gasoline. Just as the car won't run properly if you don't put in enough of the right substance, an exposure will fail if there is too much or too little light—and if the light is the wrong kind, also.

Lens aperture settings and shutter speeds

Each time you take a picture you have to use both a lens aperture setting (f/stop) and a shutter speed to control the amount of light making the exposure; the aperture governs the quantity of light admitted and the shutter speed controls the length of time for which that light is admitted.

Having said that, both controls are directly related, so you can use them in different combinations and achieve exactly the same exposure. Basically, each time you set the lens aperture to the next biggest f/number in the scale—f/11 to f/16, say—you are halving the size of the aperture and therefore halving the amount of light admitted. Conversely, if you set the lens aperture to the next smallest f/number in the scale, such as f/5.6 from f/8, you are doubling the size of the aperture and doubling the amount of light admitted.

The same principle applies with shutter speeds. Each time you double the shutter speed number—going from 1/60sec to 1/125sec, for example—you halve the length of time for which the shutter is opened. However, if you halve the shutter speed number—setting 1/15sec instead of 1/30sec—you will double the amount of time that the shutter remains open.

Stops

These units are referred to as "stops." One stop represents a doubling or halving of the exposure and can be achieved by adjusting the aperture, the shutter speed, or both.

To understand this relationship more fully, imagine you are filling your car with gasoline. The amount of fuel required (correct exposure) is provided by opening the valve in the hose (lens aperture) for a certain length of time (shutter speed). If the valve in the hose is small it needs to be kept open for much longer to fill the tank, whereas if the valve is large the tank will fill up very quickly. Either way, you will still end up with the same amount of gasoline in the tank.

Exactly the same principle applies to photography. If you set the lens to a small aperture (big f/number) you need to keep the shutter open for longer, whereas if you set a wide aperture (small

f/number), you can open the shutter for less time and still admit the same amount of light. For example, if your camera sets an exposure of 1/60sec at f/11, you could combine any of the following to achieve exactly the same exposure:

Shutter speed: 1/8 1/15 1/30 1/60 1/125 1/250 1/500 1/1000

Lens aperture (f/number): f/32 f/22 f/16 f/11 f/8 f/5.6 f/4 f/2.8

The combination of aperture and shutter speed you choose will depend on the subject you are photographing, as discussed on pages 76–7.

Giving too much or too little exposure produces images that are too dark or too light. The images on these pages are five versions of the same picture, taken at different exposures. The version above demonstrates correct exposure, whereas the images opposite show a variety of "wrong" exposures.

This version of the image was taken with -1 stop. Consequently, the image is under-exposed and too dark to be successful.

Here the image was taken with -2 stops. The result is an even darker and more greatly under-exposed picture.

Move to an exposure of +1 stop and now the image is becoming over-exposed—that is, containing too much light to be successful.

Take the setting up one more stop to +2 stops and the over-exposure is clearly becoming even more of a problem, resulting in an image that is much too light.

Choosing Shutter Speeds

As well as helping you to achieve correct exposure, the shutter speed of your camera also controls the way that movement is recorded. Fast shutter speeds will freeze movement, but slow shutter speeds will record blur, which can be highly effective. You also need to consider camera-shake, which is caused if you try to take a handheld picture with a shutter speed that is too slow, causing blur to be created when you don't want it.

Beating camera-shake
To combat camera-shake, the rule-of-thumb is to make sure that the shutter speed you use at least matches the focal length of the lens—so 1/60sec for 50mm, 1/250sec for 200mm, and so on—although much depends on the steadiness of your hand as you take the picture. You may find that you need to use a faster shutter speed than is normally recommended to ensure a sharp picture, or, if you have a particularly steady hand, that you can successfully handhold at slower speeds.

Freezing moving subjects
If you want to freeze a moving subject, there are three important factors that must be considered: how fast your subject is moving; how far away it is from the

For general picture taking using a standard zoom, go for a shutter speed around 1/125sec or 1/250sec.

When using a telephoto lens to photograph distant subjects—such as this candid, taken with a 400mm lens—you need a fast shutter speed to avoid the danger of camera-shake. In this case 1/500sec was used.

SUBJECT	ACROSS PATH FULL FRAME	ACROSS PATH HALF FRAME	HEAD-ON
Jogger	1/250sec	1/125sec	1/60sec
Sprinter	1/500sec	1/250sec	1/125sec
Cyclist	1/500sec	1/250sec	1/125sec
Trotting horse	1/250sec	1/125sec	1/60sec
Galloping horse	1/1000sec	1/500sec	1/250sec
Tennis serve	1/1000sec	1/500sec	1/250sec
Car at 40mph	1/500sec	1/250sec	1/125sec
Car at 70mph	1/1000sec	1/500sec	1/250sec
Train	1/2000sec	1/1000sec	1/500sec

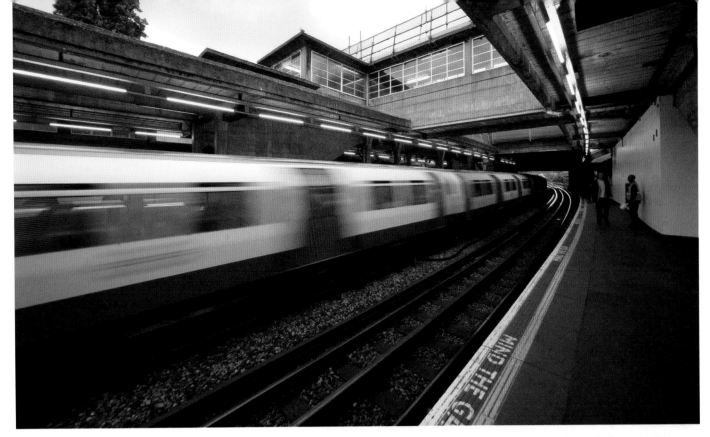

Setting a longer shutter speed—here it was 1/8sec—means that moving subjects will blur. The extent of the blur in the image depends on the shutter speed and how fast it is moving.

When there is plenty of light you can make the most of your camera's fast shutter speeds—and even something as everyday as a fountain can be made to look spectacular. Shooting into the light at 1/1000sec reveals all the individual droplets of spray.

camera; and the direction it is traveling in relation to the camera. If your subject is coming head-on, for example, you can freeze it with a slower shutter speed than if it is moving across your path. Similarly, a faster shutter speed will be required to freeze a subject that fills the frame than if it only occupies a small part of the total picture area. A shutter speed of 1/1000 or 1/2000sec is fast enough to freeze most action subjects. Unfortunately, however, light levels won't always allow you to use such a high speed—even with your lens set to its maximum aperture—so you need to be aware of the minimum speeds required for certain subjects. Use the table opposite as a guide.

Other options
Using a fast shutter speed is not always the best option, however, because by freezing all traces of movement you can lose the sense of drama and excitement. So don't be afraid to set a slow shutter speed and intentionally introduce some blur into your pictures. In the case of waterfalls, for example, an exposure of one second will record the water as a graceful blur, while an exposure of 10 seconds or longer will record movement in the ocean and clouds in the sky.

Choosing Apertures

The aperture is essentially a hole in the lens that is formed by a series of metal blades, known as the "diaphragm" or "iris." When you press the camera's shutter release button to take a picture, these blades close in on each other at the moment of exposure to form a hole through which whole light is able to pass. The precise size of this hole is denoted by the f/number you set the lens to—the bigger it is, the more light is admitted.

F/numbers

F/numbers follow a set sequence which is found on all lenses. A typical f/number or aperture scale on a standard zoom lens would be as follows: f/2.8; f/4; f/5.6; f/8; f/11; f/16; and f/22. The smaller the number, the larger the aperture, and vice versa. The first f/number in the scale is known as the "maximum" aperture, and the last number is known as the "minimum" aperture.

Not all lenses have the same maximum and minimum apertures. The scale on most telezoom lenses starts at f/4.5 and goes down to f/22 or even f/32 for example, whereas a standard 50mm lens would commonly have an aperture range from f/1.8 or f/1.4 to f/16.

The main thing to remember is that f/numbers are identical regardless of the focal length of the lens, so that f/8 on a 50mm lens will admit exactly the same amount of light to the film as f/8 on a 600mm lens or f/8 on an 18mm lens.

Selecting an aperture

Which aperture should you use? Well, that depends on what you are trying to achieve with your image. If you want to freeze a moving subject, then you need to set a wide aperture such as f/4 so that lots of light is admitted by the lens and your camera can select a fast shutter speed. Similarly, if you want to use a longer exposure, set a small aperture such as f/16 or f/22 so a slower shutter speed will be required.

More importantly, the lens aperture also helps to determine how much of your picture comes out sharply focused and how much does not. This "zone" of sharp focus is called the "depth-of-field" (see page 80).

RIGHT: Choosing as large an aperture as possible—in this case f/2.8 on a 70-300mm zoom—makes the hat stand out three-dimensionally from the background.

OPPOSITE: Combining a small aperture of f/16 and a wide-angle lens—here a 12-24mm zoom—results in depth-of-field that goes from just a few inches from the front of the lens to infinity.

Depth-of-Field

Whenever you take a picture, an area extending in front of and behind the point which you actually focus the lens upon will also come out sharp in the image. This area is known as "depth-of-field," and it is one of the most important variables in photography, because it allows you to control what will be in- and out-of-focus in your pictures.

There are three basic factors that determine how much, or how little, depth-of-field there will be in a photograph, as follows.

1 The aperture set on the lens

The smaller the lens aperture (the bigger the f/number), the greater the depth-of-field, and vice versa, for any given lens. If you take a picture with your lens set to an aperture of f/8, for example, much more of the scene will come out in sharp focus than if you use a larger aperture such as f/2.8 or f/4, but less than if you used a smaller aperture such as f/16 or f/22.

2 The focal length of that lens

The shorter the focal length (the wider the lens), the greater the depth-of-field is at any given aperture. For example, a 28mm wide-angle lens will give far more depth-of-field when set to f/8 than a 50mm lens set to f/8, but a 50mm lens set to f/8 will give greater depth-of-field than a 300mm lens set to f/8.

3 The focusing distance

The farther away the main point of focus is from the camera, the greater the depth-of-field will be for any given lens and aperture setting. For example, if you use a 50mm lens set to f/8, depth-of-field will be greater if you focus that lens on 10m than it will be focused on 1m. To check depth-of-field you can use your camera's stop-down preview facility—some SLRs have this, but not compact cameras. When activated, it stops the lens down to the aperture it is set to and by looking through the viewfinder you can then get a fair indication of what will and will not be in focus. However, at small apertures such as f/16 and f/22 the viewfinder image goes quite dark, which can make it difficult to see clearly just what is going on.

MAXIMIZING DEPTH-OF-FIELD

If you want to achieve maximum depth-of-field so that everything is recorded in sharp focus from the immediate foreground to infinity—which is normal when shooting landscapes—use a wide-angle lens such as 28mm or 24mm and set it to a small aperture such as f/16 or f/22.

Remember that the smaller the aperture is, the slower the shutter speed will be and the risk of camera-shake is increased, so try to keep your aperture as large as possible at all times. Ideally you should also focus your lens roughly 1/3 into the scene, as this will help accentuate the sense of depth-of-field in the image.

MINIMIZING DEPTH-OF-FIELD

If you want minimal depth-of-field—which would result in little more than the main point you have focused on coming out sharp and everything else in the image being thrown out-of-focus—use a telephoto lens in the range of say 200mm to 300mm set to a wide aperture such as f/4 or f/5.6.

This is common practice with subjects like portraits, candids, and sports or action, in which you want the background to be out-of-focus so that it does not compete with your main subject. Minimizing depth-of-field also creates a strong three-dimensional feel, as it makes the main subject stand out in the image.

As the series of pictures on the opposite page clearly demonstrates, small apertures (f/11, f/16, etc.) produce extensive depth-of-field, while large apertures (f/2.8, f/4, etc.) produce minimal depth-of-field.

TOP LEFT: This version of the image was taken with an aperture setting of f/2.8, resulting in minimal depth-of-field.

CENTER LEFT: This version of the image was taken with an aperture setting of f/5.6, resulting in very little depth-of-field.

BOTTOM LEFT: This version of the image was taken with an aperture setting of f/11, resulting in extensive depth-of-field.

TOP RIGHT: This version of the image was taken with an aperture setting of f/4, resulting in minimal depth-of-field.

CENTER RIGHT: This version of the image was taken with an aperture setting of f/8, resulting in average depth-of-field.

BOTTOM RIGHT: This version of the image was taken with an aperture setting of f/16, resulting in very great depth-of-field.

Metering Patterns

Although the job of your camera's metering system is to produce correctly exposed images, it may do so using a range of different metering "patterns." These patterns vary the way in which light levels are measured by the camera in order to determine correct exposure, and some are more accurate than others.

Center-weighted average

This used to be the standard metering pattern found in cameras, and is still an option in the majority of SLRs. It works by measuring light levels across the whole image area, but preference is given to the central 60 percent because it is assumed that that is where the main subject will be in the image. For typical well-lit subjects, a pattern based on center-weighted average can be relied upon to give accurate exposures, but it can also cause exposure error in uneven lighting situations.

Multi-zone/multi-pattern metering

These "intelligent" metering patterns—technically referred to by the manufacturers Nikon and Canon as "Matrix" and "Evaluative" respectively—are the most sophisticated patterns available and make taking perfectly exposed pictures easier than ever. They work by dividing the viewfinder into various "zones" and measure light/brightness levels in each. The zone readings are then analyzed by a microprocessor and

an exposure reading is set based on comparison to model lighting situations. By doing so, the exposure reading is not overly influenced by bright or dark areas in the scene—such as a brilliant blue sky—so the risk of exposure error in the image is drastically reduced.

The number of zones in the pattern varies from four to 16, depending on the model of camera that you are using—the more zones there are available, the more accurate the system is likely to be.

USING AN AE LOCK

The AE (Auto Exposure) lock allows you to take a meter reading and then hold it, even if the camera's position is changed. For example, when shooting landscapes you can tilt the camera down to exclude the sky from the viewfinder, which may cause underexposure; take a meter reading from the foreground; and then use the AE lock to hold the reading while you recompose the shot.

Traditional center-weighted patterns place most emphasis, as their name suggests, on what is in the center of the picture. They cope well with standard subjects, such as landscape, but can be fooled by images in which there is an uneven range of tones.

Spot and partial metering are valuable when the main subject is either much lighter or much darker than the background. Going in close and taking a reading ensures that you expose the most important parts of the image to their best effect.

Complex images such as the one below, which have a wide range of tones and light coming from behind the subject, are a challenge for any metering pattern. Modern multi-segment patterns analyze the subject carefully and compare the results to a database of scenes, providing unparalleled accuracy.

Partial/selective metering

This pattern measures light levels in a small central area of the viewfinder—usually 6–15 percent of the total image area—and in doing so allows you to meter from your main subject, or a specific part of the scene, without excessively bright or dark areas influencing the exposure obtained.

Spot metering

This pattern is similar to selective metering, but it measures light levels in a tiny central area of the viewfinder—anything from 1–5 percent of the total image area. Consequently, you can use it to take meter readings from small areas of a scene, and in experienced hands it is the most accurate and useful system available.

Multi-spot metering

Some cameras allow you to take a series of individual spot readings, store each one in the camera's memory, and then average them out to establish the best exposure. This is ideal in situations when you are not sure where to meter from; by metering from the lightest and darkest areas and then averaging them, you will obtain an exposure that makes a good starting point for a successful image.

When Meters Can Fail

Although modern light meters are technologically advanced, they can still sometimes struggle in certain situations. Recognizing when there could be problems with the light will enable you to take action to make sure that the exposure of your images is correct. This is a skill that will improve with practice and as your experience grows.

Light subjects

The light meters built into cameras may be very sophisticated, but none are able to distinguish between bright lighting and subjects which are themselves intrinsically bright. In order to reproduce white subjects such as wedding dresses or snow as white, you must increase the exposure that is selected automatically by the camera.

Light backgrounds

In cases when your subject is placed against a much brighter background, the camera may base the exposure on the background and leave your subject underexposed. In these situations you may need to increase the exposure to reproduce your subject properly, although modern metering systems are highly sophisticated and may not need overriding.

Dark subjects

The same applies to intrinsically dark subjects, although these are less common. The camera will assume that subjects are dark because of a lack of light and will then increase the exposure accordingly. You must reduce the exposure in order to render dark subjects as truly dark rather than the mid-gray tone that light meters are calibrated to reproduce.

Dark backgrounds

Dark backgrounds may fool the camera into increasing the exposure so that your main subject is overexposed and washed out. In this case, you need to reduce the exposure suggested by the camera. Another alternative is to use the camera's spot metering mode, if available, and take a light reading from the subject alone.

When part of the subject is in shade—such as the poppy and cross here—you may have to increase exposure to avoid the picture coming out too dark.

High contrast

High-contrast scenes include the combination of bright sun with dense, black shadows, and indoor shots taken near windows. The camera may not correctly judge which areas of the scene you want correctly exposed. You may find that the darker areas descend into blackness, and that you must increase the exposure to restore details in the shadows.

Shooting contre-jour

Shooting contre-jour (against the light) can produce very striking photographs, but the results may not always be as you intended. The light meters in simpler cameras may produce a silhouette effect, while more advanced "multi-segment" systems expose for the subject in the center of the frame and let the background wash out. Depending on your intentions, you may need to override the camera's exposure.

Lots of light

Where there is a great deal of light, it can be difficult to judge the correct exposure and predict how the camera will deal with it. The camera may attempt to "dim down" the brightness, when actually it is exactly this brightness that you wish to convey. An example might be a portrait of a light-skinned model in a white dress against a bright window.

Naked light sources

Naked light sources will usually confuse the camera's light meter and cause it to underexpose the image. If the sun is in the frame outdoors, or a domestic lamp indoors, you will usually need to increase the exposure to reproduce the scene correctly. The same applies when you photograph neon-lit city streets at night.

When the main subject is framed by something dark, there is always the danger of the camera giving too much exposure.

COMPENSATING EXPOSURE

There are three main ways of overriding the camera's chosen exposure setting: AE lock, EV compensation, and manual exposure. Practically all modern cameras will "lock" the current exposure setting when you half-press the shutter release. This enables you to reframe the scene and then shoot while maintaining the original exposure settings.

Cameras also have EV (Exposure Value) compensation controls. These are ideal when photographing intrinsically light or dark subjects. Add a positive EV compensation for light subjects and negative compensation for dark subjects. More sophisticated cameras offer a manual exposure mode, in which you set the lens aperture and shutter speed yourself. The camera will suggest the correct exposure, but you are free to ignore it.

TOP: When there is a lot of sky in the picture, or the background is bright, you need to make sure the meter does not underexpose.

ABOVE: Dark backgrounds can easily mislead the meter in the camera to give more exposure than the subject requires.

Creative Exposure Modes

The way your camera sets the exposure of your image depends on the specific exposure mode that you are using as you set up the shot. Modern SLRs usually offer four main exposure modes, and although they all perform the same task of achieving correct exposure, they vary the level of control you have over the aperture and shutter speed set.

Program mode

When you take a meter reading, the camera sets both the aperture and the shutter speed automatically. The combination is usually chosen at random and is displayed in the camera's viewfinder and/or LCD panel, though some cameras have a program shift function which allows you to adjust the aperture/shutter speed combination chosen to suit a particular subject. This is an ideal mode for beginners, but it is too automated for experienced photographers.

Aperture priority AE (AV mode)

With this semi-automatic mode, you set the lens aperture (f/number) and the camera automatically selects a shutter speed to give correct exposure. The shutter speed is usually displayed in the viewfinder and on the top plate LCD, so that it is clear what setting the camera has selected.

Aperture priority is the most versatile exposure mode for general use. It gives you control over depth-of-field, because you choose which lens aperture you want to set.

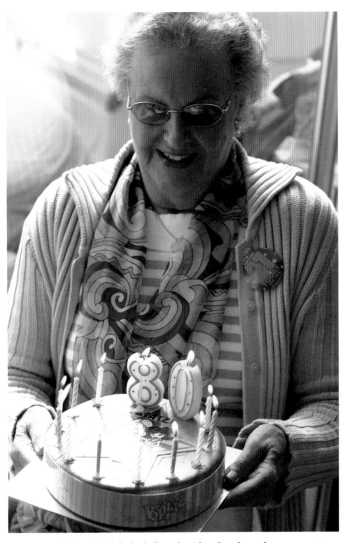

Program mode is an ideal choice in fast-changing situations when you want to concentrate on the subject and not have to worry about technicalities. Here, the key thing was to catch the woman as she was about to blow out the candles.

Aperture priority mode allows you to choose the aperture, with the camera matching it to the correct shutter speed. This is the perfect choice of mode for situations in which you want to control depth-of-field in your image.

On many cameras, apertures can be set in 1/3 stop increments, so this mode is ideal for landscapes and portraits. Aperture priority also links up with the camera's exposure compensation facility, so that you can override the metering system to avoid exposure error.

Shutter priority AE (TV mode)

This mode is very similar to aperture priority but, as you have probably guessed, you select the shutter speed and the camera automatically sets the aperture required to give correct exposure. Shutter speeds can often be set in 1/3 stop increments for greater accuracy and this is a handy mode for action and sports photography, in which the choice of shutter speed is more important than controlling depth-of-field.

Metered manual

This is the simplest exposure mode of all. After taking a meter reading with your camera, you set both the aperture and shutter speed yourself, using a needle or some other indicator in the viewfinder to show when correct exposure has been achieved.

Manual mode is ideal if you work with a handheld meter—or if you like to feel that you are in total control—but do not be misled into thinking that it is any more accurate than any of the other modes above. All these modes work with your camera's metering system and this one does not do anything different to the others—except that it is slower to use.

In shutter priority mode, you select the shutter speed— according to whether you want to freeze or blur—and the camera provides the corresponding aperture.

Manual metering needs to be used carefully, because mistakes can easily occur when using this mode, but it is great for situations in which you want to do something more creative and unusual.

PAGES **88-9**: Taking pictures toward the light is a sure-fire way of generating impact. However, there is a constant danger of underexposure, as the meter may think there is more light falling on the subject than is actually the case. For that reason you may need to allow an amount of exposure compensation.

Subject Exposure Modes

If you are a beginner to photography with limited experience and technical knowledge, anything that will help you to produce successful, appealing results every time has to be a good thing.

This is where subject-based exposure modes come in useful. These are basically program modes in which all the necessary camera functions such as aperture, shutter speed, autofocus mode, metering pattern, firing rate, and flash mode are set automatically, but they are also biased toward a specific subject so that you can fire away without worrying if you have got the camera setting right. As your experience grows, you will want to have more control over the picture-taking process, but in the early stages these modes can be invaluable.

When shooting a scenic view it is a good idea to use the landscape mode, which sets a small aperture to keep everything sharp from front to back.

In night mode you get a longer exposure than the norm, enabling you to capture atmospheric images once the sun has gone down. To avoid camera-shake, the system assumes you will be supporting the camera.

DAY EXPOSURE

PORTRAIT MODE

If you set this mode the camera will automatically bias the exposure towards a wide aperture (and high shutter speed) to minimize depth-of-field so that the background is thrown out of focus. It also sets continuous shooting so that the camera keeps firing while the shutter button is depressed. One-shot AF and metering is usually set to multi-pattern.

ACTION MODE

A fast shutter speed is set to freeze your subject and the AF mode is set to "servo" so that the lens will track your subject and keep sharp focus, emitting a "beep" when the subject is in focus. The motordrive will also be set to "continuous high," the fastest shooting rate, so that you can fire off rapid sequences of images. In this mode, metering is set to multi-pattern.

LANDSCAPE MODE

A small aperture is selected to maximize depth-of-field so that the whole scene records in sharp focus; autofocusing is set to one shot and the motordrive to single shot. Metering is again set to multi-zone, as this is the most accurate system for achieving correct exposure in a range of lighting situations.

CLOSE-UP MODE

To help you produce successful close-ups the camera automatically selects a small aperture to give increased depth-of-field—though it is still limited when shooting close-ups so you need to focus carefully. Firing is also set to single shot, the AF mode to one shot, and metering to multi-pattern.

NIGHT EXPOSURE

NIGHT PORTRAIT MODE

If you want to take a picture of someone outdoors in low light, this mode combines a slow shutter speed to record the background with a burst of flash to light your subject.

NIGHT LANDSCAPE MODE

In this mode, the flash is turned off, a small aperture is selected to give increased depth-of-field, and a long exposure set to record low light. Focus is also set to "one shot" and metering to "evaluative."

Portrait mode is optimized, as you might expect, for pictures of people. It sets just the right aperture for this kind of photography and, on most cameras, allows continuous shooting, so that you can capture any fleeting expressions your subject might make.

Close-up mode is also good for taking photographs of people, offering an alternative to portrait mode. In this mode it is easy to create strong depth-of-field effects, although this still requires careful focusing in order to work effectively.

Focusing

The focusing systems used by modern cameras are incredibly sophisticated and make it easier than ever to achieve sharp focus in the poorest lighting situations—even total darkness. But which system is best? That depends on you and the subject you want to photograph.

Autofocusing

Autofocusing makes accurate focusing much easier and has been around now for almost two decades. Motors built into the lens respond to sensors in the camera and can achieve sharp focus in a fraction of a second—much faster than you could ever focus by eye. Use of ultra-silent motors in many lenses means that focusing is achieved almost silently, which is ideal when photographing subjects such as wildlife, which may be very sensitive to noise. Also, autofocusing modes such as servo AF (see sidebar below) make it easy to keep a moving subject in sharp focus.

Early autofocus systems used a single sensor in the center of the camera's viewfinder. This meant that in order to achieve sharp focus on your main subject it had to be placed centrally in the frame—not ideal from a compositional point of view. However, modern AF systems use either a much larger focus sensor to achieve sharp focus on off-center subjects, or multi-point focusing, in which a number of small sensors are positioned around the viewfinder and are automatically activated when the main subject falls behind them. Alternatively, you can activate a specific sensor so that the lens focuses on whatever falls behind it. This is an ideal option when your main subject is placed on one side of the frame.

Eye-control focusing

A sophisticated alternative to autofocusing is eye-control focusing, in which the camera recognizes which part of the viewfinder you are looking at and then automatically activates focusing sensors in that area! This is clever stuff, but the mode needs to be used with great care, as the lens may be fooled into focusing on the wrong area by movement of your eye.

Given the obviously very high level of technology that lenses enjoy, is there still a place for manual focusing? Actually, there is. For static subjects such as landscape, architecture, portraiture, and still-life, being able to focus the lens exactly where you want is of great importance, especially if you want to control depth-of-field. This is best achieved using manual focus, because you then know that no matter where you position the camera, the focus will remain unchanged until you decide otherwise.

For general picture-taking situations like this, where the main subject of the image is off in the distance, pretty much any focusing system will perform well.

SINGLE-SHOT VERSUS SERVO AF

In single-shot AF mode the lens will adjust and lock focus when the shutter release is partially depressed. Then, once the lens locks focus on your subject, you can take a picture. This makes it an ideal mode for static subjects. If your subject is moving, however, servo AF mode is preferable, as the lens will continually adjust focus to keep your subject in sharp focus as you follow it through the camera's viewfinder, until you are ready to take a picture.

Wide-area and multi-point focusing systems are useful with off-center subjects. Here a standard, central autofocus system would have focused on the background instead of the person. One way to get around that problem is to use a focus lock.

HYPERFOCAL FOCUSING

To maximize depth-of-field, focus your lens on infinity, then check the depth-of-field scale on the lens barrel to see what the nearest point of sharp focus will be at the aperture set. This is known as the "hyperfocal distance." By refocusing the lens on the hyperfocal distance, depth-of-field will extend from half the hyperfocal distance to infinity.

Many current SLRs feature advanced "predictive" autofocus systems that are able to track moving subjects. Without such a system it would have been challenging to have focused accurately on this fast-moving tank on the streets of Sofia, Bulgaria.

PAGES 94–5: Awkward subjects like this, in which there is movement toward the camera, require fast, accurate autofocusing systems that can predict where elements of the picture will be at the point at which the shutter actually fires.

When your image features important elements both in the foreground and the background, you need to think carefully about where you will focus. Here the photographer decided that the writing on the boat at the back was the most important thing and locked focus on that.

Using a Strobe

Modern strobes are very sophisticated pieces of equipment, capable of producing perfect exposures time after time and allowing you to take pictures in situations in which, without flash, photography would prove almost impossible.

That said, in order to get the most from your strobe you need to understand how it works and then use it with care. Read the instruction manual so that you know what all those buttons and dials are for, learn about the different features and functions, and use the strobe on a regular basis, rather than dusting it down for the occasional party, so that you are properly familiar with it.

Problems with flash

The most common flash problem that you are likely to encounter is "red-eye," which is caused by flash bouncing off the blood vessels in your subject's eye so that they record bright red. It is most likely to occur if you use the strobe on your camera's hotshoe (see Glossary, page 245)—the obvious place to put it—though avoiding red-eye is relatively straightforward.

Many strobes have a red-eye reduction mode which either fires a pre-flash or a series of weak flashes before the main flash exposure is made. The idea is that the pre-flash makes the pupils in your subject's eyes much smaller so that the risk of red-eye is reduced. The problem with red-eye reduction is that it can confuse people into thinking the picture has been taken, so by the time the main flash fires they have already started moving away! If you find this to be the case, try the following:

- Ask your subject not to look straight into the lens.
- Use a flash diffuser to weaken the flash.
- Bounce the flash off a wall, ceiling, or reflector.
- Take the strobe off your camera's hotshoe and either hold it higher above the lens or off to one side.

The latter option above is perhaps the most effective, because as well as preventing red eye it also gives you more control over the direction of the light.

Direct, on-camera flash is very harsh and unflattering, casting ugly shadows on the background and making your subject look like a rabbit caught in automobile headlights! However, by taking the strobe off the camera and holding it off to one side or higher up you will achieve much better results.

All you need is a sync lead which connects the flash and camera together so that the flash fires when you trip the camera's shutter release to take a picture. If you have a dedicated strobe, buy a dedicated sync lead so that you can still achieve TTL flash control (see sidebar below) and ensure perfectly exposed results. Brackets are also available that hold the flash in the required position so that you are left with both hands free to handle the camera.

OPPOSITE: In situations where there is not enough light to take a picture, you have no choice but to use flash. Providing you don't go too close, you will achieve an image with an evenly illuminated subject that looks both sharp and crisp.

FLASH MODES

Modern strobes generally offer a bewildering range of modes and features. Here is a rundown of the most common and what they do:

Variable power output—Allows you to set the power output of the gun to 1/2, 1/4, 1/8, 1/16, etc., so that you can balance flash and ambient light for fill-in and slow-sync flash techniques.

Strobe mode—Some flashes can be programmed to fire a rapid sequence of flash bursts automatically, allowing you to create multiple exposures of moving subjects, such as a golfer taking a swing.

Flash exposure compensation—Allows you to force the strobe to give more or less light than it would if left to its own devices. This enables you to overcome exposure error when faced with a really light or dark subject, or for creative effect. It can also be used for fill-in and slow-sync, as an alternative to the variable power output.

TTL exposure metering—Ensures that correct exposure is achieved by linking the flash to the camera's integral metering system so that the flash output is precisely measured and controlled.

Slow-sync mode—Allows you to combine a burst of flash with a slow shutter speed (see pages 98-9).

First and second-curtain sync—Allows you to set the strobe so that it fires at the beginning of the exposure or the end. Second or "rear" curtain sync is mainly used with slow-sync flash.

Manual—If you want to have more control over the flash output, you can set the gun to basic manual mode so that it is not linked to the camera's metering system.

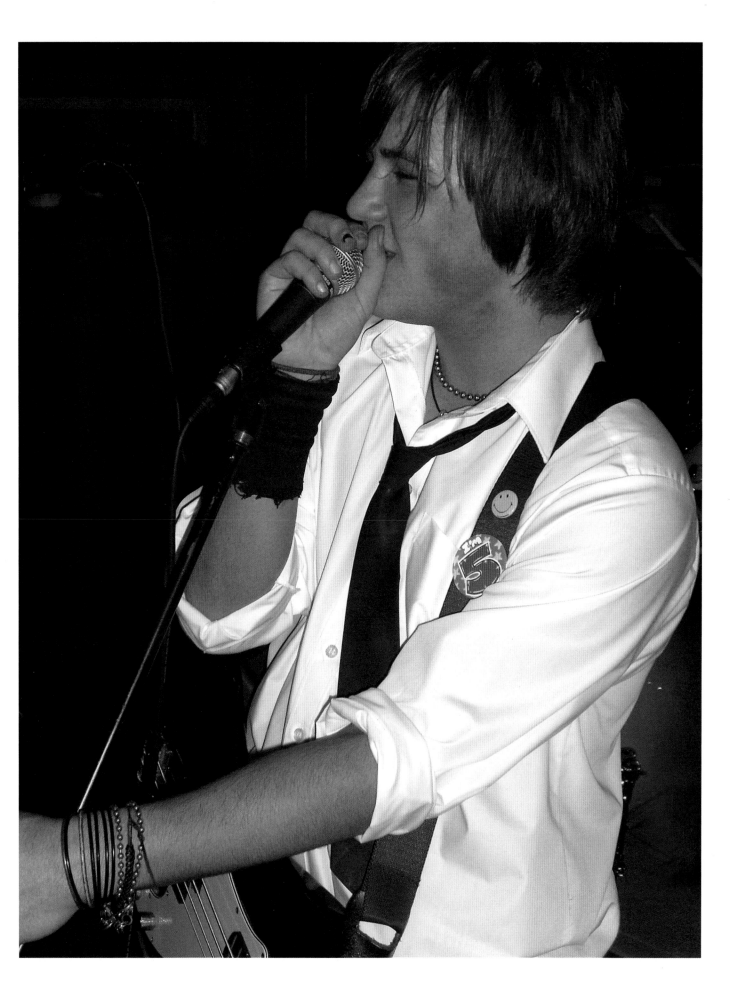

Advanced Flash Techniques

Once you have mastered the basics of operating your strobe, it can be used for experimenting with numerous creative techniques.

Using flash indoors

When using a strobe indoors, bouncing the flash off a wall or ceiling will help to improve the quality of light and produce much more flattering results. Most strobes have a bounce and swivel head; all you have to do is adjust its position so that the light can reflect off a suitable surface and back toward your subject. Dedicated strobes will even adjust power output accordingly to ensure correct exposure. Just one tip: avoid bouncing flash off colored surfaces, as this will give the light in your image a strange color cast.

An alternative approach is to use a flash diffuser. There are numerous models available from manufacturers such as Lastolite and Sto-Fen in various shapes and sizes, but they are all intended to do the same job—spread the light from your strobe over a wider area so that it is softer and more flattering.

Using flash outdoors

Your flash can also be put to good use outdoors. When shooting portraits in harsh sunlight, for example, ugly shadows will be cast on your subject's face—especially when the sun is overhead. To avoid this, a technique known as fill-in flash is used, in which a weak burst of flash is combined with the daylight exposure so that shadows are softened and attractive catchlights are added to your subject's eyes.

The key with fill-in is to provide just enough flash so that it has the desired effect without dominating the shot. This is achieved by setting your strobe to fire at half or quarter power. With dedicated strobes you can use the variable power feature or the flash exposure compensation. Generally, a flash-to-daylight ratio of 1:4 gives the best results, though in really bright conditions 1:2 may work better. For a ratio of 1:4, set the variable power to 1/4, and for 1:2 set 1/2 power. If you are using flash exposure compensation, set −2 stops for a ratio of 1:4 and −1 stop for a ratio of 1:2.

Slow-sync flash

Slow-sync flash is very similar to fill-in, but the flash is combined with a slow shutter speed. This has two main uses. Firstly, if you are taking pictures in low light you can use a long exposure to record the ambient light and a burst of flash to illuminate something in the foreground of the scene, such as a person posing in front of a floodlit building. Secondly, by combining an action-stopping burst of electronic flash with a

Using flash in conjunction with a long shutter speed— a technique known as "slow-sync"—gives a ghostly effect. Foreground subjects in range of the flash are frozen, while things farther away are blurred by movement of the camera.

Be prepared to break the rules. Red-eye is normally considered a fault, but here it works beautifully. Using a special ring-flash produces a characteristic shadow all around the subject and dramatic soft lighting.

USING MORE THAN ONE STROBE

If you want to create professional-quality lighting, several strobes can all be used together at once. Some modern flash systems have a wireless option that allows you to synchronize several guns without connecting them all to the camera, though if your flash doesn't have this capability, accessories are available to achieve the same effect. These include:

- a multiple connector that lets you plug several sync leads into the camera, and

- slave units that clip onto additional strobes and trigger them simultaneously when the main flash attached to your camera fires.

Using a system like this, when shooting portraits you could deploy one strobe to provide the main light on your subject, a second to light their hair, and a third to light the background.

slow shutter speed, you can capture both a frozen and blurred image of the same subject in a single picture and create a dramatic sense of movement.

With both moving and static subjects, make sure that your camera or strobe is set to second/rear curtain sync, so that the flash fires toward the end of the exposure. This gives a more realistic effect if your subject is moving, because the blur caused by the slow shutter speed will trail behind the frozen, flash-lit image, whereas if you use first curtain sync your subject will be frozen at the start of the exposure and the blur will record in front of them, which looks unnatural.

Experimenting with flash
Experiment with different shutter speeds to vary the amount of blur in the picture. For a person running, 1/15sec will be ideal, whereas for a speeding car 1/6osec will be slow enough.

If you want to try something even more ambitious, how about using your strobe to "paint with light"? For example, outdoors at night, you can mount your camera on a tripod, set the shutter to B (bulb), then while the shutter is locked open using a cable release, you can walk around and light things like buildings or trees with repeated bursts of flash. Try placing different colored filters over the flash to produce unusual effects, and if you have two strobes, use them both so that you can fire one while the other is recharging.

Using two strobes, one behind the bride as well as one in front, highlights the transparency of the wedding veil. The clean white of the flash separates the young woman from the orange glow of the church lighting, emphasizing the main subject.

Rapid, repeated bursts of flash can also be used outdoors at night or in a darkened room to create multiple exposures. Ask someone to walk slowly toward the camera and fire several bursts of flash while the camera's shutter is open so that different overlapping images are recorded on the same frame. If your strobe has a strobe setting, you can use the same technique to record rapid action, such as someone using a hammer to smash an egg!

PAGES 100–101:
Combining flash with a long shutter speed can produce dramatic, eye-catching images.

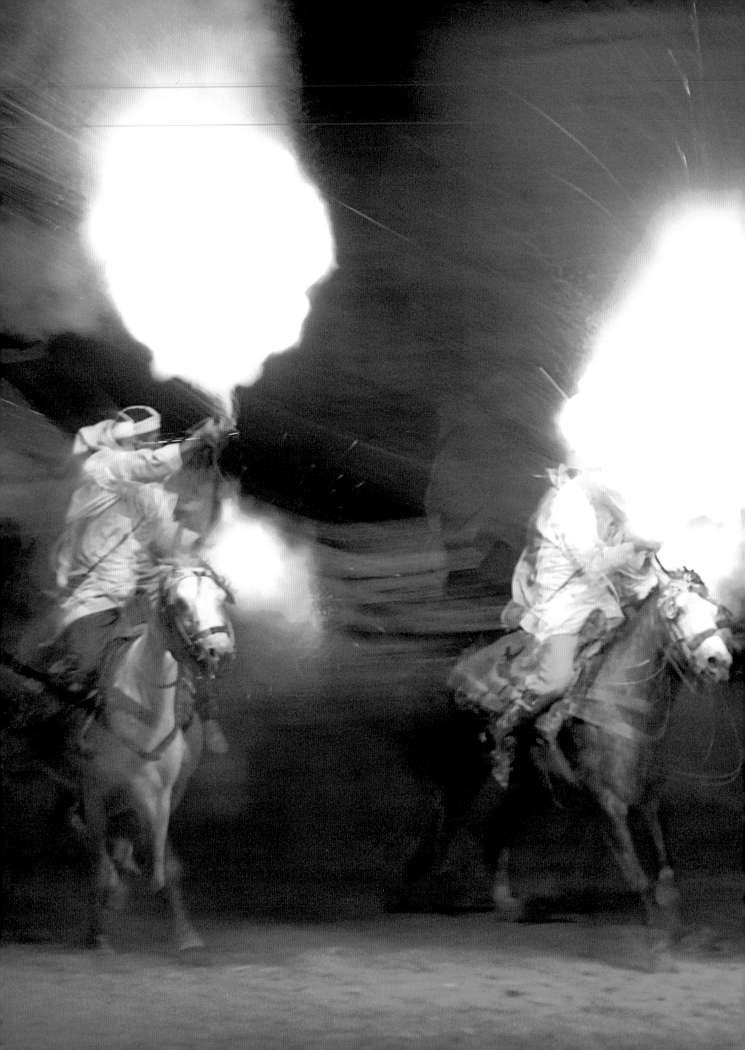

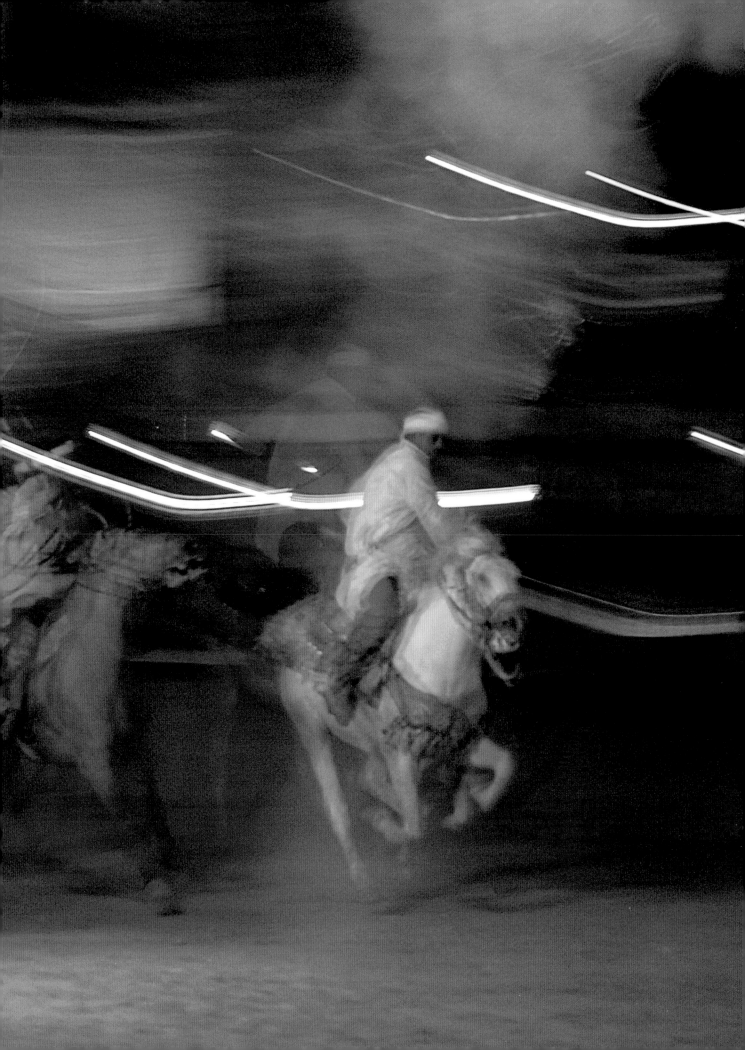

Capturing Sequences

A single image can be extremely powerful—a moment frozen in time for posterity. But if one picture can paint a thousand words, what effect could a series or sequence of images have?

Look out for ways you can "tell a story" by capturing several images one after the other. It could be something as simple as showing how an incident unfolded, such as the sets of pictures published here of the woman standing by the statue or the girl with the hula-hoop. None of the photographs on their own mean a great deal, but when you put all three together in each set, what is happening in the pictures becomes more interesting.

Subjects for sequences

This approach can also be effective when shooting portraits. Instead of taking a single picture, you fire away and record a range of expressions. Put them all together and you show different aspects of your subject's character—something it is impossible to do in just a single shot.

Taking pictures in this way is also valuable for action of all kinds, from sports to everyday movement. A "before," "during," and "after" series can be especially appealing.

How to shoot sequences

Shooting sequences could not be easier. You simply hold down the shutter release and a series of images is captured one after the other. The rate at which these can be recorded depends on a number of factors, including the resolution of the images and the speed at which the camera can store them on the memory card.

One of the latest digital SLRs is capable of capturing ten high-resolution images every second, but on most digital cameras the rate is much more modest—typically one or two shots every second. Also important is the shutter speed you are using—the faster it is, the more quickly you can shoot a sequence, so try to keep it up around 1/250sec. You should also avoid using flash, which usually takes a few seconds to recharge between shots, greatly limiting the speed at which you can shoot.

Once you have captured a sequence, go through the shots carefully. You may well have more than you need. Do not feel you have to use every one. Pick only those that are essential, and which tell the story in the most engaging way.

RIGHT AND OPPOSITE: Initially attracted by the statue, the photographer then noticed that while the woman in the picture talked animatedly on her cell phone she was unconsciously mimicking the pose of the statue.

ABOVE, LEFT TO RIGHT: When you are photographing children playing, it is always worth taking a sequence of pictures, because they will tell the story far more effectively than a single shot.

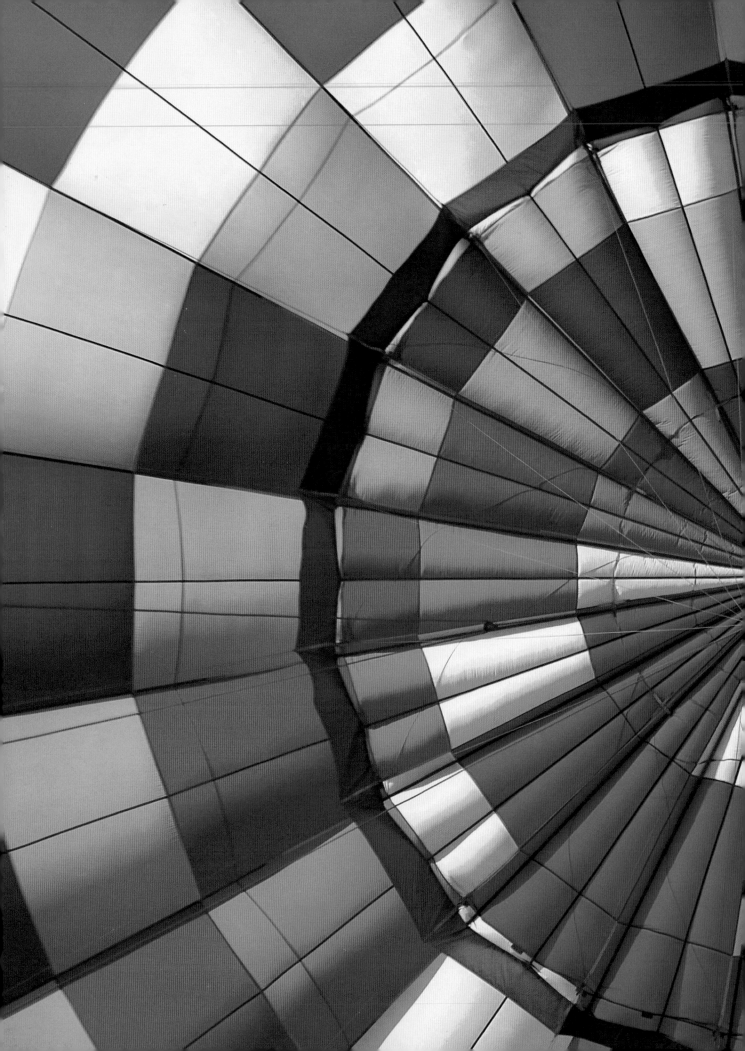

chapter 4

Composition, Lighting, and Color

Taking pictures is easy. But taking strong pictures that catch the eye and communicate powerfully is more difficult. You need to be able to create interesting compositions and use light effectively. Some photographers find this comes naturally. Others need to learn how. However, the good news is that mastery of a handful of techniques is all that is required to improve your image making.

The Principles of Composition

Painters have a distinct advantage over photographers when it comes to composing a picture. Their canvas is empty, and they can arrange the elements in a scene more or less as they wish—even excluding features, if they feel that this is necessary.

Unfortunately, you don't have the same freedom. Your canvas is already full, so in order to create a successful composition you first have to decide which part of the scene you want to capture, then arrange the elements contained in it so that they form a visually pleasing whole.

A good composition should be like a good story—with a beginning to grab your attention, a middle to hold that attention, and an end to bring your journey to a satisfying conclusion.

To help you achieve this effectively, there are many different tools at your disposal. Lenses allow you to control how much or how little is included in a shot. Choice of viewpoint and use of perspective affect how your subject appears. The quality of light can also be used creatively because it influences how well texture, shape, tone, color, and form are defined in a scene.

Ultimately, however, good composition is about looking and seeing. It's about making visual decisions and allowing your own vision to guide you toward those decisions, so that the pictures you make are unique to your own way of seeing but nevertheless appealing to others at the same time.

Think carefully how you arrange the various elements of the picture before you press the shutter. In the image below, the curves of the building have been placed so that they lead the eye of the viewer off into the distance.

HOW TO HOLD A CAMERA

How you hold your camera is vitally important when composing a picture. In the case of digital compacts which have a "live" screen on the back (LCD) rather than a viewfinder, the technique is to hold the camera level with both hands out and elbows slightly bent, so that you have a clear view of the screen as you take the picture (see below).

In the case of SLRs that give direct viewing through the lens, what you see through the viewfinder is pretty much what you will get in the final picture, so hold it close to your face with the left hand cupping the lens, the right holding the body, and the left eye (or right if you prefer) up to the eyepiece, so that you can clearly see the full picture area (see right).

Framing the subject creates a sense of depth (top). You can create a dynamic composition by placing the subject across the diagonal of the frame (far left). Making use of naturally occurring shapes gives the image structure and form (left).

Dividing the Frame

The way you divide up the picture area of your photograph can have a strong influence on its impact and how it is "read" by the viewers—even though they won't be aware of this at the time of viewing.

For example, if you place the horizon low in the frame, emphasis is placed on the sky and a general feeling of wide open space is created. This technique works well when the sky is interesting and demands attention—such as a mackerel sky at dawn or dusk.

Alternatively, placing the horizon high in the frame, the foreground of the scene is emphasized and features close to the camera are given priority so that you can make the most of lines to lead the eye into the scene, or foreground objects to add a sense of perspective and scale.

Trying alternative frames

Placing the horizon across the center of the frame so the image is split into two is often frowned upon, as it is said to produce static, boring compositions.

However, do not be afraid to try it—a lake scene featuring perfect reflections might work well with this approach.

Physical features in the scene can also be used to divide the frame. A tree or the corner of a building will effectively cut off part of the picture area by blocking your view beyond it, but this in turn will focus the eye on other parts of the scene by directing the viewer toward them.

The same applies if you shoot through a frame—such as an open window, archway, or doorway—or from beneath the overhanging branches of a tree. All of these things will help to direct the eye into and through the picture.

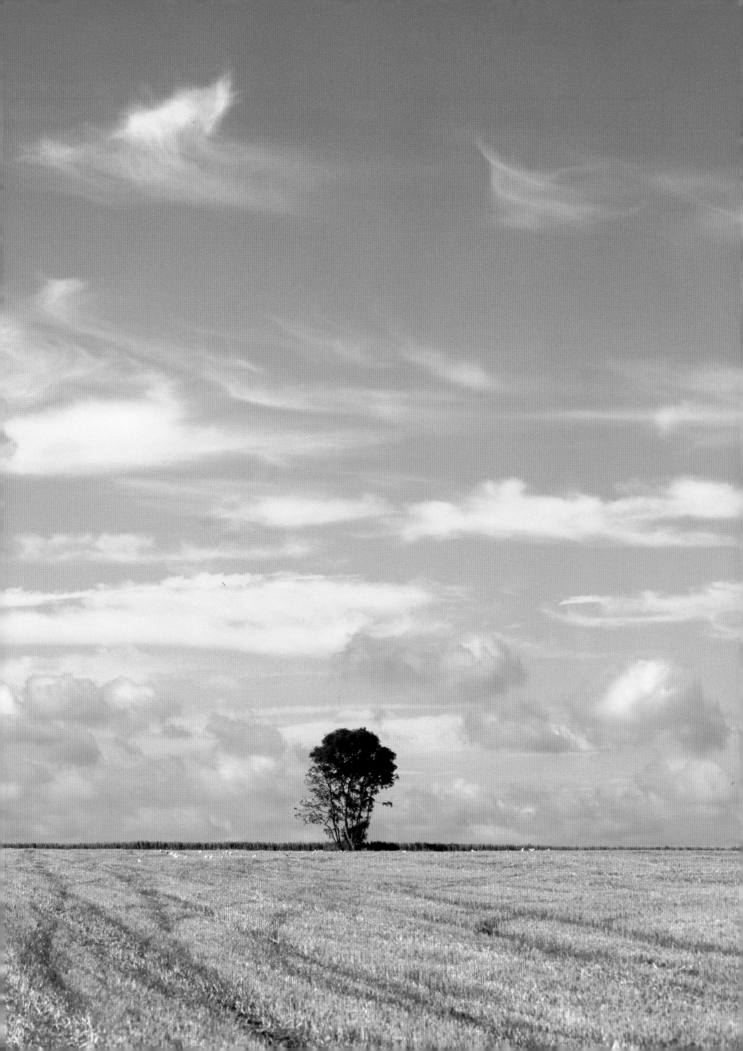

Ensuring You Have a Focal Point

Most pictures will have or should have a main point of interest. This is known as the focal point, and it serves two important purposes: firstly, it is the element in the composition to which the viewer's eye is naturally drawn and finally settles upon, having gone on a journey around the picture; secondly, it adds a sense of depth and scale to the composition.

For example, if you photograph a landscape scene and there is a tractor chugging away in the distance, that tractor automatically becomes the focal point because our eye is naturally drawn toward it. The same applies if you photograph a seascape featuring a lighthouse on the horizon, a field with a barn in its middle, or a cliff face with a climber suspended halfway up it.

The focal point does not have to be big in the picture to do its job, providing it is clearly visible. Color can help here. A splash of bright color will always attract attention—especially red. A single red flower in a field of crops, for example, will scream for attention, though any bright color will stand out against more muted colors.

An easy way to assess the importance of the focal point in a picture is to cover it up with your thumb and then look at the shot again. More often than not it will look empty and dull, even though the focal point may only be small. It just goes to show how that extra element can make such a huge difference to the overall picture, in nearly all cases.

Placing the important part of the picture in the center makes for a clear, strong focal point—but make sure it is big enough to have plenty of impact.

The girl, the drawing of her, the pictures scattered around the main subject—this image has lots of competing points of interest which prevent the viewer's eye from settling successfully in any one place.

CREATE VISUAL TENSION

A picture need not just have one focal point. In fact, including two or more focal points can produce more powerful images, because the viewer's eye is no longer sure where it should settle.

Think of a single red tulip in a field of yellow tulips. On its own, the flower stands out and is the obvious focal point of the photograph. However, if there are three, four, or five red tulips in the same composition, each one demands the same level of attention so that the eye cannot help but move from one to the other, creating visual tension.

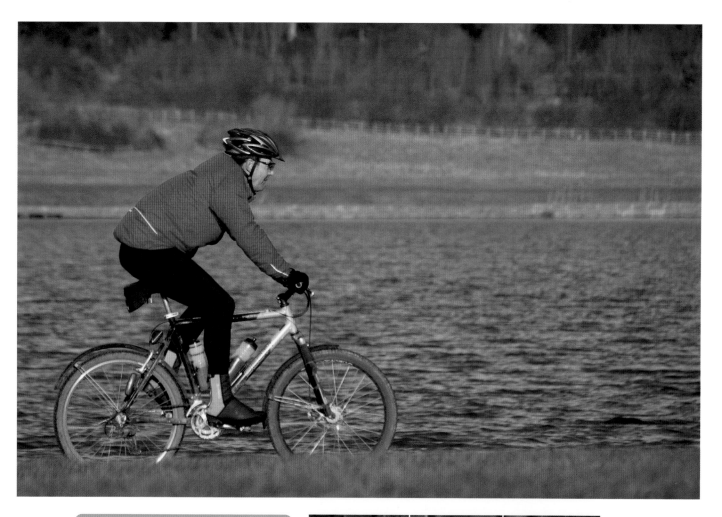

USING THE RULE OF THIRDS

The most common compositional "device" is the rule of thirds. It involves dividing the picture area into a grid of nine equally-sized segments using imaginary horizontal and vertical lines (see right). The idea is that you then place the focal point on one of the four intersection points created by those lines so that it is always a third in from the side of the image and a third up from the bottom or a third down from the top. Doing this is said to produce more balanced compositions.

The nine-part grid can also be used to aid placement of the horizon or other important features in the scene.

In this picture the face of the cyclist has been carefully placed according to the rule of thirds, giving a balanced, pleasing composition. Plenty of space has also been left to the right, into which the viewer can imagine the cyclist moving.

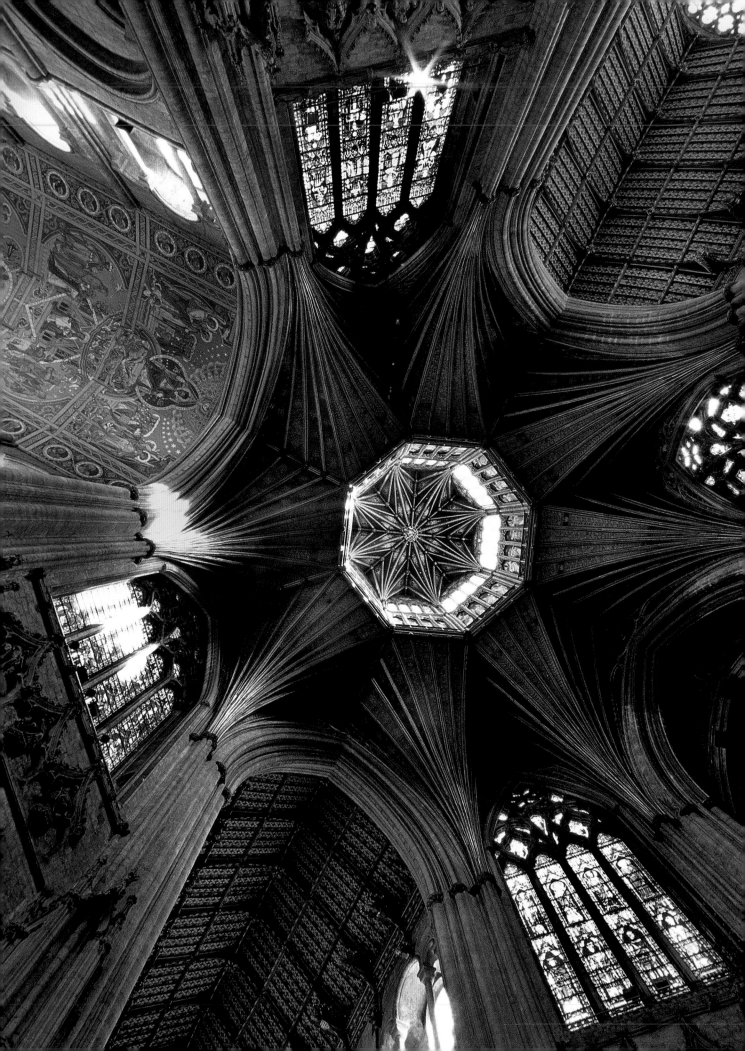

Varying the Viewpoint

Where you stand to take your picture has a profound effect upon the result you achieve. As you become more experienced as a photographer, why not experiment with unusual points of view and shooting subjects from angles that are out of the ordinary?

When you encounter an interesting subject, do not just fire away from where you are standing. Rarely will you stumble upon the best vantage point the minute you arrive at a location; so, make sure you spend a few minutes wandering around exploring it from every position—the chances are you will find a better one. The more time you spend looking for alternative viewpoints and different camera angles, the better your pictures will ultimately turn out to be.

Move for better angles

It is surprising how moving just a little to the right or the left, to the front or behind, can significantly improve the picture. This is especially true with "large" subjects where taking a few steps one way or another can dramatically alter the perspective. Most buildings, for instance, look better if they are photographed from a corner rather than square-on—in which case they often end up looking two-dimensional. It is a similar story with landscapes. Turning one way or another just a handful of degrees can totally change the result you get. Moving forward sometimes has the advantage of excluding extraneous detail around your subject, and can improve the overall impact of the image enormously.

Experimenting with viewpoints

While you look for the best angle you should also experiment with different viewpoints—you may find the whole feel of the composition changes. Too many photographers take every picture standing up and with the camera at eye level, which can result over time in pictures that are boring and predictable. Crouch down with a wide-angle lens and you get a worm's-eye view of the world. Stand on a wall or scramble up a hill and you get a bird's-eye view of your subject.

Some professional photographers shooting on location even take a stepladder around with them, so that they can quickly and easily gain an elevated position—and so change the perspective they achieve.

OPPOSITE: It is amazing what you see when you look up. The dramatic vaulted ceiling of this cathedral has been captured perfectly with an ultrawide-angle lens.

PAGES 114–15: Finding a high vantage point—the higher the better—gives you a dramatic bird's-eye view of the world. Once you get there it is relatively easy to take exciting pictures, like this one of Chicago. The secret lies in choosing the most interesting subject matter—perhaps by cropping in using a zoom lens—and making sure that the horizon, if it is included in the image, is level.

Walking around this mosque at different times over the course of three days—and using different lenses—has yielded a variety of treatments and perspectives.

When shooting portraits do not just do the same old thing—try something new. Placing the subject several flights of stairs down produces a whole new perspective.

Framing for Depth

There are various ways of creating a sense of depth in a picture. One of the quickest and easiest methods is to find or place something in the foreground that can "frame" the main subject.

The principle is the same as putting a painting in a frame. Many subjects can look rather lost on their own, especially if there is nothing of interest at the edges of the picture. Strengthening the edges helps concentrate attention on the most important part of the picture—the subject—while at the same time giving the whole image a much more three-dimensional feel.

Having said that, the frame does not, however, need to go all around the subject. Sometimes it will, but in practice it may often be positioned along only two or three sides—or even, on occasion, just one.

Finding a frame

Many different things can be used as a frame. Look around you and you will discover that there is no shortage of natural props for creating depth. One of the most readily available, whether you are in the countryside or a town, is an overhanging tree. This can be used to frame a wide range of subjects—from landscapes to buildings to portraits. Simply place a branch so that it fills in the blank area of sky at the top of the frame, and your picture is immediately improved.

In towns and cities, you will find plenty of man-made frames to choose from. Arches are not only common, especially around older buildings such as

> **HOW TO CHEAT AT FRAMING YOUR IMAGES**
>
> When there is no suitable frame available, one option is to cheat, which is what some professional photographers do as a matter of course. For example, when taking a picture of a new housing development, where the trees are not yet mature, clever photographers who are thinking ahead might take along with them a branch they cut off from another tree before setting out. By holding it in front of the camera, they can position the frame exactly where they want it.

cathedrals and period houses; they often tend to be very elegant. Gateways, and even ordinary doorways, can work equally well. In fact, with imagination, virtually any strong upright or horizontal shape can be used to form part of a frame for your image.

There is not always something suitable on hand, but if you look around, considering different viewpoints, it is surprising how often you will come up with a way of composing the shot that allows you to place a frame around it. Try stepping back and using a telephoto lens, or going in closer with a wide-angle. The size of the subject will remain the same, but the composition of the shot will be completely different.

Whenever possible the frame of your image should relate to the main subject. Landscapes look most natural framed by a canopy of leaves or a graceful arch but look wrong when the frame is too artificial and man-made. With architectural subjects, it depends to a large degree on their style and age. When photographing modern structures, you can select more unusual frames that might seem inappropriate for older buildings.

Your eye will be most drawn to the main subject, and the sense of depth enhanced, when the frame is out of focus but still recognizable. If it is too sharp, it will compete for attention with the subject, while if it is allowed to go completely out-of-focus it can end up as a complete mess. All this is good news, because in practice it is seldom actually possible to keep the frame completely in focus, especially if it is right in the foreground—unless, perhaps, you are using a tripod, a wide-angle lens, and a small aperture.

Placing the overhanging leaves of a palm tree in the corner of the picture makes all the difference. Cover that area with your hand and see how much weaker the composition is without it.

Arches are perfect for framing distant buildings. Don't worry about keeping the foreground sharp—if anything it helps to have it slightly out of focus.

Using Lines

When it comes to adding depth and dynamism to a picture, using lines cannot be beaten. As well as creating a strong sense of direction, they also carry the eye through the picture, so it takes in every element along the way.

If you keep your eyes peeled when you are out and about, you will start to see lines everywhere—roads, fences, rivers, lines of houses, rows of parked automobiles—and you will then be able to use them to improve the composition of your pictures.

Horizontal lines divide the frame, and produce a restful effect, because they echo the horizon. The eye normally travels from left to right, because that is the way in which we read. You will not have any problems finding horizontal lines—much of the man-made world is made up of them, so look for walls, boxes, roofs, and so on.

Thrusting upward, vertical lines are a lot more active—so they can give a picture a strong sense of structure. Once again, you will find it easy to come up with subject matter. Most buildings feature strong verticals, along with natural structures such as trees and rock faces.

Converging lines add a powerful sense of perspective. They are easily created by using a wide-angle lens. Get down on a road, or go up close to a

tall building, and the lines all seem to rush off to a vanishing point in the distance.

Lines are not always straight, of course. Sometimes they wind through the picture, curling and curving as they go, like a river in a landscape or a railway line.

Finally, it is not essential that lines in your images are real. Sometimes they are just implied, like the imaginary line created by one person looking at another, or the way in which elements in the picture seem to relate.

DIAGONAL LINES

Diagonal lines are the most dynamic of all. They contrast strongly with any horizontal or vertical elements, and carry the eye through the whole scene. Lines that go from the bottom left to the top right deliver maximum power. While there are plenty of subjects that feature diagonals, one simple way of creating them is to angle the camera slightly. Do not be heavy-handed, though—if you do it too much it can look like a mistake in the finished image.

Thanks to a low viewpoint and the use of a wide-angle lens, the lines in this landscape lead the eye directly to the castle in the distance.

In this beautifully crafted portrait, the combination of horizontal and vertical lines creates a wonderful tension against which the roundness of the man's body contrasts nicely.

There are lots of different lines here—from the horizontal rows of rolling pins to the diagonal lines that cut across them. However, because there are so many competing points of interest, the eye is unable to settle on any particular part of the image.

Diagonals are always dynamic—and sometimes all you have to do to create them is to tip the camera to an angle of 45 degrees. This immediately adds drama and tension to the image.

Using Shapes

Shapes can be a useful compositional aid in photography, bringing structure and order to what might otherwise be a collection of random elements within a picture.

We live in a world that is made up of shapes: the sun is circular; a family portrait often forms a triangle, with the parents in the middle and children to the sides; houses are square or rectangular.

We take these shapes for granted and are often not aware of them—but they can be used to make your photographic compositions stronger. By studying the various elements in the scene, and arranging them effectively, you can give your pictures more impact.

Real or implied?

Shapes can be real or implied. A roof could be triangular; a face might be oval. Keep your eyes peeled for subjects that provide ready-made shapes and you will have a head start when it comes to composition.

Implied shapes depend upon the way the elements in the pictures relate to each other. In portraiture, for instance, if your subject were to cup his face in his hands a triangle will be formed by his arms. This would direct attention toward his face—the most important part of the scene. Similarly, when you photograph a couple admiring their new baby, the line of their gaze creates an imaginary triangle that links all three together. See how it works?

Sophisticated shapes

Beyond the obvious shapes all around us—squares, rectangles, circles, ovals, triangles—there are other, more sophisticated shapes that can be used to create great images. A river snaking off into the distance may suggest the letter "S." Someone at the left-hand edge of a picture looking out would create an L-shape.

Evaluate before you take

So, take a moment to evaluate what you have in the frame and think through the relationship between the various elements. Everything in the picture must contribute to the whole. It must have a coherent shape and structure. Most landscapes, for instance, are complex, and the trick is to make them simple to understand by using shapes to their best advantage.

It is the way that you combine the geometric shapes in the frame that makes all the difference.

OPPOSITE: One of the reasons why this picture works so well is the way the various lines—the horizon and the wall—divide the frame into three shapes. At the top there is the strong rectangle of the sky, and below the horizon two clear triangles separated by the wall.

BELOW: The large black hat this woman is wearing frames the elliptical shape of her face perfectly, while her eyes and smiling mouth create a strong triangle.

The circle and triangle of England's York Minster are immediately evident, but have you noticed the way that the photographer has composed the picture in order to create two blue triangles in the corners?

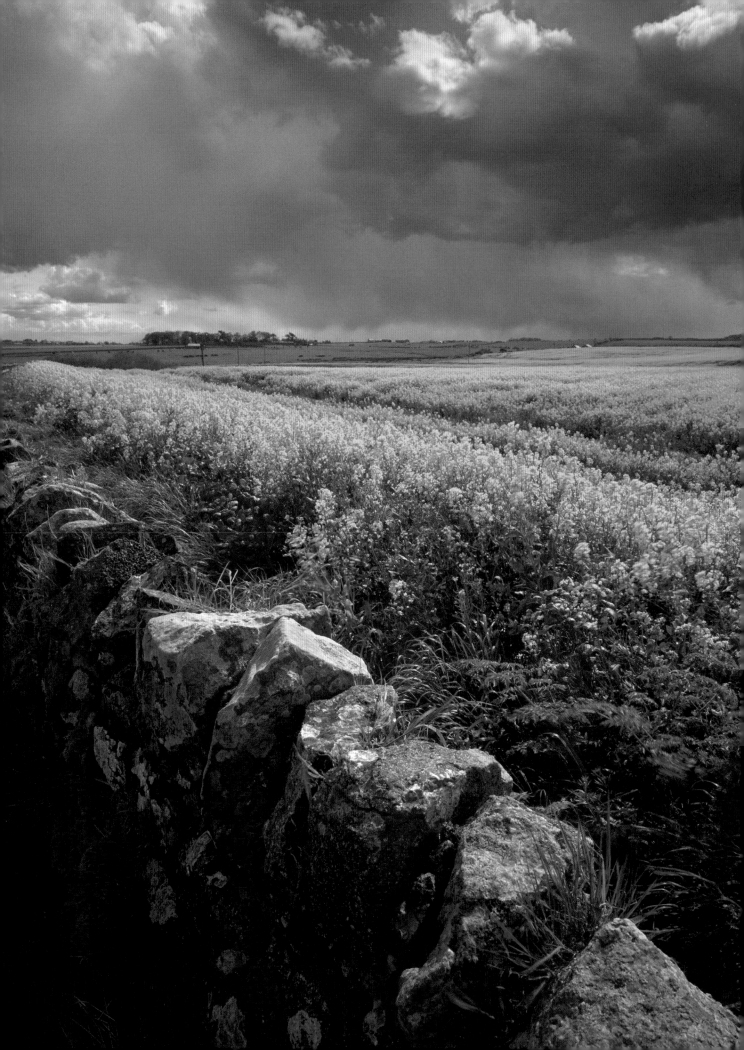

The Power of Light

Light varies enormously, particularly in terms of contrast, intensity, and color, and to be a successful photographer you need to take this into account.

Contrast

One of the key ways that light varies is in terms of contrast—that is, the range of tones between the lightest and darkest parts of the scene. Sometimes this range is very large, featuring intense, rich blacks and bleached, white highlights. At other times the range is more limited, representing subtle shades of gray, rather than extremes.

The principal factor in whether the contrast in the scene is high or low is the light. Intense light from a point source produces hard, contrasty lighting; gentle light from a diffused source produces soft, shadow-less lighting. Neither is better than the other; both—and all the steps in-between—have their place in photography. Indeed, it is this gradation of light which offers such freedom of expression.

Intensity

Taking pictures is easier when there is plenty of light. You are free to choose whatever combination of shutter speed and aperture you like without having to worry about camera-shake or subject movement. However, do not for a minute confuse quantity with quality. The blinding light you find outdoors at noon on a sunny day may be intense, but it is far from ideal for most kinds of photography. Better results are generally achieved when the light is softer. A golden rule of photography is that the quality of light is always more important than the quantity.

Color temperature

We generally think of light as being neutral or white, but in fact it can vary considerably in color—you need only think about the orange of a sunrise or the blue in the sky just before night sets in. The color of light is measured in what are known as kelvins (k), and the range of possible light colors—which is exten-sive—is shown in the Kelvin scale in the panel opposite.

The harsh, contrasty, blue light that you get in the middle of a summer day does not suit every subject, but it can work extremely well with buildings, as in this case.

THE KELVIN SCALE

2000k
The light from candles and fires in general is extremely orange, and registers on the film as a very strong cast—although slight over-exposure will somewhat weaken the bias.

3000-3200k
Although our eyes have become accustomed to the fact, the light from household tungsten lamps is very warm, producing a strong orange coloring.

3500-4000k
Sunrise and sunset are among the most photogenic of times for taking pictures, thanks largely to the yellow/orange coloring that prevails.

4200-4800k
Early morning and late afternoon sun often has an attractive warm quality that records beautifully without being too orange. It is great for enhancing skin tones and for bringing stonework to life.

5500k
Noon sunlight is neutral in color, which produces pictures without any color cast at all.

5500k
To make using electronic flash as straightforward as possible, it has the same neutral color temperature as noon sunlight.

6000-6500k
Hazy skies tend to have more blue in them, and can give your pictures a slightly somber feel.

7000k
On heavily overcast days the light can be a very strong blue, giving your photographs an extremely cold feel that will kill the mood of subjects such as people and landscape.

The light you get late in the afternoon and during early evening is often warm in tone, and casts a wonderful golden glow that brings even the most mundane subject to life. In this image, the lifebelt stands out like a beacon.

Although our eyes compensate for it, the light you get from a normal household lamp is actually a strong orange. The white balance control on a digital camera will often remove it, but you can make sure it does not—since the results are sometimes attractive, as in this case—by choosing the "daylight" or "5500k" setting.

One of the most important things about light as far as the photographer is concerned is that it casts shadows—and these can be important elements in a picture. In fact sometimes, as here, there would be little to photograph if it were not for the shadows that define the image, like those in the sand dunes.

Lighting Direction

The direction from which light is coming has a significant impact on the overall look and feel of a picture. Think about where the light is in relation to you when you take the shot and your pictures will always benefit.

Many people are told when they first start taking pictures that the sun should always be behind them. However, while that approach certainly has some advantages—your subject is evenly illuminated, colors are saturated, and scenery is crisp and clear—it has some downsides as well. Taking pictures of people in bright conditions, for instance, can lead to them squinting as a result of having to stare at the sun. Additionally, shadows fall away from the camera, and are often completely out of view. As a result, pictures can look flat and two-dimensional.

Side lighting

Turn through 90 degrees when preparing to take your picture, and you have the sun coming in from the side. Doing this immediately opens up an exciting door to creativity: where once stood flat, featureless scenes, there are now highlights and shadows. Suddenly the world looks three-dimensional again! You can see that objects in the foreground are independent of the background because shadows falling to the side emphasize distance. Side lighting also reveals texture better than any other kind of lighting—especially the "raking" light that you see

late in the afternoon on a sunny day. Unfortunately it does not last very long, and you will need to work quickly to take advantage of its magic.

Side lighting can be used to create dramatic character portraits, but is less suitable for more flattering pictures of people because it reveals every flaw. 90-degree lighting can, however, be a problem when it comes to exposure. Because the contrast level is so high, there is a risk of either over- or under-exposure, depending upon where the highlights and shadows are in the frame.

Top lighting

Of all the kinds of lighting available to the photographer, top lighting is probably the least satisfactory. You get it around noon on a sunny day in summer, when the sun is at its highest. Shadows are short, downward-pointing, and rather dense. It is best avoided, particularly for portraiture, when you can end up with dark areas under the eyes, nose, and chin. Most professional photographers avoid taking pictures between 11am and 2pm on a sunny day in summer, because the light is so unappealing—and that is a good example to follow.

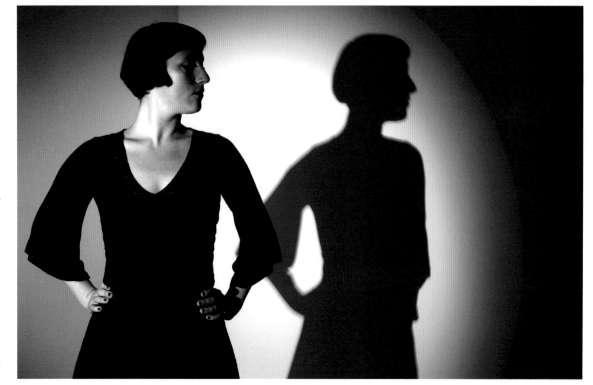

Side lighting is perfect for character portraits —and throws evocative shadows also.

TOP LEFT: The "raking" light of late afternoon vividly reveals the texture of this stone-built wall. The warmth of the illumination adds the atmospheric effect.

BOTTOM LEFT: Shooting toward the setting sun in Marrakech using a telephoto zoom results in a stunning silhouette of the Kotuba mosque.

BELOW: Top lighting is strong and harsh, but can work for certain kinds of subjects—such as this man sleeping on a park bench in Bulgaria.

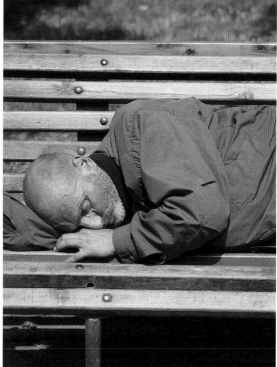

INTO THE LIGHT

When you want real impact, try shooting toward the sun and see a dramatic transformation. A shimmering halo is created around your subject when shooting portraits, the delicate hairs on plants are clearly revealed, transparent objects start to glow beautifully—and ordinary scenes in which the shadows would often disappear into the distance come to life as they suddenly race toward you. The effect you get then depends on how you expose the shot—because you will be unable to capture the full range of brightness.

You will either need to make sure there is shadow detail—in which case the highlights "burn out" and you get a high key effect—or you expose for the lighter areas of the picture and end up with a stunning silhouette.

When shooting into the sun, flare can be a major problem. This is caused by stray light finding its way into your lens and causing ghostly patches or streaks across your images. Contrast is reduced and color is washed out. To avoid flare, you need to shade the lens so that no light glances across the front element —a good lens hood will often take care of this and is not too much of an investment in terms of cost.

Light From Dawn to Dusk

Successful outdoor photography depends on an understanding of light, and how it changes through the day. This is especially important in landscape photography.

How light changes

The light changes in three ways: its direction; its quality; and its color.

On sunny days, the changing direction of the light is most obvious. Early in the morning or late in the day the sun is low in the sky and the light "skims" across the landscape, highlighting textures and forms. In the middle of the day, the sun is higher in the sky. The light is quite harsh and uninteresting, and few landscape photographers take pictures at this time.

The light quality—its "hardness" or "softness"— may vary considerably, as well. This is most obvious on overcast days, when the light comes from the whole of the sky and not from any one particular direction.

The softness and warmth of afternoon sun allows you to capture stone buildings at their best.

COLOR TEMPERATURE AND TIME OF DAY

The color of light can be measured as its "color temperature." The units for this are "degrees Kelvin," or "K." Lower temperatures correspond to warmer tones (reds and yellows) and higher temperatures correspond to cooler colors (blues). The color temperature of daylight changes constantly throughout the day, so any competent photographer needs to be aware of how the light is changing at any given time and the effect that that will have on the photographs he is taking.

Dawn before sunrise: 10,000 degrees K
Before sunrise the only illumination comes from a blue sky, which produces a characteristic strong blue color.

Dawn: 2,000–2,500 degrees K
The first appearance of the sun on the horizon produces very warm colors. Look for the first appearance of shadows.

Early sun: 3,000–4,000 degrees K
As the sun climbs higher in the sky, the color temperature rises and colors become progressively less warm and more neutral.

Midday: 5,500 degrees K
Overhead sun at noon produces neutral colors, though this may not be best pictorially.

Overcast: 7,500 degrees K
Overcast conditions increase the color temperature markedly, producing cooler colors.

Shade: 10,000 degrees K
The color temperature of shade on a sunny day is extremely high because it is lit solely by the blue sky.

Afternoon sun: 3,000–4,000 degrees K
As the sun goes down, so does the color temperature—the light becomes warmer and "redder."

Sunset: 2,000–2,500 degrees K
When the sun is on the horizon, the light is at its "reddest."

Twilight: 10,000 degrees K
The light color changes rapidly after sunset, suddenly becoming very "blue."

Light tips

Overcast days are much better for outdoor portraits because there are no harsh shadows. There may still be a directional quality to the light which you can use to bring out shape and form—look for partially-shaded areas under trees, for example, or in doorways, or by walls.

Light changes color during the day because of the position of the sun and the properties of the atmosphere. Blue light is scattered more strongly than red light, and when the sun is lower in the sky it passes through a thicker layer of atmosphere. The blue light is scattered more, which is why the light appears redder at these times of day.

Before dawn and after sunset, however, the light color changes dramatically, becoming much bluer.

Changes in the color of the light are far less noticeable on overcast days, when the light has a colder tone all through the day. For this reason, many landscape and outdoor portrait photographers deliberately use color correction filters to "warm up" the color in their photographs.

LIGHT AND SEASONS

Light changes throughout the day, but it changes through the seasons, also. The changes may be subtler, but each season nevertheless has particular characteristics which you need to bear in mind.

- In winter the sun is generally lower in the sky, and hence more photographically "interesting," and the light on sunny days will be warmer in tone.

- Springtime brings longer days and a higher sun, but the air is still quite cool and you may find it has a clarity and a freshness that disappears as the weeks go by.

- Summer can yield wonderful photographs at the beginning and the end of the day, especially if you can capture the warm haze of a late afternoon.

- Fall brings a return to low temperatures and crisp, clear air. Look out for evening mists as vapor from warm rivers and lakes condenses in the rapidly cooling air.

TOP RIGHT: During early morning and late afternoon, when the sun is low in the sky, shadows are long and atmospheric. Make the most of them to build drama and tension into your images.

BOTTOM RIGHT: Getting up before the sun will enable you to capture the first rays as they appear over the horizon. Early morning skyscapes often feature stunning colors.

PAGES 128–9: Sunsets can make stunning and evocative images when the light is right and you use the correct exposure.

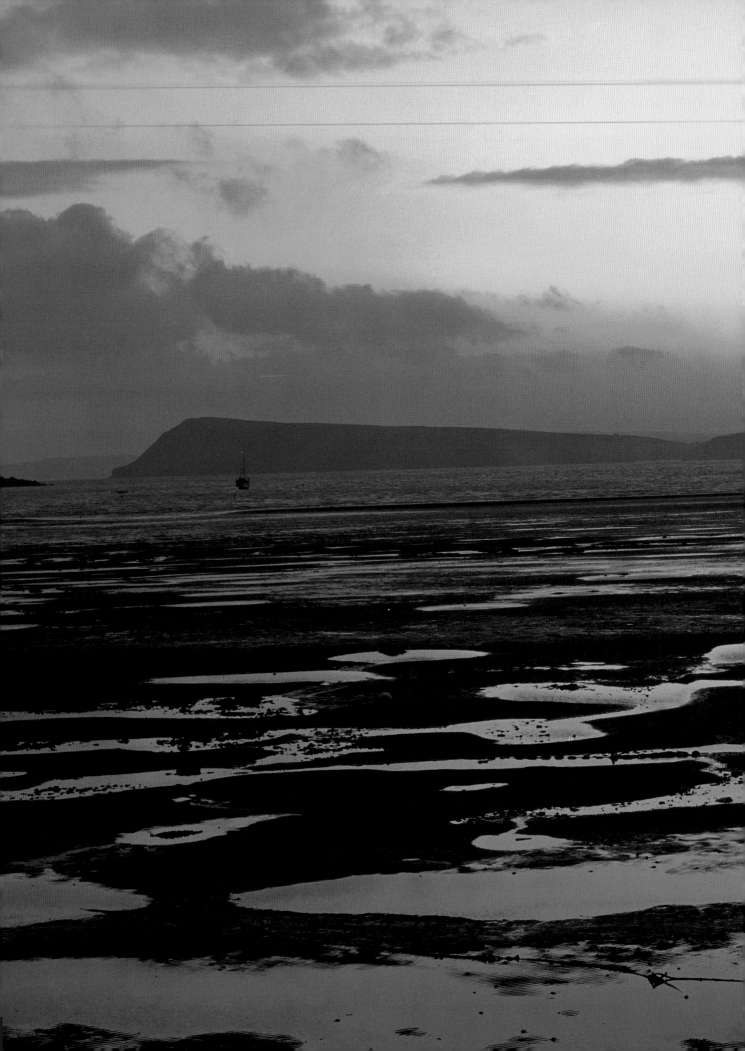

Using Daylight Indoors

Poor weather conditions do not mean you have to stop taking pictures. There is plenty you can shoot indoors using daylight or household lighting, and many different effects can be achieved.

Sometimes it is not possible to take pictures outside— the sun may be too harsh or rain may prevent you— but you can always retire indoors and continue shooting. Light levels will generally be a lot lower inside a building, but with the aid of a faster ISO setting or a tripod you can keep on firing away.

Windowlight

The best way to start is by using windowlight. Unless you live in a one-room dwelling, you will have a choice of rooms. Think carefully about which one you use. The key issues here are the number of windows, their size, and the direction they face. You will get the softest light in the room with the largest expanse of glass—such as a patio door or a bay window.

Obviously there are limitations to what you can photograph indoors, but subjects like still-life, portraiture, and close-ups are perfectly viable. Whatever you decide to shoot, experiment with lighting positions. Stand with the window behind you and the light will be even and soft. Stand sideways and you will get more contrast—which can be controlled by holding up a piece of white paper on the shaded side to provide better balance.

Tungsten lighting

One of the great advantages of digital photography is that it compensates for different lighting sources, which means that you can take pictures using household tungsten lighting without the pictures coming out orange. Generally the auto setting will cope. With some cameras, though, you may need to use a manual setting to achieve a good result.

Avoid shooting when the illumination is coming from a bulb and shade on the ceiling. The effect is similar to that which you get at noon on a sunny day, with nasty shadows appearing under features in your image. Table lamps and stand lamps are much better, and you can move them around in the same way professionals do in a commercial studio to get the best results. A couple of table lamps placed one each side of the subject at the same height as their head and a yard or so away can create an extremely flattering result. Most flexible of all, however, is an anglepoise lamp, which you can position exactly where you want. Place it so that it is just above the subject's head and angled down, with a sheet of white card at waist height to bounce light back up, and you will be replicating a classic fashion lighting setup.

Focus carefully

Whatever you photograph, take great care with your focusing. Low light levels inevitably mean that depth-of-field—the zone of the picture which will appear sharp in the finished image—is more limited, because the camera will be setting large apertures. If in doubt, use your focus lock to ensure that the important part of the subject is kept sharp.

Support matters

To counteract what will almost certainly be low light levels, try increasing the ISO rating of your camera. Up to ISO 400, image quality is usually satisfactory . Even so, you may find that shooting indoors leads you to some relatively long shutter speeds, as long as 1/15sec, 1/8sec, or even 1/4sec. Take some trial pictures and examine the results carefully. If there is any blurring or other signs of unsharpness, you will need to support the camera in some way. While you can improvise a stand with a table and a stack of books, there is nothing to beat the versatility of a tripod.

Place a large window behind you and you will get some beautifully illuminated portraits.

A loosely arranged bunch of tulips produces a charming still-life image when illuminated from the side by windowlight.

Pretty much anything can make an interesting close-up—especially if you use a vivid background such as this bright yellow card from a craft store.

Low Light Photography

If you want to capture the mood of a subject successfully, avoid flash whenever possible and use the light that is already available. This way, the light in your images will be softer and more forgiving.

When light levels begin to drop, most photographers heed the camera's shake alert and switch over to flash, thus avoiding the risk of camera-shake. However, this can be a disheartening experience. The problem with using flash is that it can all too easily obliterate the mood that made you want to take the picture in the first place.

This dilemma can arise in any situation: shooting sports on an overcast winter's day, doing portraiture indoors, taking close-ups in a wood, architectural interiors... But happily there are ways you can continue using the available light and not have to resort to flash.

Although the fluorescent strip lights in this underpass look bright, in fact it was very gloomy. Even using fast-aperture 50mm f/1.8 lens and an ISO800 setting, the shutter speed was still only 1/60sec due to the lack of quality light.

Support the camera

Supporting the camera in some way allows the shutter speed to drop to levels which otherwise might cause camera-shake. Normally it is not advisable to hand-hold the camera below 1/60sec for a standard zoom or 1/250sec for a telephoto zoom. However, if you brace yourself carefully you may be able to get away with 1/15sec and 1/60sec respectively. You will need to hold the camera tightly, though, to avoid camera-shake. Tuck your elbows in close to your body and then breathe out before squeezing the shutter release button smoothly.

A better option is to look around and see if you can find some way of supporting the camera, such as a wall, table, or other flat surface. Whenever possible, though, you should use a tripod, in which case you

can set whatever shutter speed you like without fear of lack of sharpness caused by camera-shake ruining your picture.

Invest in an image-stabilizing lens

A number of leading manufacturers now incorporate advanced "image-stabilizing" technology in their cameras. This minimizes, but does not remove entirely, the effect of camera-shake. Generally you gain two to three stops advantage. So, if you would normally be able to shoot at 1/250sec, you should be fine with 1/60sec or even 1/30sec.

Move closer

One simple way of keeping shutter speeds up is to move closer to the light source, whether that be a street lamp outdoors or a large window indoors. Because of what is called the inverse square law (see page 188), the nearer you get, the more light there is.

Fit the lens with the fastest maximum aperture

Lenses vary in how much light they can let in, with their light-gathering power defined by their maximum aperture. An f/2 lens lets in twice as much as an f/2.8 lens, which lets in twice as much as an f/4 lens, which lets in twice as much as an f/5.6 lens—and so on. So if you want to work in low light, you should obviously fit your fastest lens—the one with the largest maximum aperture.

Stage lights can be extremely atmospheric, and using flash here would have completely ruined the mood of the shot. Increasing the ISO rating to 800 results in an image that is a little soft but more than acceptable.

Getting closer to the light makes it easier to maintain a shutter speed that avoids camera-shake—and if you include the light source itself it becomes easier still.

> #### INCREASE YOUR FILM SPEED SETTING
>
> Increasing the ISO setting, so that the sensor is more sensitive to light, will enable you to keep taking pictures when light levels drop. If you generally shoot at ISO100, you could go to ISO200 or even ISO400—in most cases without a significant drop in quality. But once you go beyond that—to ISO800, ISO 1600, or even ISO 3200 film, which are two, three, and four times as sensitive respectively—you will end up with images that are not as sharp, not as rich in color, and not as detailed. Only ever use the highest ISO setting you actually need.

Shooting at Night

Taking pictures at night is easy—and the results can be spectacular. All you need is a camera which can give exposures measured in seconds and a tripod to prevent camera-shake.

At night the sky melts into an attractive steely blue, while the world undergoes a visual transformation as the glow from street lights, neon signs, and houses intensifies—turning places that look mundane by day into a blazing myriad of man-made color.

When the sun clocks off it is time for you to clock on. You may not be a regular on the night shift—perhaps you prefer putting your feet up in front of the television

or drinking a few beers at a bar—but getting out and about when it starts to get dark will open up a whole new world of picture-taking opportunities.

If you live in an urban area you will find plenty of things you can photograph when it gets dark. Even towns that look dull by day will often come alive at night, as the lights go on inside buildings, their exteriors are floodlit, and street lights are illuminated—while cities can be an absolute riot of color.

However, if you wait till it actually gets dark, you will be too late. The sky will come out a solid black and your picture will look dead. In fact, the best time to snap your "night" shots is at dusk, just after the sun has set, when there is still some color in the sky.

Getting a balanced exposure is also easier at twilight. If you wait until it is totally dark, the contrast range is too great to be captured successfully—and there is a constant risk of over-exposure if you leave the camera to its own devices.

You will also need to watch the white balance. Part of the charm of night shots is the vibrancy and excitement of the many different colored lights. But auto WB systems can easily "compensate" for the variety of sources, leaving you with images that are rather bland. Most of the time you will find it best to set the white balance to daylight, so that floodlit buildings have the warm, orange glow we expect them to have.

On a dark fall evening nothing catches the eye more than a bright neon sign—and they make excellent

Make sure your white balance is set to daylight if you would like to capture floodlit buildings at their best. If you use the "Auto" setting the golden glow could be neutralized in the image.

Neon signs are a common sight in most big cities. Take care with your exposure, though, as dark surrounding areas can cause the lights to burn out.

photographs, also. In cities you see them everywhere, advertising bars, restaurants, and clubs. Capturing them successfully is easy if you crop in tight, to exclude as much of the dark background as possible, and keep your ISO setting low to maximize the colors and minimize noise.

If you want to capture a city at its best, try photographing the skyline as twilight descends. An elevated vantage point away from the center will often give you the best view. Alternatively, find a spot in the heart of the action and capture all the hustle and bustle from close quarters. One of the most exciting ways of doing this is by photographing motion trails of vehicles using a long shutter speed to convert them into a river of light. With an ISO 100 sensitivity, you set an aperture of f/11 and then vary the shutter speed from a few seconds to up to a minute,

depending upon how busy the traffic is. Choose a location where there is a steady succession of cars going both ways, so you have both red and white streaks in the picture, and interest in the surrounding buildings.

If it's bright lights with fun and action you are after, look no further than your local fairground. As all the rides spin past you, keep your camera stationary, allowing the lights to carve dramatic pathways across the frame. Your exposure will vary from one ride to another, but something like 4 seconds at ISO100 at f/5.6 is a good starting point.

With their blaze of bright lights, fairgrounds are great places to visit with night photography in mind. Shooting an hour before dusk means the sky is a rich blue rather than a dense black.

PHOTOGRAPHING FIREWORKS

There are two things you need to take great pictures of fireworks: a tripod and a piece of black card. Having secured the camera to your tripod you should select the "B" setting, and once the display starts, open the shutter and keep it open. If there is a lull in aerial activity, hold the card over the front of the lens. Then remove it once more fireworks go up. Continue until you have three or four lots of fireworks on one frame, then close the shutter.

Understanding Color

Because color is all around us, we often take it for granted. That is regrettable, because one of the easiest ways of giving your pictures more impact is by improving your use of color.

Color is one of the most valuable compositional tools you have at your disposal, allowing you not only to determine the overall mood of the picture, but also where to place the emphasis.

Take a look at the color wheel on this page and you will see how all the colors relate to each other. If you want to produce a picture which is restful, balanced, and harmonious, you should choose colors which are next to each other on the wheel. Yellow, orange, and red work well together, as do green, blue, and purple. Soothing, relaxing scenes made up of harmonious colors crop up everywhere. It is just a matter of looking out for them.

Contrasting colors—those on the other side of the color wheel—give a much more dynamic feel compared to harmonious colors and create more visual tension. Put red and blue together, for instance, or green and pink, and you have a dramatic contrast that is guaranteed to be eye-catching.

Individual colors

Psychologists have carried out an enormous amount of research into the emotional effects of color, and nowadays they have a clear idea of how people react to each of the tones.

A standard color wheel, demonstrating which colors are complementary to one another and which contrasting.

The three primary colors—red, blue, and green—are particularly powerful, and add energy and impact to any image. Red is the strongest color of all and can dominate a picture even if it occupies only a small area. As well as grabbing attention in their own right, blue and green also make excellent background colors, as they are said to "recede." For the best results, shoot in strong, bright light.

Sometimes, though, you want colors that are more muted—and here the best approach is to shoot when the light is soft and hazy.

One important distinction to be aware of is between "warm" and "cool" colors—because these go a long way toward establishing the overall mood of a shot. "Warm" colors—yellow, orange, and red—give a positive, upbeat feel, while "cool" colors—blue, cyan, and green—have a more tranquil effect.

Colors from the same part of the color wheel—such as the yellow, green, and red in this image of cooked peppers—nearly always work harmoniously together.

OPPOSITE: Colors can be extremely powerful. The vivid primary reds, blues, and yellows of the boat and the sky make this striking image almost leap off the page.

Using Color

Creative use of color makes an enormous difference to a picture because it determines the overall effect of your image—so do not leave it to chance. Think carefully about the use of color in all your images.

It is all very well knowing color theory, but how do you go about putting it into practice? Well, in addition to shooting for harmony and contrast (as explained on pages 136–7) there are three other valuable techniques that you should always bear in mind: filling the frame with color; monochromatic color; and isolating color.

Fill the frame with color

The secret to this approach is to choose a subject that is bursting with color and then go in close—as close as you can. You can do this with any lens you choose. Use

a wide-angle and you will end up with dramatic perspective as well. What kind of subject? Any kind. In fact, you should stop thinking about looking for a "subject" and focus on looking for "color" instead. In a nutshell, make color the whole point of the picture, not just something that is in it.

Monochromatic color

Another good way to work with color is to let a single color dominate a scene. Such "monochromatic" images have a mood all their own, which is dictated by the color involved. Simple subject matter often works best, so look for graphic shapes that really stand out.

Isolated color

In the same way that a shout is sometimes more powerful as a whisper, a small splash of color can sometimes grab your attention more strongly than a whole frame full of it. A poppy in a field of corn or a seagull against a blue sky both work extremely well. Subjects like this are not to be found everywhere, so if you have trouble try setting up something yourself. A cherry tomato resting on a bed of pasta would have exactly the same effect. Think also about where you place the splash of color. The best results are often produced by following the rule of thirds, which is explained in detail on page 111.

Looking for the secret of success in photography? Simply choose subjects that have strong, bright colors and crop in close.

The splash of red made by the lone poppy is what makes this photograph so successful, although the image is also full of interesting textural contrasts.

In some pictures just one color predominates. The limited palette of such "monochromatic" images gives them a unique appeal.

CONTROLLING SATURATION

One of the simplest ways of controlling the color in an image is by changing it on the computer. Most programs allow you to vary the saturation, generally by moving a slider control. Increasing saturation gives bold, vivid images; reducing saturation gives images that are muted and softer.

The original image (left) was opened in Photoshop and the Color Saturation tool was then selected (see the screen grab above).

In this version of the image the colors have been desaturated.

In this version of the image the colors are brighter, following saturation.

chapter 5

Themes for Photography

One of the most wonderful things about photography is that you never run out of subject matter. There are so many different themes to explore. Many people start with landscapes, portraiture, travel, wildlife, children, and architecture—and there is enough there to keep you going for a good many years. It takes time, effort, and practice to learn how best to tackle a subject, and the techniques you need for success in each are different. Once you have tried the most popular areas you will almost certainly want to have a go at something more unusual—perhaps close-up, documentary, or nude photography.

Portrait Photography

Successful portrait photography is straightforward—providing you follow a few simple rules. With a little effort and thought it is possible to produce portraits that really stand out from the crowd, portraits in which the person seems to come alive in front of you.

For a start, decide what kind of approach you are going to take. Do you want a posed picture, in which the person is looking at the camera, or a candid, where he is unaware that you are taking the shot? Posed pictures offer the advantage that you have more control, but the disadvantage that people often freeze, making it difficult to capture them in a natural way.

One of the most important skills is "connecting" with your sitters, so that they trust you and will open up for you. Many people get tense and nervous when a camera is pointed at them, resulting in stiff body language and cheesy grins that ruin the shot.

However, with the right approach, using rapport skills and natural posing techniques, the picture can be a true and lasting portrait that reveals something of the real person, and not just a superficial snapshot.

Lighting portrait photography

In most cases soft lighting is best—the sort you get on a hazy day outside, or the light that streams in through a large window. Avoid strong, contrasty light, which produces heavy, unattractive shadows.

For portraits with more character, try unusual poses. It is not essential that your subject is looking at the camera.

OPPOSITE: Soft lighting produces the most flattering portraits. In this case the picture was taken against a doorway on the shady side of a building.

HOW TO FLATTER YOUR SUBJECTS

Most of us are less than perfect when it comes to looks, so it is important to be able to flatter people—maximizing the positives and minimizing the negatives. Here's how you do it...

- **Long/large nose**
 Shoot with a longer focal length than normal—200mm to 300mm. The foreshortening of perspective flattens the nose. Shoot head-on, rather than from the side.

- **Double chin**
 A slightly higher than normal shooting angle does a good job here, because the neck is partially obscured. Asking the person to push the chin out slightly can also help.

- **Wrinkles**
 Illuminate your subject with soft light coming from behind you to play down wrinkles. Make sure you avoid contrasty lighting from the side.

With candids you get pictures of people as they really are, but the lighting is not always ideal or the background is messy. Unless you are shooting an environmental portrait—such as a butcher in a butcher's shop—then it is a good idea to choose a plain, uncluttered backdrop that will not distract.

The most flattering results are achieved using a focal length in the range 70-150mm. Do not go in close with a standard or wide-angle lens—the face of your subject will appear rounded and unattractive.

They say that when you are buying a house the three most important things to consider are location, location, and location. It is a similar case with portraiture, when the three things you need to think most about are expression, expression, and expression.

The reason that so many portraits lack impact is that nothing seems to be happening. The people are just standing there, staring at the camera. Often they look bored. Sometimes they even look scared. Rarely do the people actually look as if they are having a good time. Learn to elicit attractive expressions and your portraits will always be winners.

Photographing Couples and Groups

One of the most challenging areas of portraiture is photographing couples and groups—because there is so much more to think about and attend to than with individuals.

Each person in a group portrait needs to be posed well, lit clearly, and looking at the camera—but the group needs to work compositionally, also. It can be a tall order, especially with larger gatherings and when there are children and babies, who are most likely to sulk or cry at a moment's notice. However, with a little know-how it's easy to get the kind of results you are after. Success in posing couples and groups is, to a large extent, a matter of where you position the heads of your subjects—as they will almost always be the focal points in the picture. It goes without saying that you do not want anyone obscuring the person behind, or casting a shadow on him—so there is quite a lot to juggle. As a result you can end up with people scattered across the frame without any discernible arrangement, and a picture that looks a complete disaster.

So, whether you are photographing your family or friends, shooting indoors or outdoors, using flash or daylight, and taking a candid or posed approach, keep in mind the need to produce a composition that is, above all, visually pleasing.

Couples

Many pictures of couples show them standing awkwardly side-by-side in the middle of the frame staring blankly at the camera—as if they were strangers. There is no interaction, no intimacy, and no interest. The photographer has obviously said something to the effect of *"I would like to take your picture,"* and the two people have positioned themselves the best way they know how. Which is not very well. Usually, you need to get involved and give some direction. How should you pose them? Well, there are dozens of effective ways of putting two people together, and really no "right" or "wrong" way.

The most obvious manner in which to produce a feeling of connection is to have the two people touching. The options depend to a large degree upon the relationship between them and what kind of people they are. Whatever the relationship, get them close enough so that their bodies are in contact. This creates a good, tight composition. A simple way of enhancing this basic pose with family members or close friends is to ask them to tilt their heads together,

Weddings provide an ideal opportunity to practice photographing couples and groups.

Be imaginative with poses—do not just have couples standing side-by-side.

When photographing two people together it is usually better to have them looking at each other rather than at the camera.

While lining people up is not always the best approach, here it works just fine.

so that they touch. Then you might suggest that they put their arms around each other, or link them, if that feels appropriate.

Groups

The most obvious way of posing three people is to have them standing in a row. But make sure everybody is touching shoulder-to-shoulder and smiling, or the group can end up looking like a firing squad! Done well, this can work effectively, but it is a rather static approach to an image.

There is often a variation in the height of people, and it is a good idea to place the tallest person in the middle, creating a triangle effect. This can be enhanced by asking him to stand behind, so that he is looking through the shoulders of the other two. If the height differential is not enough, see if you can find something

for the person at the back to stand on—perhaps a couple of old books or magazines. Overall, the aim should be to prevent all of the eyes from being at the same height, and to create more of a sense of depth by having some individuals in front of or behind the others.

However, unless you are taking pictures in which there is a lot of light, allowing you to set a small aperture of f/11 or f/16, you need to keep everyone roughly the same distance from the camera if they are all to be in focus. You have more latitude when you are using a wide-angle lens and the group is farther away, but whenever you zoom in or get closer, you cannot afford to have the group too deep.

Of course, there are many, many other options, including having the smallest person in front of the other two; seating one person in a chair with the other two either standing behind or to the sides; positioning all three on a couch—and so on.

Babies and Children

As with general portraiture, you can either pose babies and children or shoot candids. The best approach depends on how cooperative they are and their age and temperament.

If you have children of your own you will need little encouragement to photograph them—it is one of the main reasons people buy a camera in the first place. However, it is all too easy to go into "snapshot" mode when taking pictures of children. Set your sights higher and try to capture some memorable moments for posterity. They soon grow up!

Babies

An unhappy baby makes for a miserable photographer. To make life easy for yourself, take your pictures after the little honey has been fed, changed, and settled. Then set everything up in advance, double-checking

Babies are best photographed under soft lighting—and converting the image to black-and-white can give it a special quality.

everything before you start taking pictures and only introducing the baby once you are ready.

Young babies are easiest to photograph when they are asleep or held in the arms of an adult. Their head needs to be supported at all times, so keep a supply of cushions at hand.

It is easy to get a soft, romantic look to your baby pictures—simply use diffused lighting. Outside you will find it on hazy and overcast days, or in the shade when it is bright and sunny. Avoid flash—it can look harsh and unflattering and may disturb the baby.

Toddlers

Toddlers tend to make the most of the fact that they can walk, and enjoy nothing more than rushing toward you when you point a camera toward them. So you need to be quick or, more usefully, photograph them when they are doing something, such as playing with toys or a pet. Avoid shooting while looking down on them—you will end up with big heads, little bodies, and stretched necks. Get down to their level by crouching or sitting on the floor.

Infants

With slightly older children, from the age of five upward, it is possible to go for a posed rather than candid picture. But do be aware that their attention span is extremely brief and they won't sit still for long. Never lose your patience, however frustrated you might become. If things are not going well, try again another day.

At this age children tend to be mischievous, and respond well to silly jokes and make-believe games. But their lack of self-consciousness will enable you to capture delightful expressions.

Kids are full of life, so try injecting some energy into your picture taking. Do not make it boring and serious. Have some fun. Take them to a park or playground and get them to let off steam.

Tweenies and teens

Older children—"tweenies" and teens—tend to shy away from the camera, and you may struggle to get them to pose without pulling a face. For that reason a candid approach is often best. Do not try to tell them what to do—they will respond by being even more uncooperative, and this will show in your pictures.

ACROSS THE GENERATIONS

Of course, you will also want pictures of the baby with many different members of the family—proud grandparents, older brothers and sisters—and for safety's sake many of these will show the baby being held in somebody's arms. The best shots tend to be those which are captured spontaneously. Also bear in mind the following points:

- Soft lighting is ideal for babies, so avoid direct flash whenever possible.

- Ideally, take photographs of babies either outdoors on a hazy day or indoors by the light of a large window or patio door.

As well as such spontaneous shots, remember to take time out to produce some more formal posed shots. Perhaps Mom and Dad with their hair done all fancy, and baby dressed in Sunday best, with the lighting carefully arranged.

Of course, you do not have to include everything—details can sometimes be as effective. How about photographing the baby's soft, tiny fingers as they rest gently in grandfather's large, rough old hands?

Pointing a camera at some children inspires them to start playing around—and all you have to do is capture the action as it unfolds.

The best way of photographing a parent and child is to wait until they are involved and interacting with each other—rather than posing for the camera.

Children are generally more expressive than adults—so keep your camera ready to catch the perfect moment. Here a telephoto zoom was used to capture this amusing candid.

Pets

Pets are one subject where fancy techniques are not required; just fill the frame with your subject and fire away. Remember, though, that animals are not always the easiest subjects to work with.

Many people regard their pets as part of the family—and photograph them along with the rest. Getting good shots of your cat or dog is relatively easy—because they are always around. The secret lies in having your camera loaded with film or with its battery charged and ready for use at a moment's notice. That way you can react as soon as you see the potential for a good photograph.

As far as possible, you should avoid the use of flash, as this can bounce back from your pet's eyes, producing the canine or feline equivalent of human red eye. Instead, go for an ISO400 setting and try to take your pictures when there is a reasonable level of light.

Spontaneous, natural pictures are often the best, but there is nothing to stop you setting up a more posed shot—the way you would shoot a portrait of a person. Once again, you need to work in good light, so that flash is not required, but you should also seek out a plain backdrop, such as a wall, to help concentrate attention on the subject.

Perfect timing

One of the best times to photograph animals like cats and dogs is when they have just eaten—they are less likely to be energetic and more likely to stay in one place. That said, you might prefer to take some action shots, of a dog jumping in the air to catch a stick, or maybe a cat chasing a toy mouse.

What technique do you use if you have a different kind of pet? It depends on a number of factors, including how big it is, how active it is, and how tall it is. With smaller animals, such as hamsters, gerbils, or tarantula spiders, you may need to get in closer to be able to fill the frame. In the case of creatures such as rabbits or ducks, you can stand farther away and use a telephoto lens. If you are the proud owner of something more exotic—a snake or a gecko, for example—you will need to adapt your photography according to its habits. Take a broad range of images at first, including some of the pet with its owner.

These days pets come in all shapes and sizes—but do not feel you have to include all of them in the picture. Cropping in tight often produces a great deal more impact.

The secret to photographing cats lies in holding their attention. Here the photographer got everything ready and then made a squeaking sound.

OPPOSITE: The faces of animals can feature expressions, also. This dog seems to have a superior, haughty manner that is emphasized by the strong eye contact.

AQUARIUM PHOTOGRAPHY

The problem with photographing anything in an aquarium is that if you use a built-in flash the light bounces off the glass and causes hot spots which ruin the shot. One alternative is to switch the flash on the camera to "off," and use the available light—but you will almost certainly need to crank up your ISO rating or use a tripod. The problem then is that you are stuck with a long exposure, and fish will move and blur. You may also need to experiment to find the best white balance setting.

For all these reasons, the best approach is to use an SLR with an external strobe and a dedicated off-camera cord. Always bear these points in mind:

- Placing the strobe so that the light comes from above and to the side will not only give attractive results but will also freeze any subject movement.

- When photographing an aquarium it is a good idea to wear dark clothes and to switch off any room lights. Otherwise, your own reflection in the glass of the tank might spoil the picture.

- Placing the lens as close as possible to the glass and cupping your hand around it will cut out stray light—but unless the tank is large you may need to use a wide-angle to fit everything in.

Vacations and Travel

Many cameras are bought in order to photograph vacations, trips overseas, and days out. All photographers, experienced or otherwise, will want to record these events.

Be selective

While it is tempting to photograph anything and everything that catches your eye in an indiscriminate fashion, a little planning and attention to detail will produce a much more satisfying visual record.

The obvious candidates for photography are local views and landmarks. The postcards in the tourist shops can give you some great ideas for locations and viewpoints. However, there seems little point in simply duplicating a postcard. Look for a new angle on the scene and include yourself or other members of the party in the photography to give it a more personal appeal in the future.

Additionally, be careful that you do not simply photograph "things." Vacations and outings are not just about the places you visit—they are also about the things you do while you are there. Consequently, make sure that you record your activities as well. This aspect is easy to overlook, but such images will form an important part of your memories in the future.

Taking pictures of children playing on the beach or in a pool is an essential part of summer vacation for many people. However, make sure that you protect your camera from sand and water, so that these images remain evocative for the right reasons!

Think before you shoot

There are a number of practical considerations to bear in mind when you are embarking on travel photography. One of these is to travel "light," and this does not stop at limiting the weight of the equipment you take with you. You should also travel "light" in a mental sense, sticking to a simple camera that you can operate without concentrating (you will have other things on your mind), or practice beforehand with common adjustments and settings so that you are not distracted by them when the time comes to take your picture.

You should also consider the security of your photographic equipment. While branded camera bags are a neat lifestyle accessory, they can also serve as a blatant advertisement for thieves. Plain, unbranded bags are generally a safer bet. Try to avoid waving your camera around in too obvious a fashion or leaving it in plain view on a strap around your neck, for example. Straps offer a level of security against pickpockets, but expensive and highly visible camera gear may also tempt muggers, which can result in much more serious problems.

Always be on the lookout for subjects that give a flavor of the place you are visiting. For example, Las Vegas makes people immediately think of wedding chapels, and this bold, vivid sign sums up the place perfectly.

Protect your equipment

Cameras may need protection from the elements as well, especially on trips to the beach. Keep your camera in a bag and place it carefully on a beach towel or a chair whenever it is not actually in use. Sand quickly gets into knobs, dials, and seams in camera bodies and can be next to impossible to get out again.

The same applies to any other equipment you take with you. Lenses, lighting aids, tripods, and other supports are all expensive items which should last you years if they are looked after properly. However, one overly casual visit to the beach on a windy day could change all that and could prove an expensive mistake in the long run.

One of the great things about being on vacation is that you have the freedom to take pictures when the light is at its most perfect. This dramatic photograph was taken just as the sun was about to disappear over the horizon.

Take care when photographing the locals. The best approach is to ask permission loudly and clearly, or at least make it clear that you would like to take a picture. Always keep your subject's personal feelings closely in mind.

PHOTOGRAPHING THE LOCAL PEOPLE

Local people can make great subjects for your photographs, and we have all seen many appealing and fascinating examples in magazines and photography books. However, it is important always to approach people with caution and, above all, respect.

Performers at organized tourist events will expect to be photographed, but ordinary members of the population might not. It is not difficult with today's compact digital cameras to take candid shots surreptitiously, but this can be an unnerving and unsatisfying experience, and if you are discovered you may face an angry reaction. It is always safer and more courteous to ask first.

Many local people will be happy to be photographed, but do not be offended by a refusal or, in some countries, a demand for money in return. Ask the advice of your tour representative, if available, or the hotel staff. They may be able to tell you the best way of approaching the local people.

PAGES 152-3: Street musicians in the Jemma-el-Fna square in Marrakech are more than happy to pose for you—providing you are prepared to contribute to their coffers! In situations like this you need as large an aperture as possible—here it was f/4 on a 70-300mm zoom—to throw distracting elements in the background out of focus.

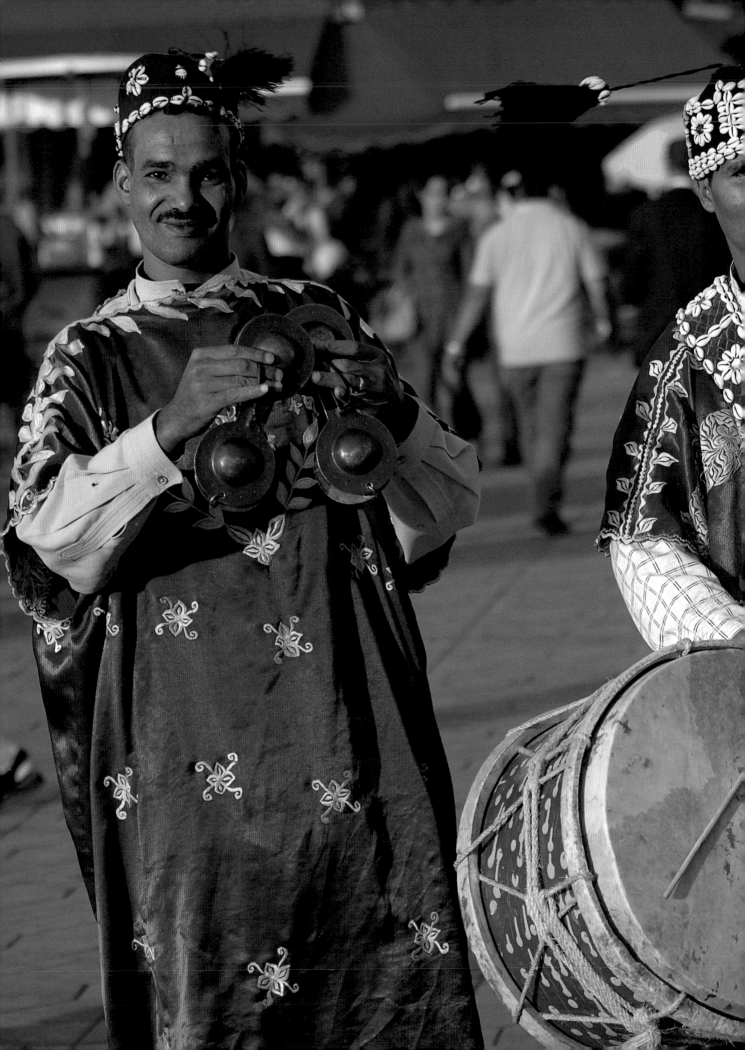

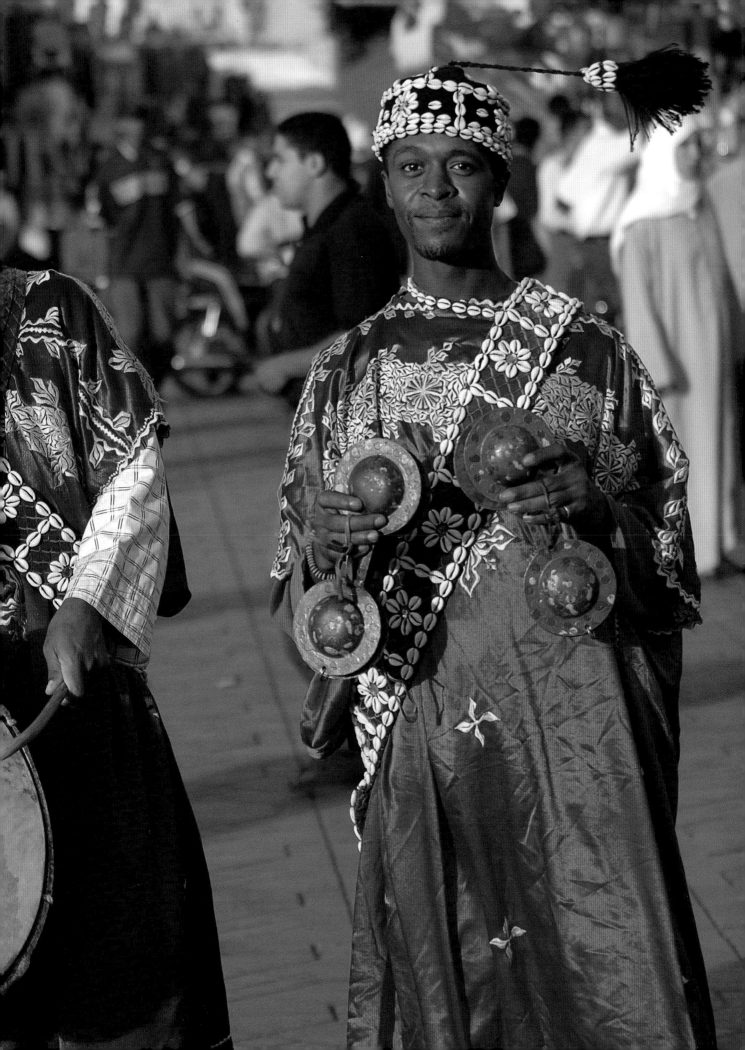

Action Stations

Action is one of the most challenging subjects to photograph. As well as having to worry about all the normal things—such as exposure, lighting, and composition—you also need to focus accurately on something that is moving, possibly so fast that you can hardly see what's going on.

On top of the speed with which things happen when you are taking action photographs, you need to fire the shutter at precisely the right moment, or the opportunity is gone forever. However, while it is challenging, action photography is not impossible. In fact, all it takes—as with most areas of photography—is practice. Things are complicated further, though, by the need to find suitable action to shoot; it is simply not always as readily available as other subjects, such as portraits, architecture, and landscape.

Shoot everyday action
While it is natural to equate action with sport, in fact it is only the tip of the iceberg. A better approach is to think of action as capturing movement, and no matter where you live you will find opportunities to take great action pictures. So do not ignore the more common subjects that are around you every day—such as your kids jumping off a trampoline in your garden or skateboarders honing their skills on the street.

By far the most difficult part of focusing is keeping a moving subject in sharp focus. Happily, most autofocus cameras will handle this chore for you—and many have a "predictive" capability that anticipates where the subject will actually be when the shutter fires.

To freeze or not to freeze?
The speed of your subject is obviously an important consideration when setting your exposure. You can freeze most action with a shutter speed of 1/1000 sec—even a sprinter in full flow. However, it is not always easy to achieve this. You need full sun and a lens with a reasonably fast maximum aperture. If your subject is moving toward you, generally a lower speed will work.

Of course, you will not always want to freeze the action. A speeding race car can end up looking motionless—which is far from exciting. In such situations, a degree of controlled blur that comes from using a longer shutter can make the difference between success and failure.

Introduce even more blur, and the effect is more expressionistic—and unpredictable. Try 1/15 sec to 1/4 sec. You may get some camera-shake, but that all adds to the overall effect.

In the majority of sports, things happen very quickly, and you only have a split second in which to capture the action at its peak. That is why it's best to start with activities you know and understand—maybe those you have participated in yourself. Running, football, cycling, shot-put, baseball, pole-vault, ice hockey... whatever action you enjoy, it will certainly make a fantastic picture.

Action is all around us—and can be just as captivating as sports. Here the photographer was interested in contrasting the movement of the boy on the left with the stillness of the boy on the right. A dozen pictures were taken and this one—with slight movement in the jumping boy's legs—was the best.

You need quick reactions, a reasonably long lens, and a shutter speed of at least 1/500sec to capture racehorses galloping towards you. Get it right, though, and the results can be spectacular.

One of the best ways of representing action is by setting a long shutter speed and blurring the subject. These fairground bumper cars were photographed at 1/4sec, with the camera panned to render the bumper car recognizable.

Sports and action come in many different forms, each with its own challenges. In watersports like this the movement of the participants can be unpredictable, so you will need to take lots of shots to get a few good ones.

Photographing Winter Sports

The techniques for photographing winter sports such as skiing and snowboarding are largely the same as those for general action photography, although there are specific technical and practical issues to take care of and bear in mind at all times.

Special considerations when shooting winter sports include the need to check the exposure carefully. Snow is white. To a human, such a statement is obvious; however, to a camera, it is not. When it is pointed at snow, the camera simply "sees" a great deal of light and reduces the exposure to compensate. The result is dingy, dirty snow and figures which come out far too dark. One solution is to leave the camera set to automatic exposure, but apply an EV compensation value of +1EV to +1.7EV, depending on the camera and the prevailing conditions. Alternatively, set the camera to manual mode, take a meter reading from a subject in the same lighting, and use this exposure for your photographs.

Protect yourself and your camera

You will not need to be told of the need to wrap up warm for shooting in cold conditions, but your camera may need the same protection. Batteries do not like cold, and their capacity is greatly reduced at low temperatures. Be sure to take a spare set, and keep them in an inner pocket close to your body so that they remain warm at all times.

Additionally, remember that snow can melt. It might seem perfectly harmless outside in freezing temperatures as it packs on to your camera, but when you step inside it will melt, and water and electronics do not mix. Make sure you brush away any snow on the camera while it is still frozen.

Look for ways of improving images in the computer. This bobsled shot lacked impact, but a little motion blur, and tipping the subject to more of an angle, increases the interest factor overall.

PANNING

Panning is a very successful technique for conveying a sense of movement. It is particularly effective for subjects which follow a smooth and predictable course, such as skiers. However, it requires preparation and practice, and you must be prepared for your first few attempts to include a high proportion of failures.

1) Choose your viewpoint
Firstly, prepare carefully for the shot. Plan where you are going to stand to get the best view of your subject. Think about the background as well, and try to pick one without too much detail (even though it will be blurred in your finished images). It is also best to avoid sudden changes in tone (such as trees giving way to clear sky, for example).

2) Set a slow shutter speed
You may need to experiment with shutter speeds to find the one which offers the best compromise between background blur and still keeping the subject acceptably sharp. This will depend on the speed of the subject, its distance from you, and the focal length of your lens. Start with a shutter speed of 1/30sec and work up or down as necessary.

3) Match the camera movement to the subject
The next part is the most difficult. You need to follow the subject with the camera as it passes, releasing the shutter as you do so. You will need to practice to discover the right timing for the shutter release. On your first attempts you may find that you are releasing it too soon or too late. You must also overcome the temptation to stop moving the camera once the picture has been taken—as any sports fan will tell you, you need to "follow through."

You need a long telephoto lens, a shutter speed of 1/1000sec, and perfect timing to capture images like this—but the effort is certainly worth it.

Shooting Landscapes

If you want some great landscape shots, a willingness to spend time exploring the countryside on foot is vital. The best views are rarely found at the roadside, so be prepared to get away from the car or tour bus. Only by going off the beaten track with a map in your hand will you discover things that many photographers miss.

The most important thing with landscape photography is not to include too much. Faced with a great expanse of glorious countryside, you may be tempted to just start snapping away. However, when there is too much in the frame you can lose impact. Start, then, by deciding what it is about the scene that attracts you. Maybe the light on the hills catches your eye, or the pattern created by a stone wall?

Once you have established what the main point of interest is, you can set about emphasizing it. As a rule of thumb, keep your compositions simple. A single feature, such as a cottage at the foot of a mountain, can make an attractive shot in its own right. By isolating what you want to show, and excluding the rest of the elements—perhaps by using a telephoto lens—you can make a stronger image. That said, when you have something fantastic in the foreground, or a great sky formation, it cries out for a wide-angle treatment.

Ideal conditions

Successful landscape pictures can be taken at any time of the day, but certain conditions stack the odds of success in your favor. If you rise at dawn you are almost certain to capture some stunning images as the earth awakens after a night under the stars. From high ground you will often see veils of mist hanging in valleys, or floating gracefully over rivers, lakes, and forests. The first rays of sunlight bathing a hillside also look stunning, and the low angle of the light reveals texture and creates a sense of depth.

However, although bright sunshine and blue skies promise great conditions for shooting landscapes, nothing beats a bit of stormy weather if you want really dramatic images. The most spectacular images are produced when rays of sunlight break through a dark, brooding sky and illuminate the foreground or distant features. A sudden rainstorm can be rewarding because it cleanses the atmosphere to produce beautifully crisp, clean light afterward. If you are really lucky, the sun may cut through, giving you the opportunity to capture a beautiful rainbow arching across the landscape. Probably the most photogenic period of all is the last hour before sunset, when everything glows beautifully.

Use a tripod

One of the keys to producing great scenic pictures is to use a tripod whenever possible. Not only will it ensure you get sharp pictures, and enable you to use a small aperture of f/16 to maximize depth-of-field, it will also slow down your picture taking—resulting in more considered, creative compositions. When you think you are ready to fire the shutter, take one last, long look through the viewfinder and ask yourself *"So what?"* If the view passes that test, fire away—you will know you have got a great shot.

Placing one of these dramatic-looking trees so that it looms large in the foreground gives the picture a powerful sense of depth. For this kind of picture you need a wide-angle lens and as small an aperture as possible—around f/16 or f/22.

OPPOSITE: The mist of early morning rolling over the hills, the sprawling long shadows of the trees, the compressed perspective created by using a telephoto lens... landscape images do not get any better than this.

PAGES 160–61: Although the subject matter here is obviously exciting in its own right, it would nevertheless have been easy to have taken a dull picture. However, using a wide-angle lens, getting close to the rock face, setting a small aperture of f/22, and composing the image so that the lines lead out of the bottom left-hand corner extracts the full potential of the scene.

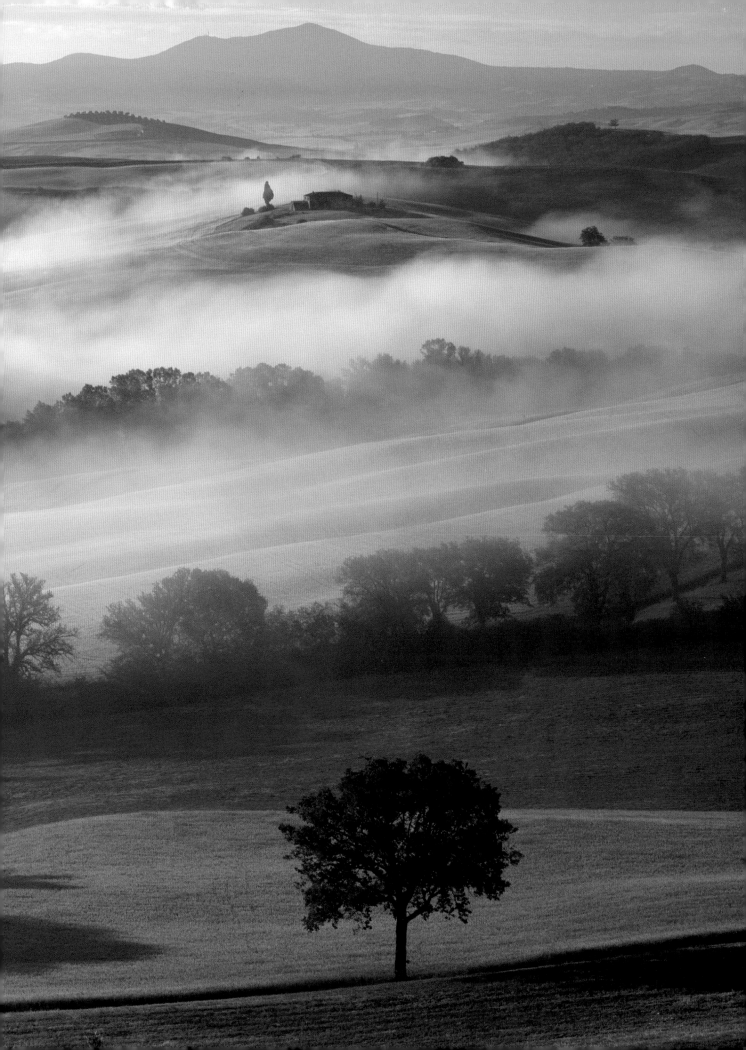

Waterscapes

A large proportion of the earth's surface is covered with water, so it is not unreasonable to think of it as a subject in its own right, as we do landscape. After all, what a range of options it offers us: waterfalls; rivers; lakes; reservoirs; pools—plus, of course, the ocean. Water is such a commonplace phenomenon that everyone can take advantage of it. The beauty of water is that it is powerful and uncontrollable—the ultimate expression of the raw force of Mother Nature at work.

The appearance of water is determined largely by the quality of the light and the color of the sky. Shoot at different times of day and in a variety of different weather conditions and you get a wide range of results. In bright, sunny conditions, rivers and lakes tend to look blue, whereas early or late in the day they take on an attractive warm coloration. Both can be extremely photogenic. However, in dull, overcast weather, water tends to look lifeless and boring—hardly meriting you getting your camera out of the bag.

The position of the sun also plays a role. When it is overhead, around noon, a highly reflective finish is

ON REFLECTION

One of the first things that comes to mind when you think of water is reflection (see below). From perfect mirror images in a tranquil lake to shimmering abstracts in a bustling harbor, reflections make great subjects. Use a wide-angle lens if you want to include both the reflection and what is being reflected, or a telephoto zoom to crop in on just a small area.

produced, with lots of highlights dancing on the surface. But during the morning or afternoon, when the sun is at a lower angle, light rakes across the surface, revealing the texture of the water.

Best of all, though, is a sunset over water—which is closely matched by the delightful colors you get an hour or so after the sun has gone to sleep.

Whenever you photograph water, make sure you watch your exposure carefully. With all that light bouncing around, there is a constant danger of under-exposure. Check the first couple of images you take, and if necessary allow a one- or two-stop increase to compensate.

PHOTOGRAPHING MOVING WATER

Moving water has immense power, and the most effective way of capturing it is by setting a long shutter speed. The result is an atmospheric, creamy froth that flows effortlessly around rocks or plummets earthward from a waterfall (see below). The longer the exposure, the greater the degree of blur. Start by mounting your camera on a tripod, then experiment with a range of shutter speeds, to see what works best—this will often be in the range of 1/4 sec to 4 seconds. To achieve that you will often need a slow ISO setting—around ISO100 or 50.

Close-Ups

Some of the best photographic subjects are right under our noses.
Insects, plants, and man-made objects can all make great subjects
and do not necessarily require expensive equipment.

The main requirements of good close-up
photography are patience and attention to detail,
so that you give yourself sufficient time to adjust the
camera, the composition, and the lighting to show
off your subject to the best effect. Two pieces of
equipment that you will definitely need, though,
are a tripod and a camera or lens that is capable of
focusing closer than normal.

Selecting a tripod

When choosing a tripod, go for one that offers you
sufficient flexibility for confined spaces and for
gaining access to subjects that are awkward to
reach. Tripods with boom attachments (or with
center columns that can act as a horizontal boom)
allow you to get close to the subject without
disturbing it with the tripod legs.

A tripod is important because depth-of-field is
very limited in close-up photography, and you will
often be working at small lens apertures and slow
shutter speeds, in which cases the risk of camera-
shake is high.

Macro modes

Digital compact cameras usually have a "macro"
mode that enables you to focus on subjects which are
just a few inches away. Standard SLR zoom lenses do

Soft lighting is great for close-ups, allowing you to capture
maximum detail. These colorful brooches were photographed
on a cloudy day at an outdoor flea market.

not usually focus this closely, so if you become serious
about taking close-up photographs you may want to
invest in a dedicated "macro" lens. These not only
focus closer than standard lenses, they are optically
optimized for close focusing and will give sharper
pictures with no distortion.

Lighting close-up photography

If you are shooting close-ups indoors you will have a
good deal of control over the lighting. Window lighting
offers soft, directional lighting which is perfect for
bringing out three-dimensional form and subtle
textures. You may find that the shadows are a little
dense when using window lighting, but they can be
lightened easily by using a reflector to bounce light
back. These are available commercially as fold-out
white disks, or you can improvise using a sheet of
white card or aluminum foil.

Flash can sometimes be useful for filling in hard
shadows, especially outdoors on a sunny day. When
you are using an SLR, however, the camera lens may
cast a shadow on the subject when you are just a few
inches away. Some close-up photographers use "ring
flash" units which are mounted around the lens
itself. These produce a much more even and natural-
looking style of lighting.

DEPTH-OF-FIELD

Depth-of-field is the near-to-far sharpness in your
photographs. It diminishes as you get closer to your
subjects, so that for an extreme close-up shot of an
insect, for example, you may need a very small lens
aperture simply in order to get every part of the
insect sharp in the image.

Close-up photographers frequently work at lens
apertures of f/16, f/22, or even f/32. The shallow
depth-of-field has another effect that you will need
to watch out for: if you are using the camera hand-
held, it is very difficult to avoid rocking slightly on
your feet or prevent your arms moving the camera
slightly between the time it focuses and the time
the shutter is released. Movement of just a few
millimeters can push the subject out of focus. This
is another good reason for using a tripod—it locks
the camera into a fixed position.

ABOVE: Powerful close-ups can be created using an ordinary telephoto zoom—as in this case, in which the photographer used the top end of a 70-300mm to crop in on a horse's eye.

BELOW: Depth-of-field is extremely narrow when you move in close. This can be exploited to good effect by making part of the subject stand out dramatically from the rest.

Architectural Photography

When you think of architectural photography it is probably country houses and skyscrapers that come immediately to mind—and with subjects like that you certainly have a head start when it comes to capturing some great images. However, don't despair if you live in a small town or the heart of the countryside; there are photogenic buildings to be found pretty much everywhere.

It's not just a matter of what you photograph, it is also how you photograph it. A simple country cottage or a brownstone townhouse have potential when photographed in the right way—and that's without considering the opportunities offered by office blocks, shopping malls, or even your local diner.

The importance of light

One of the key factors to consider when photographing buildings is light. Few buildings look their best in overcast lighting, and it is usually a waste of time taking pictures of them under such conditions. However, even the most ordinary-looking place can be brought to life when bathed with a little sunlight. Generally, though, it is a good idea to avoid photographing buildings in the middle of the day, when the sun is high in the sky, and casting heavy shadows downward. Far more atmospheric conditions can be found early in the morning or late in the evening, when the sun is lower, and also warmer in color than the bluer light which is so often found around noon.

Stained glass requires careful exposure if you are to keep the richness of the colors and not allow them to "burn out." Take a test shot and check it carefully before firing off a series.

Architectural details, whether door handles like these or the gargoyles on a church or cathedral, make fascinating studies. They are easy to capture using a telephoto zoom.

ARCHITECTURAL DETAILS

Architectural details can sometimes be more interesting than the whole of the building. They could literally be anything: an unusual window; a gargoyle on the front of a church; a door knocker; a sundial; or a house number. You could even shoot a series of abstracts of the very fabric of the buildings themselves—focusing on the stone, brick, flint, cobbles, and roofing materials that they are made from. A telezoom in particular can be excellent for homing in on such details, but in practice any lens will do.

If you are going to use converging verticals for dramatic effect, do it with style. Go in close, use the widest lens you've got, and tip the camera right back—as was done to capture this shot of a skyscraper in Frankfurt, Germany.

Traditional stone buildings, such as King's College in Cambridge, U.K., are best photographed when the light is warm and mellow—in the late afternoon and early evening. Care should be take to ensure the sides of the building remain upright.

CORRECTING CONVERGING VERTICALS

There are specialist perspective control lenses that enable you to avoid converging verticals when photographing buildings, but they are well beyond the means of most amateur photographers. An easier option is to correct the problem in your image editing program (see pages 202–3).

The angle of the sun is also important. Best results are achieved with the light striking the building obliquely and bringing out the texture of the materials used in its construction. For many subjects, there is nothing to beat the "raking" sunlight you often get at the end of a bright day, which gives a strong sense of depth. Placing the sun so that it strikes the building head-on will lead to flat and disappointing results.

Take particular care when taking pictures of buildings that are especially light, such as those painted white or made of pale stonework—you may need to increase your exposure slightly. These features can easily cause under-exposure. You should also watch your exposure when you are including lots of sky in the picture—perhaps because you are tipping the camera back to include the top of a tall building. Done badly, this can make it seem as though the building is falling over. However, if you do it intentionally, it creates a dramatic and eye-catching image (see above). In theory, though, buildings should be photographed so that all the uprights are perpendicular to the side of the

image. That means having the camera completely square when the photograph is taken. In practice it is often difficult to do that. Even with your widest lens fitted, the building may be too big or there may not be enough room to get far enough back to include it all in the frame. That means you have no choice but to tip the camera back, and you will then get "converging verticals" as they are called. But don't do it half-heartedly—if you go for a low viewpoint and a dramatic angle, you can make the building look as if it is flying off into space.

Wide-angle lenses

A wide-angle is considered the "standard" lens as far as architectural photography is concerned—the wider the better. The ideal tool for anyone serious about photographing buildings is a wide-angle zoom, starting at 17mm or even wider. Telephoto lenses, though, are excellent for buildings in which there is plenty of room, allowing you to get farther back and still fill the frame. This can be an excellent way of keeping the verticals of buildings upright.

Photographing Building Interiors

Architecture is not just about exteriors—the interiors of buildings can be fascinating as well. It can sometimes be challenging to achieve good results, but it is more than worth the effort.

The main problem you will encounter when you step inside most buildings is the lighting—which can be a mixture of daylight streaming in through windows, tungsten balanced bulbs, and sometimes fluorescent tubes as well. It can be a nightmare. So, check how your camera's auto white balance is coping. If the answer is "not very well," try one of the other settings—perhaps for tungsten—and see if the results are better. Keep taking and reviewing test shots until you are happy.

Interior light levels are likely to be low, so you might be tempted to use flash. This certainly is an option if the interior is relatively small, but even then it is not usually the best choice. A strong blast of flash can easily destroy any sense of mood.

With large interiors such as cathedrals or shopping malls there is obviously no point in using flash unless you have access to the megawatts of lighting that some architectural professionals employ.

Whenever possible use a tripod. This will give you the freedom to choose the ideal shutter speed and aperture combination without having to worry about camera-shake. Tripods, though, are often forbidden or at least frowned upon—and sometimes you will have no choice but to hold the camera. This makes

ramping up your ISO setting virtually essential. However, do not go higher than ISO400 unless you absolutely have to, as the quality of your images will deteriorate. Having said that, you may have no choice if things are really gloomy.

Reading the light

If time allows, and you are not in any rush, notice how things change during the day as the sun moves around the building. Assuming there are windows, the lighting in the room will be completely different in the morning, through noon, and into the afternoon. See how the light falls on the walls and on the objects in the room. With a digital camera it costs nothing to take pictures at various times and then choose the ones that work the best.

When shooting interiors you will generally want to use the widest lens you have, simply to get everything in and show the scale of the place. Even then you may sometimes find it impossible to include everything, and you will need to compromise when it comes to composition. Pick out whatever seems most important or interesting, ideally with something in the foreground in order to create a sense of depth.

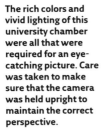

The rich colors and vivid lighting of this university chamber were all that were required for an eye-catching picture. Care was taken to make sure that the camera was held upright to maintain the correct perspective.

OPPOSITE: To make the most of architectural interiors you need a wide-angle lens—the wider the better. For this dramatic picture a 12mm ultrawide was used at an aperture of f/16 to keep all the floors in focus.

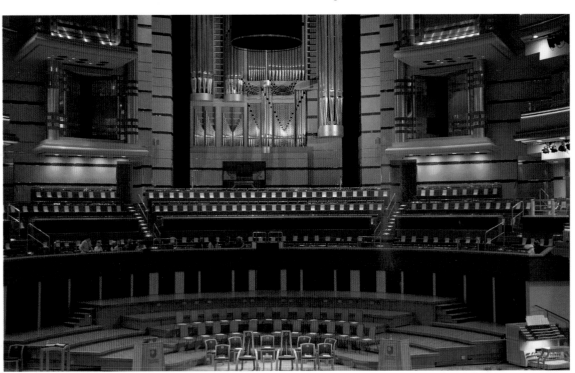

Animals in the Wild

Photographing wild animals is more of a challenge than taking pictures of your pets—but it can be extremely rewarding. The key to good shots of wildlife is patience, combined with luck and practice.

Birds

Wherever you live, there is a very good chance you will be able to take pictures of birds—possibly without even having to leave your home. Though you may not find exotic species like golden eagles in your backyard, you will probably have crows, chickadees, and thrushes around you in abundance.

With a reasonably powered telezoom that goes up to 300mm, you will be able to get a decent-sized image—which subsequently may need cropping and enlarging in the computer to fill the frame.

However, birds have far greater appeal when they are on the wing. But capturing them in flight can be far from easy, especially in the case of small species that travel at great speed, such as swallows and swifts. To get good pictures of birds like these, you need fast reactions. Your best bet, therefore, is to get out and about and find some larger birds, such as geese, ducks, or gulls, which are slower and more graceful in flight.

If you go to a park, the birds will be used to humans coming and going, and are consequently less likely to be scared away. This is a good way to begin taking pictures of birds and to accumulate valuable experience without complications. Toss the park birds some bread or seeds and you will be able to photograph them as they come in to land or take off. Make sure you choose a vantage point in relation to the background and direction of light which shows the subjects at their best.

Wildlife

Venturing into the countryside to photograph animals in the wild for the first time can be an exciting experience, but also a disappointing one. Most species quite sensibly stay well away from people, so you need an extremely powerful lens to stand any chance of filling the frame. At the right time of day you may have success with rabbits and

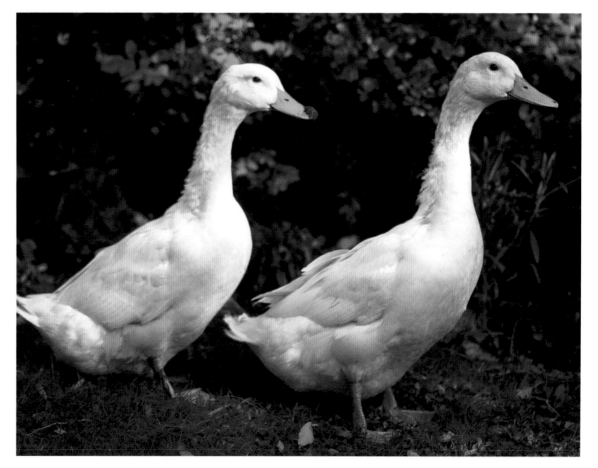

Small birds can be difficult to photograph well, but larger species, such as ducks, can be photographed readily where there is plenty of water.

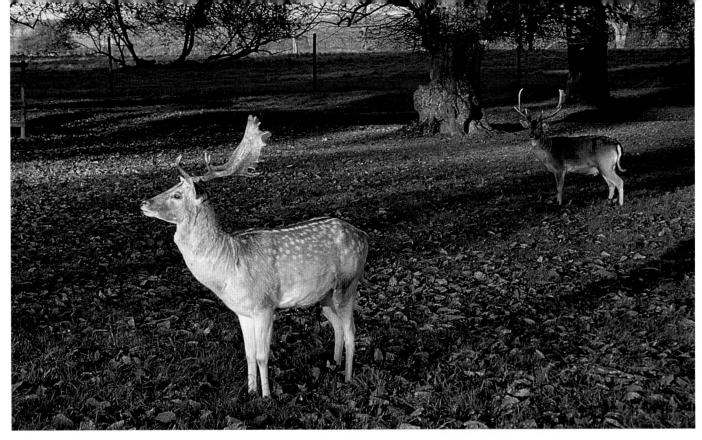

Move slowly and steadily and you should be able to get reasonably close to deer in parks and gardens. Very often they are quite used to people and will not scare too easily.

deer, but animals such as foxes and raccoons may prove elusive unless you have specialist knowledge of their habits and habitats. To stand any chance at all you will need to wear drab clothes, avoid aftershave or perfume, and move slowly and carefully.

So, as with birds, a visit to more accessible locations, such as parks and gardens, may well give you better results. Here you will often see squirrels. Most are used to people, and will come within range if you put out some nuts. Even so, don't make any sudden movements, or you will scare them away. A 70–300mm zoom set to the top of its range should be sufficient to capture a squirrel at a reasonable size in the frame. Make sure you have a shutter speed of at least 1/250sec. Watch your exposure when shooting up toward the sky. You may need to increase it by a stop or more to avoid ending up with a silhouette.

Ponds can also be a good source of wildlife images, with subjects such as frogs readily available.

On safari

While it is perfectly possible to take some good pictures of exotic species at your local zoo, there is nothing to beat going on safari with an experienced guide who can take you as close as is safe to rhinos, lions, elephants, and so on. It is not cheap, obviously, but the quality of the images you will shoot will far exceed what is possible when the animals are in captivity.

Using a telephoto zoom it is possible to get decent shots of small animals such as squirrels. Try to capture them when they are doing something interesting—as here, when the animal is eating, or when it is about to leap from one branch to another.

Plants and Backyards

Plants and backyards make ideal subjects for photographers who are interested in natural history. Up close, plant structure, color, and texture are fascinating and varied. What's more, your subjects are patient and static, giving you plenty of time to experiment.

You can start by taking a walk around your own backyard. It does not have to be filled with perfect botanical specimens, since even a humble weed can make an interesting subject in the right conditions.

The time you spend experimenting in your own backyard will pay dividends when you visit public parks and gardens, because you will be able to set up and compose shots much more quickly. This may be important at busy times of day when there may be people queuing behind you or continually getting in the way of the shot. In public gardens, of course, you may get the opportunity to photograph species and arrangements you could never nurture at home.

Shooting in the wild
True natural history fans, however, will be happier photographing flora in the wild, where it can be found growing in its natural environment and where there is always the excitement of not knowing what you are going to find, for example when embarking on fall mushroom hunts. Many of the most interesting subjects in this area may be visible for only a few days in the year, so some specialized knowledge can be useful. Do your research before you set out.

Tripods and subject movement
Outdoor close-up photography can involve shooting at or near ground level, so a tripod offering a wide range of movements and positions is a big advantage. Buy the best one you can afford—one that is easy to adjust and with as many features as possible.

However, even though a tripod can prevent camera movement, it cannot prevent subject movement. Even the lightest breeze can create subject blur, and it is often necessary to wait for the wind to die down between shots, and to take a number of different exposures on the expectation that many will have to be discarded. Don't despair, though: there is something else you can do. Take a stiff sheet of white card with you on your shoot. This can be used as a reflector to bounce light back into shaded areas, and it can also be used to shield your subject from the wind.

OPPOSITE; FAR RIGHT: Individual plants are best photographed using a telephoto lens and a large aperture around f/5.6 to throw potentially distracting backgrounds out of focus. This approach brings home the full effect of a dramatic subject.

OPPOSITE; BOTTOM: Flowers are best photographed in the flat, soft lighting you get on a cloudy day. This preserves the maximum amount of detail and keeps contrast to a minimum. It is a common mistake to think that bright sunlight improves images like this.

Mushrooms and toadstools are more often photographed from the side, but here the photographer has taken a different viewpoint and shot from above.

CLOSE-UP DETAILS

Trees are fascinating natural subjects due to their scale, their shapes, and their architectural properties. They also offer many fascinating close-up details, including the rough texture of the bark; the colors, shapes, and textures of the leaves; and the buds, flowers, and fruit that may appear at different times of the year.

Indeed, the appearance of whole trees changes markedly throughout the year. The bare branches of an isolated tree against a winter sky or a snow-covered landscape can be very effective, while in the fall the same tree may be covered in yellow, red, and bronze-colored leaves that contrast spectacularly against a blue sky. As a subject, trees' variety is amazing.

Shooting Still-life

Spend a few minutes in any museum or gallery and you will quickly see that still-life has long been a popular subject for art. It is also a great medium for producing some attractive compositions in photography.

Good subjects for still-life photography

One classic subject is food and drink. Simply collect together some fruit, bread, vegetables, bottles, and so on, and arrange them in a pleasing way. It can be tempting to cram too much into your still-life pictures—but if you are not careful you will end up with a frame full of clutter. Start with just a few items and build up from there; for example, try a couple of red onions with a brown paper bag for a backdrop. Often it is simple compositions that work best of all, because the space between the various props allows the picture to breathe.

Generally you will want to set as small an aperture as possible—ideally f/16—to keep everything sharp from front to back, but occasionally you will want to isolate something from an out-of-focus background, and here you should go for a larger aperture of f/4 or f/5.6.

Other subject matter could include a collection of tools, such as wrenches, screwdrivers, and pliers, painting equipment such as brushes and watercolor paints, or even high-tech office equipment such as a cell phone or DVD recorder.

Effective backdrops for still-life photographs

The backdrop to the shot is extremely important, and is often where found still-life shots fall down. Avoid backdrops that are fussy or confused, or conflict with the foreground subject. If you really start getting into still-life photography, you will find it a good idea to build up a collection of suitable items for backdrops that you can use over and over again, such as sheets of old pine, marble, or aluminum.

Lighting still-life shots

Another important consideration in still-life photography is lighting, which should also, of course, be appropriate to the kind of subject you are photographing. The good news is that as far as this aspect is concerned, you have complete control, because still-life photographs are nearly always taken indoors, where the prevailing light is at your mercy. If you don't have studio lights, use windowlight supplemented with reflectors for the best effects. Experimentation is the key to success.

Exquisite arrangement and delicate use of light results in a beautiful still-life that looks almost like a Renaissance painting.

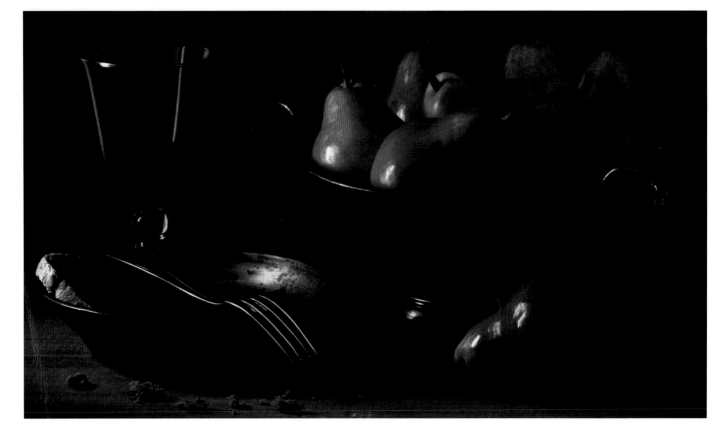

If you can conceive it, you can achieve it. Still-life photography is all about creative thinking and coming up with interesting and unusual ideas.

"FOUND" STILL-LIFE

Still-life photography has a reputation for being boring: not everyone has the patience to arrange things in a painstaking way before taking their shot. However, there is another way of tackling the subject, and that is by "finding" still-life subjects that are already set up. These are all around you, just sitting there, waiting to be photographed. All you have to do is become aware of them and point your camera in the right direction.

Where will you find these still-lifes? "Anywhere" is the simple answer. Look around you now—there are plenty of opportunities. Take a stroll around your house. How about a shot of some of the objects on your mantelpiece—a collection of ornaments or a simple bunch of flowers in a vase? In the bathroom you will come across old razors, combs, and brushes, flannels and towels. Step outside, and a whole new world of opportunity opens up. Seek out flea markets, garage sales, white elephant stalls, and places selling bric-a-brac. You are bound to discover all sorts of found still-lifes here—and all you need is a standard zoom to capture them in an effective manner.

Found still-lifes are everywhere. The secret of success lies in selecting just the right amount of the scene to include and shooting when the light is at its best.

Of course, sometimes you might see a subject that you think would make a great picture, but it is not exactly right. Should you rearrange it? Of course you should. Generally, a little regrouping will improve things considerably, and give the still-life some coherence and structure.

PAGES 176–7: Inspired subject matter, meticulous composition, perfect lighting—it all adds up to a virtuoso advertising photograph.

Textures and Patterns

Most of the time when we take pictures we are thinking about how best to tackle a particular subject—be it landscape, portraiture, or still-life—and choosing our techniques accordingly. However, rather than concentrating on the content of the picture, if you focus on its form—that is, the way it actually looks as opposed to what it is—you will come up with some great texture and pattern images.

The key is to weigh up the potential of a scene in a different way. You have to think past the subject and see it as a collection of graphic elements, from which you choose those that suit your purpose.

Suppose you spend a day at Buckingham Palace, in London, England. In normal circumstances you would probably take some architectural shots of the buildings, some candid pictures of the crowds, and some portraits of the guards. But if you were looking for pattern photographs, you might find the way in which the rows of guards line up appealing. Or if you were after textures, you might go in close for a detail of a tunic.

Similarly with trees—you don't have to photograph them in their entirety. Isolate textural parts, such as the bark or leaves, or look for interesting shapes within a wood or forest.

There is potential for eye-catching abstracts pretty much everywhere. A dynamic diagonal composition and a standard zoom lens were all that was required to make the most of these tiered seats at a sports stadium.

Textures

Everything has a surface, and every surface has a texture. Some textures are fine, others coarse. This texture provides you with a great opportunity to take some great pictures. But first you have to learn to see the texture, and for this you don't need a camera. Just spend some time looking at things closely, carefully, as if for the very first time. Feel the texture with your fingers. How smooth the page of this book is, how rough the skin of a pineapple.

Now do it with photography. Take pictures of those textures and you will produce a fascinating portfolio of shots that will seem very real—because they engage the tactile senses of people who see them.

All you need for an appealing texture shot is side lighting and something with interesting texture. Exposure in such situations will often be a challenge, and it's always a good idea to take a series of pictures at different settings.

Highly textured surfaces make the easiest subjects, because they can be photographed successfully in just about any way. With finer-textured subjects you will need to do two things: one, go in a lot closer to bring out the texture, and, two, make sure you have strong side lighting cutting across the surface, casting deep shadows. Early morning and late evening light is ideal.

Patterns

Look at some of the most successful photographs, and you will see that they have a strong element of pattern, which is all down to the way that the elements in the shot are organized, creating visual shapes or rhythms.

One option is to look for ordered rows of things, so that the picture area has strong lines that give the picture solidity and direction. These lines can be horizontal, vertical, or even diagonal. In fact any repetition of shape or color can create an interesting pattern.

How do you achieve these effects? First of all, by being tuned into them—once you become aware of them, you will find that they are all around you. Using a telephoto lens can help, because it will allow you to isolate a small part of the scene as well as compressing perspective to create new relationships between the elements of a scene.

The interplay of lines and shadows at a railway station provides fascinating subject matter for an abstract composition. Keeping the horizontal lines level gives a sense of stability.

Shot from a gently floating hot air balloon, this picture reveals the texture created on the landscape by farming. Late afternoon sun throws evocative, atmospheric shadows.

Documentary Photography

Photography is not just about recording vacations, family events, and beautiful landscapes. It can be used for more serious social purposes as well, as demonstrated by the great black-and-white documentary photographers of the 20th century.

Indeed, it is worth spending time studying the work of photographers such as Cartier-Bresson, Robert Doisneau, Don McCullin, and others to gain an understanding of how a photograph can tell a story and convey a greater meaning than the literal image might suggest.

Whether you are recording a sports event for your local school, the activities of your operatic society, or the demolition of an old landmark, the storytelling ability of photography remains as powerful as ever. Camcorders may be the tools of choice for news professionals, but video footage does not offer the depth, the opportunities for reflection, or the lasting impact of still images.

However, it is not always possible just to pick up your camera and shoot. Much depends on the subjects, the circumstances, and the events taking place. It is usually wise to seek the permission of those you are photographing before you start. Alternatively, do not hide the fact that you are there to take photographs. If you make your intentions clear, you also give people the opportunity to ask you questions. You may need to seek permission from an owner or manager if you are taking photographs on private property, even if this is normally accessible to the public.

Documentary photography demands a simplified approach to your camera settings, because you will need all your attention for what is going on in front of the camera. Traditional documentary photographers would use "zone focusing," setting a focus distance and a lens aperture that would make everything sharp within a range of distances from the camera. This meant they did not have to think about focusing. This is a good strategy today, since no autofocus system is truly instant, and documentary photography often relies on instant responses. So, for example, you could set your digital SLR to manual focus, focus on a distance of around six feet and set an aperture of f/8. This will eliminate any shutter lag and, if you use aperture-priority mode, the camera will automatically adjust the shutter speed to produce the correct exposure.

There is a gritty realism about close-up black-and-white photography that makes it especially appropriate for documentary images.

RECORDING YOUR NEIGHBORHOOD

You can try your hand at documentary photography by starting small. Pick an event or a theme in your local neighborhood. It might be a day in the life of a shopkeeper or a farm worker who you know. How about the regulars in your local bar? Find out if there are unusual local clubs and societies, like those which specialize in historical re-enactments.

Documentary photography does not have to concern itself with major, global events. Indeed, it is arguably more valuable to record an everyday way of life and simple, daily occurrences, since these are what are likely to prove more fascinating to future historians.

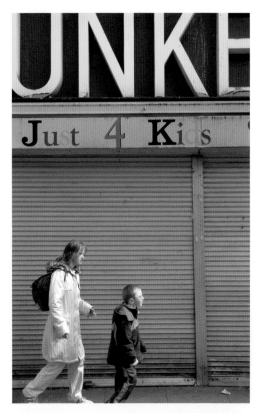

No matter where you live, there is the opportunity to capture your neighborhood for posterity. It is not only beautiful places that make effective photographs.

OPPOSITE: Light levels were low for this documentary study of a church interior, but it was still possible to get an attractive image by increasing the ISO setting to 800. The powerfully evocative atmosphere of the subject did the rest.

Nude Photography

Photographing the nude is both challenging and rewarding. It is important to consider exactly what you are trying to achieve before you start, because this will make it much easier to choose the lighting and the props and to direct your model.

Do you want your photographs to be a celebration of that individual, or of the nude form in general? By including your subject's face you invite the audience to try to relate to him as a person. Here, your study of the human figure can sometimes become confused with the techniques of portrait photography. Photographs need a focus, and it helps to decide whether that focus is the person or the body before you begin setting up and taking shots.

It is a good idea to clarify your ideas in your own mind before the shoot so that your subject understands and is comfortable with what you are trying to achieve. Are you shooting a glamorous pin-up, an atmospheric figure study, or an abstract examination of the human form?

You should also be frank about your own motives. Personal fantasies can produce striking and memorable photographs, but you owe it to your subjects to spell this out at the start. They may want to be reassured that you are not using nude photography as a subterfuge for something else. If in doubt, ask them questions before you begin.

Male nudes may prove more challenging than female nudes, not least because this is a less common and less widely understood style of photography. Another factor is that the work of photographers like Robert Mapplethorpe—despite its undoubted merits—has lent male nude photography a homoerotic image that it can be difficult to move away from.

LIGHTING THE NUDE

Can you use the same lighting for nude photography as you do for portraits? To a large degree, you can, although the kind of studio lighting set-ups used in commercial photography are a little too banal and anatomical for anything except glamor and pin-ups. For more reflective and atmospheric figure studies, soft directional lighting is best, such as that you might get from a single softbox or a large, sunless window.

A reflector can help bounce light back into darker areas—try hanging a white sheet from a wire just out of shot. Alternatively, you can produce a brighter, more ethereal look by placing your subjects with a bright window behind them. Choose an exposure which records their skintones correctly, or even a little lighter than usual.

WHERE TO FIND SUBJECTS

Finding people willing to pose nude might be difficult—and actually asking them could prove the hardest thing of all. You could start by making discreet enquiries amongst your friends, reminding them that you are a photographer.

Alternatively, join a local camera club and make enquiries there. Amateur models are unlikely to advertize their services, so you will have to rely on word of mouth. It may be worth approaching a local art college. Many will run life classes using nude models and they may be able to put you in touch with people willing to pose.

chapter 6
Advanced Photography

Once you have mastered the basics of photography, and are able to take high-quality pictures of most popular subjects, it is time to go to the next level and tackle something more advanced. You might, for instance, like to get into studio photography, where you have total control over every aspect of the lighting. By adding different accessories, and more lights, you can produce images that a professional would be proud of. In fact, you may get to the stage where you could start selling your pictures.

Setting Up a Studio

It might surprise you to learn that you only need one light to get started in studio photography—especially if your main interest is portraiture. Studio photography is not as complicated as it is sometimes made out to be.

Whether you opt for a continuous light source—that is, tungsten—or electronic flash will depend on budget and preference. Tungsten lights are much cheaper than flash and you can see exactly the effect the light has on your subject. The downside is that they are not very powerful, the light is very warm so it requires filtering or white balance adjustment to avoid color casts, and the lamps get very hot. Flash, on the other hand, is daylight-balanced and has more power—which is also variable—and studio flash units come with modeling lights so you can see the effect the flash will have on the final image.

Starting out with one light, experiment with using it in different positions around your subject and see how this affects the feel of the shot—next to the camera, front 45°, 90°, rear 45°, behind pointing toward the camera, and above the camera aiming down.

Lighting strategies

Front 45° and 90° are ideal for portraiture—the former will produce reasonably even lighting and the latter position bold side-lighting, with half the face lit and half of it in shadow.

Try using the light close to your subject, then farther away, and note how the quality of the light changes.

BACKGROUND STORY

The background is a vital part of any photographic studio, so never underestimate its importance.

Purpose-made studio systems are widely available; most commonly a tubular frame which supports wide rolls of background paper or fabric backgrounds. Self-supporting backgrounds are also available on sprung frames from companies such as Lastolite.

Having said that, it is not particularly difficult to make your own background. Large sheets of card can be used in white, black, brown, or other colors of your choice. Linen sheets or hardboard can also be painted to create bespoke backgrounds, while pieces of old canvas and other fabrics are ideal for textured backgrounds.

The key with backgrounds is always to keep them simple so that they don't dominate the picture. For portraiture, plain colors such as white or black are ideal.

Professional-quality backgrounds are available at relatively low cost that enable you to turn your home into a studio in just minutes.

HOW TO USE A FLASHMETER

You should use a flashmeter (see above) in order to determine the aperture (f/stop) you need to shoot at to achieve the correct exposure with studio flash.

Many hand-held incident lightmeters (standard lightmeters) also double up as flashmeters. To use a flashmeter, hold it just in front of your subject and, pointing back to the camera, press the metering button so that the flash unit(s) fire. Then, simply read off the recommended aperture from the display.

You can also assess the lighting balance when using more than one flash unit by pointing the flashmeter toward one flash, then another, and comparing the readings you receive for each one.

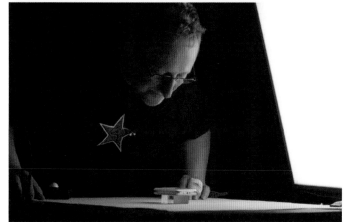

Some professional studios are large enough to accommodate an automobile (above) and several other "sets" at the same time, but it is also perfectly possible to get started with just a single light and a dining room table (left).

Adding a white reflector to bounce some of the light into the shadows will give you even more lighting options—a sheet of white card is all you need.

Locating your studio

If you have a room you can dedicate to your studio, that is ideal. Equipment can be left set up permanently, allowing you to use it at a moment's notice. For many amateur photographers, however, that may not be possible. You will have to pack everything away after every session. While this is obviously not as convenient, in practice it only takes a few minutes to set up a couple of lights and a background.

It is also possible, if funds are limited, to start with a "daylight" studio—using the light that floods in through windows and doors. While not as versatile as tungsten and flash—you cannot turn the power up and you will not be able to take pictures once it gets dark—it is excellent during the day. Large sources of light, such as patio doors, are ideal, especially if you use a large reflector, such as a white sheet, to bounce light back into the shadows.

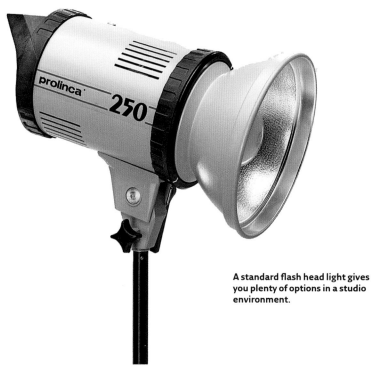

A standard flash head light gives you plenty of options in a studio environment.

Modifying the Light

Bare studio flash units, like portable strobes, produce a light that is very harsh and unflattering, so if you want to create professional-quality results then you will need to modify the light in some way.

Umbrellas and softboxes

There are numerous accessories available to help you modify and improve the prevailing light in your studio; one of the most common is the traditional flash umbrella—a white, silver, or sometimes gold umbrella into which the flash head is fired. This causes the light to be spread over a wider area so that it is softer and produces shadows which are less defined. The great thing about using an umbrella is that it folds down and opens up in seconds, and is easily transported. For general use, a 30-in (76-cm) diameter umbrella is ideal.

Softboxes also diffuse the light. As the name suggests, the flash head is placed inside a box and the light is directed through a white diffusing screen. Softboxes come in a range of shapes and sizes. Most are square, some are rectangular—and there is even an eight-sided version call an Octa. A popular size is 3ft (1m) across—big enough to give plenty of softening, yet capable of being accommodated in an average-sized room without difficulty. For maximum diffusion, when photographing cars and other large subjects, giant softboxes known as "fish-fryers" are available. Many photographers prefer softboxes to umbrellas, as they add an attractive square catchlight to the subject's eyes when shooting portraits. Softboxes are also designed to be packed away when not in use, but this takes longer than with an umbrella.

Umbrella
This is a popular and versatile accessory.

Softbox
Placing a "softbox" over the light softens it considerably.

Snoot
This device gently directs and controls light.

INVERSE SQUARE LAW

One factor you need to consider when positioning studio lights is that as distance increases, the intensity of light is reduced according to the inverse square law.

This law states that the intensity of light radiating from the source is inversely proportional to the square of the distance from the source. So, if you double the distance between the light and the subject, the subject receives only a quarter of the light and the exposure will therefore drop by two stops. You can see how the inverse square law works from the illustration opposite.

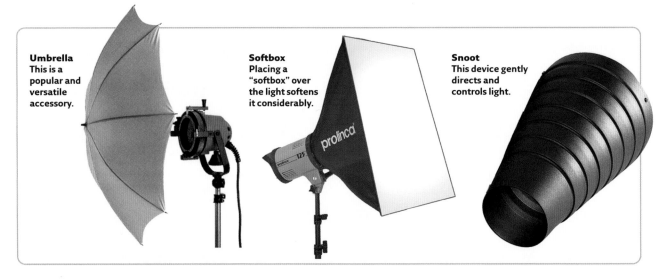

2 x distance = ¼ light
or
2 x distance = $\frac{1}{2^2}$ light

Inverse square law
This easily understood law governs rules of light intensity.

Snoots, barn doors, and reflectors

Snoots are conical-shaped attachments which funnel and focus the light so that it can be directed onto a smaller area, to highlight part of your subject—such as a model's hair. The light is not softened in any way, but you have great control over where it falls. Snoots are also widely used in still-life photography.

Barn doors consist of a frame with four hinged metal flaps. The position of each flap can be controlled independently to help you direct light on one area but hold it back from another.

One of the most versatile accessories for modifying light is the reflector, which is used to bounce light back into shadow areas. At its simplest, it is a sheet of white card. At its most sophisticated, it is a purpose-made silver or gold accessory that folds down to a small and convenient size but which can be opened up instantly, ready for use. There is even a special unit called the Tri-flector which features three built-in reflectors that can be adjusted to give perfectly illuminated portraits (see image bottom right).

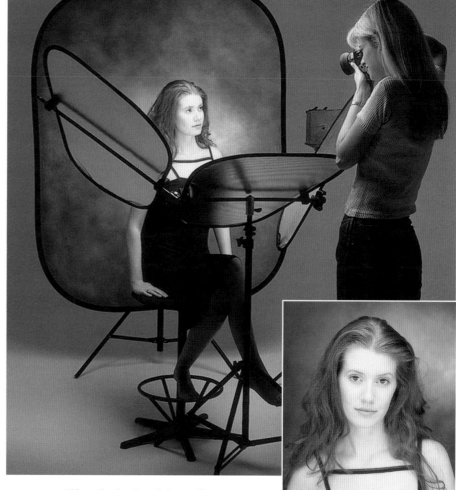

One light (top left) produces harsh illumination and ugly shadows. Adding more lights and reflectors (below) progressively creates a more flattering effect.

Barn doors
These aptly named flaps regulate the position of light.

SHADOWPLAY

One interesting technique that is worth experimenting with in the studio is placing objects in the path of the light so that shadows are cast over your subject.

Attachments known as "gobos" can be fitted to studio lights to do this, but you can mimic the effect quite easily using things like Venetian blinds to produce a series of slatted shadows.

Shapes can also be cut out of black card to mimic things like light shining through a window frame, a keyhole, and so on. Varying the distance between the light and object or mask will change the shape and size of the shadow.

PAGES 190-91: This professional studio image illustrates studio lighting at its very best. The highlights on the model's hair and face are soft and flattering.

Freelance Photography

There are few enthusiast photographers who don't dream of one day seeing their work in print—and, better still, even making some money from their hobby. The competition is fierce, but it can be done.

Fortunately, there are many markets out there in regular need of good photography, and in this age of digital technology it is probably easier now than ever before to sell your work.

The most accessible market for photography is magazines. With thousands of titles in print, covering all manner of subjects, there is bound to be something out there that suits your style of photography. Perhaps you combine photography with another hobby such as fishing, modelmaking, camping, or hill-walking? If so, target magazines that deal with those subjects; just send in a speculative submission of images—either mounted and captioned color transparencies, 10" x 8" color prints, or digital files on a CD or DVD—with an accompanying contact sheet so that the editor can see at a glance what is on the disc. You may not get an instant reply, but be patient, and who knows what might happen?

Picture libraries are another possibility. Online libraries are ideal for hobbyist photographers, as you can supply your images in digital form and some libraries even let you upload your own work. However, beware of libraries that charge contributors, and only submit work of the highest quality: garbage will never sell, and could weaken the impact of really good images.

Calendar and greeting card publishers are another favorite market for freelancers, and you will find a range of companies by doing a quick internet search.

The key here is to give the client what they want—and make sure it is top-quality material, especially for the calendar market. Look at samples in drugstores to get an idea of what different publishers want and supply more of the same. It may take numerous rejections before any work is accepted, but patience is crucial in this game. If you fall at the first hurdle, pick yourself up and try again; eventually you will strike gold.

PAGES 194–5: Group portraits do not have to be corny. By finding a real background and asking the girls not to look at the camera, the photographer has created an image with lasting appeal.

TAKE PICTURES THAT SELL AND SELL AND SELL...

Most freelance photographers find that certain images in their collection sell time and time again, to a range of different markets, while others never achieve a single sale. The market can be very fickle.

Characterful pictures of children always seem to do well (right), as do unusual or exotic landscapes, such as this scene from the Australian outback (above).

Nobody is suggesting that you go out and copy images purely to make money, but there is nothing wrong with copying a concept if it sells. It is also important to keep an eye on the type of images that seem to crop up time after time.

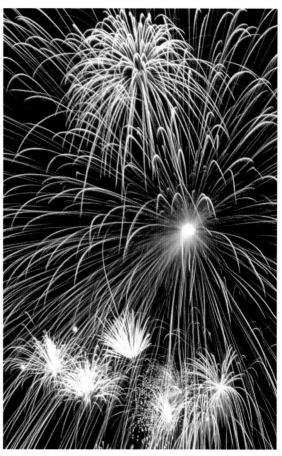

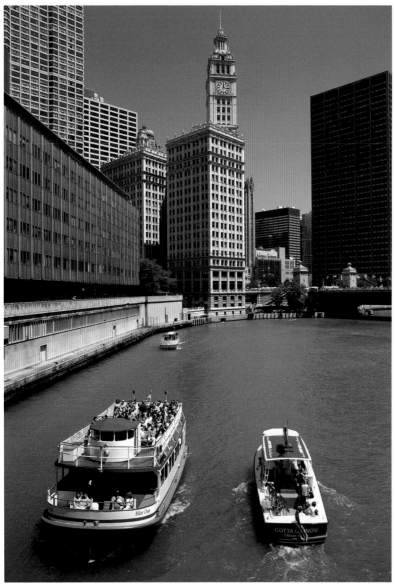

APPROACHING YOUR MARKET

The key word here is professionalism. If you are making an "on-spec" submission of images (that is, one that is not expected) ensure that it is neat, tidy, and easy to inspect, as follows:

- Do not include hundreds of images—a total of 20 or maybe 25 is sufficient in the first instance.
- Digital files should be accompanied by either small (A4) prints or contact sheets for assessment.
- Slides should be neatly mounted, captioned, and supplied in file sheets for easy viewing.

Include a covering letter on headed paper which explains why you are making the submission. Enclose a stamped, addressed envelope if you want the work back, and keep it simple so that it is neat and easy to open. Finally, give the client at least a week to contact you before you contact them.

People, places, products—along with nature, generally—these are the most popular subjects if you are looking to sell your pictures. When shooting travel, make sure that the sky is blue and the sun is shining. When photographing people, smiling faces and happy expressions are usually required.

Making Money From Photography

Do you love photography so much that you would like to earn your living from it? There are various options available if you want to become a professional photographer.

Wedding photography

One of the inherent problems of turning professional is giving up the security of a steady monthly paycheck for a more precarious and uncertain stream of income. It can take time to build up a business to the point where you are earning enough to pay all your bills. That is one of the reasons why wedding photography is such a tempting proposition. Most ceremonies take place on weekends, which means that aspiring professionals who are employed from 9am–5pm Monday through Friday can dip their toe in the water safely—only "taking the plunge" into their freelance career when they feel entirely confident that they have enough work. The good news is that wedding photography can be extremely lucrative. Providing you are not at the "bargain basement" end of the market, you can make a decent living from taking photographs at, say, 50 weddings a year.

Modern wedding photography tends to be relaxed and informal—candid shots like this one, as opposed to stiff and starchy groups neatly lined up and posed.

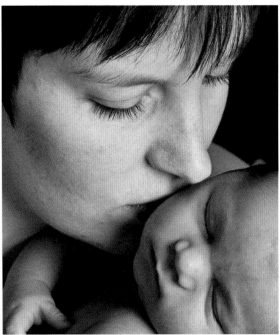

Most people are capable of taking decent snapshots of themselves and their family, but from time to time want professionally taken portraits that capture emotional relationships and special moments.

However, there is a distinct "Catch-22" situation to be faced when you are starting out as a wedding photographer. You cannot demonstrate that you are competent at shooting weddings until you have actually shot one—and at the same time you can't shoot one until you show you are competent.

Happily, there are a couple of ways around this problem. Once word gets out that you are a good photographer, sooner or later a friend, colleague, or relative will ask if you would like to take some pictures of their wedding. Maybe they cannot afford a professional photographer, or perhaps they just want a few good shots to record the day, as opposed to a full, formal wedding album? Make it absolutely clear that you cannot guarantee the quality of results—you do not want to risk ruining their day—and if they are happy with that, then go for it. If it all turns out well, you will have the beginning of a portfolio that you can show prospective clients.

If such opportunities do not come your way, another option is to get a couple of attractive friends to stage a "wedding"—hiring the dress for the "bride" and a tuxedo for the "groom." The modest investment that

you make in hiring these props, and maybe a suitable location, will easily be recouped in the first two or three real weddings that you photograph subsequently.

Of course, photographing a wedding is a serious business. There is no possibility of doing a re-shoot if something goes wrong. Consequently, only say "yes" if you feel totally confident of your ability to deliver. To be successful at wedding photography, you also need to be good with people—in fact, in this case your social skills are probably more important than your competence with the camera. However, if you are well-organized, good at working under pressure, and have strong interpersonal skills, wedding photography might be right for you.

Shooting portraits

In your quest to become a professional photographer, another option is to start taking portraits locally; there is always a steady demand for this kind of material. On this occasion, building up a portfolio is much easier. Begin by shooting family and friends for free and it will not be long before people start knocking on your door. At that point you can start charging for your services. However, don't be tempted to sell yourself too cheap. Find out what other photographers in your area are charging and then set your prices at a similar level. If you start out by pricing yourself too low, you may struggle to get up to a decent level later on.

Ideally, you will have access to somewhere suitable you can use to take the pictures. This might be a spare bedroom, a converted garage, or just a living room with all the furniture pushed back against the walls to make space for your creative efforts. If for domestic reasons the latter is not really possible, you could always consider offering a location portrait service— photographing people in their own homes or in the surrounding area.

Whichever way you decide to go, you will need some lighting equipment and the ability to use it. A couple of flash heads fired through umbrellas will be sufficient to get you started. Place them at 45 degrees to the subject and you will create soft, flattering, even lighting.

Commercial and advertising photography

There is also a steady demand for commercial photography—pictures of products, premises, and so on—although not as much as there was a decade ago. The ready availability and high quality of digital photography means that many companies now shoot "bread and butter" shots for catalogs and newsletters themselves. Most, however, know their limitations, and when they need something more sophisticated they call in the professionals. If you have the patience and creativity to produce high-quality work, you could do well in commercial and advertising photography.

If you can produce creative images of this quality—just look at the lighting—you will always find work as a commercial and advertising photographer.

chapter 7

Post-Production and Printing

Taking a picture is just the beginning. Once it has been transferred to the computer the next step is to consider how it can be improved. Many photographers now think of their PC as a digital "lightroom"—the modern equivalent of the traditional darkroom, but without the need to black out the windows or use smelly chemicals. No matter how good a picture is right out of the camera, it can always be improved—perhaps by increasing and reducing the contrast, lightening or darkening certain areas, changing the color balance, or removing unwanted elements. You may even want to go further and combine several images together or turn them into a work of art.

Digital Processing

Most of the time your digital camera will produce images which are good enough for viewing or printing right away. It uses the white balance, sharpness, and other settings selected on the camera to "process" the data captured by the sensor into the image stored on the memory card. However, while most digital camera shots are of adequate quality, they can often be improved on your computer.

Correcting exposure and colors

Incorrect exposure can lead to images which are either too dark or too light. However, as long as the fault in the original image is not unduly severe, a problem like this can normally be put right using image editing software. Similarly, your photographs may display the wrong colors. For example, pictures of people taken on overcast days or under artificial lighting often suffer from unhealthy-looking skin tones. Again, a problem like this can be put right without any difficulties on the computer after the picture has been taken.

Improving framing

It may also be possible to frame your picture more effectively in imaging software on the computer. Perhaps you did not have the time to arrange the perfect composition at the time of shooting and now wish to improve the general presentation of the

THE INS AND OUTS OF RAW FILES

RAW files offer greater flexibility and image quality because they enable you to choose certain camera settings on your computer later on, including white balance, contrast, sharpness, and even exposure compensation. You will often find that the definition and tonal range of your photographs is improved in RAW files, as well. However, RAW files have significant disadvantages, as follows:

- They take up extra space on the memory card.

- RAW files cannot be viewed or printed directly in the same way that JPEGs can. They must first be converted into an image file using a "RAW conversion" program (although many image-editing packages can now process RAW files).

- The RAW file conversion process can be time-consuming, especially with larger batches of photos.

- In addition, each digital camera uses its own proprietary RAW format, and you will need to use the camera maker's own RAW conversion software or make sure that the program you want to use can work with that particular camera's files.

FILE TYPES

Digital cameras usually save photographs as "JPEG" files on the memory card. In JPEG files the image data is compressed so that it takes up less space on the memory card. There is some slight loss of picture quality as a result, but this is rarely visible.

Some older cameras can also save TIFF files. These are not compressed. This means that the picture quality is potentially higher, though it is often impossible to tell the difference between TIFFs or JPEGs.

The main disadvantage of TIFF files is that they are many times larger than JPEGs. Mainly as a consequence of this single fact, the TIFF format is now seldom used on digital cameras. Instead, photographers looking for maximum quality are turning to the RAW format.

In RAW files, the camera saves the data captured by the sensor without processing it at all. RAW files are larger than JPEGs but not nearly as large as TIFFs. They offer the maximum image quality and image-editing flexibility, but the RAW format is only available on digital SLRs and more advanced compact digital cameras.

photograph? The cropping tool in your image editing software will enable you to cut out unwanted detail at the edges of the frame and, at the same time, you can straighten pictures taken at a slight slant. The latter is a common problem with images of landscapes and buildings, or particularly in the case of photographs of the ocean, in which the horizon is in the frame.

To give yourself the maximum flexibility for editing your images after taking them, shoot your pictures in RAW format. There are certain disdvantages to these files, but you will have the greatest choice when it comes to reviewing your pictures on the computer.

OPPOSITE: When shooting "RAW" the file becomes a kind of "digital negative," and with the right software—such as Adobe Lightroom, as shown here—every last drop of quality can be squeezed out of it. Notice how many different controls there are available to the photographer.

Correction and Manipulation Tools

The way you divide up the picture area of your photograph can have a strong influence on its impact and how it is "read" by the viewers—even though they will not be aware of this at the time of viewing.

The following is a guide to the principal tools available in most good image editing programs these days, with information about what each one can achieve. Do bear in mind that each software is slightly different.

- **Cropping and straightening tools** are often combined so that you can mark out a rectangular area ("marquee") to indicate the area of the photo that you want to keep and then rotate it slightly if the picture also need straightening.

- **The Levels dialog** will show you how the tones in your image are distributed from light to dark, using a "histogram" display. The Levels dialog has controls for adjusting the contrast range and overall brightness of your picture.

- **Curves** offer a more complex kind of contrast adjustment designed to help you optimize the shadows in your picture, the mid-tones, or the highlights. Not all image editing programs offer curves adjustments.

- **Color correction tools** come in many different forms. There may be an "auto color" option which attempts to fix the color balance automatically, a color balance window with sliders for red, green, and blue, or an "eyedropper" tool for clicking on a neutral tone in the image. With practice you will soon discern the slightly different effects that each of these options offers.

- **Red-eye correction** is often needed for portraits which have been taken using flash. Many cameras have special red-eye flash modes, but these don't always work. In most programs you simply have to click on the red eye to fix it—it really is as simple as that.

- **Sharpening filters** can make your digital photos look crisper, though over-sharpening can produce visible "halos" around objects. You can improve shots with camera-shake or bad focus, but only if the problem is not too severe.

Marquee	Move
Lasso	Magic Wand
Crop	Slice
Spot Healing Brush	Pencil/Paint Brush
Clone Stamp	Art History Brush
Eraser	Gradient
Blur/Sharpen/Smudge	Sponge/Dodge/Burn
Path Component Selection	Type
Pen	Line/Shapes
Notes	Eyedropper
Hand	Zoom
Foreground Color	Switch Colors
Default Colors	Background Color
Standard Mode	Quick Mask Mode
Standard Screen Mode	Full Screen Mode
Edit in Image Ready	Jump to Image Ready

LAYERS AND MASKS

Many image editing programs can work with images in "layers." This enables you to combine or blend different photos. You can think of each layer as a transparent sheet onto which you place an image.

Any image on a layer will normally cover up the layers below it, but you can change the opacity (transparency) of a layer and you can also erase or hide parts of the layer so that what lies underneath can show through. To erase parts of an image layer you can use the eraser tool or select an area and then delete it. With programs that offer "layer masks," though, you can draw or paint a mask to hide parts of the layer.

The advantage of layer masks is that they can be deleted or modified at any time. Layers and layer masks are not needed for regular image editing and enhancement, but they are important for special effects and more complicated creative techniques.

Every software package is different—some have features that others do not—but most are similar, both in terms of design and usage. We have used the tools palette from Adobe Elements/Photoshop (left) as an example of what is available.

Many different effects and "filters" are available in all types of image editing software which enable you to transform your photograph from something ordinary to something a little more unusual.

Much of the software offered by camera manufacturers is excellent, offering not only basic but sometimes more enhanced controls, and is more than sufficient for most users.

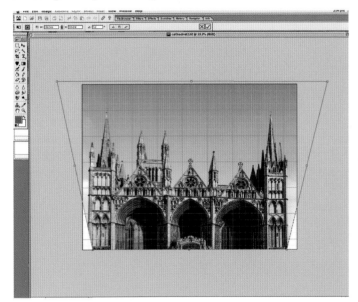

Placing a "marquee" around the part of the image that you want to work on allows you to adjust only that area. Here, the perspective of a building that appears to be leaning over is being adjusted so that it stands upright.

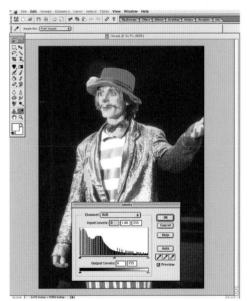

Most imaging programs feature a number of different ways of adjusting brightness and contrast. Each will offer marginally different options and effects.

You can even increase the image size by adding more pixels—a process called interpolation.

Various dialog boxes provide all the information you need about an image.

Working with Layers gives infinite control over the various elements of the picture.

Rotating, Cropping, and Straightening Images

Digital photos do not always display in the correct orientation. Some cameras have internal orientation sensors which can detect when you turn the camera on its side to take a vertical-format shot. These cameras will rotate the picture so that it displays as a vertical image. Otherwise, vertically orientated pictures will appear on their side on the computer screen and you will need to rotate them back to the vertical position.

Rotating images

Rotating images is usually very straightforward. Some image editing programs have buttons for rotating photos through 90 degrees either clockwise (right) or counter-clockwise (left). Otherwise, you will find the rotation commands on one of the menus. In Adobe Photoshop, for example, these commands are found on the Image > Rotate Canvas menu.

Images may need to be rotated by smaller amounts to correct skewed horizons or buildings which are "leaning over." Some image editing programs have "straightening" tools, with which you drag out a straight line along an object that should be completely horizontal or vertical. The software will then rotate the photo by the amount required in order to straighten it. You may also be able to straighten and crop images at the same time.

Cropping and straightening images

Images can be cropped (trimmed) using the Crop tool in your image editing software. With the tool selected, you draw out a rectangle on the image to indicate the area you want to keep. Anything outside this rectangle will be deleted (cropped). Once you have drawn the crop rectangle ("marquee"), you can adjust its position by dragging it from the center, or change its size by dragging on its corner handles or edge handles.

You may now be able to straighten the photo, also. In Adobe Photoshop and Adobe Elements, for example, if you move the mouse pointer just outside the crop marquee it will change into a "rotate" symbol. Now, as you drag the mouse pointer, the entire crop marquee will rotate.

In the "before and after" example shown on these pages, all the above techniques have been applied in Adobe Photoshop. The original image (below) was skewed to the right, was poorly cropped, and featured too much foreground. In the amended version (see opposite page), the entire image has been straightened up so that the buildings now stand upright at 90 degrees. The cropping of the image has also been improved immeasurably, with much of the superfluous foreground removed, together with extraneous parts of vehicles and the disembodied streetlight head that marred the original image.

All in all, with the application of a few quick and easy digital tweaks, what was once a faulty image is now greatly improved and well presented.

RIGHT AND OPPOSITE: Not all pictures are perfect when they come out of the camera. If they were taken in "portrait" format, you will need first of all to rotate them. Then you should check whether they need to be straightened. In this image of Chicago the buildings were not quite upright. Finally, think whether you can enhance the impact by cropping. Removing some of the foreground improves things considerably.

Correcting Exposure

The light meters built into digital cameras can measure the brightness of each scene under review and will adjust the camera's shutter speed and lens aperture to achieve the correct exposure. However, even though today's digital cameras feature extremely sophisticated exposure systems, exposure errors can still occur.

Exposure problems often arise in difficult lighting conditions, for example when the light is behind the subject (back lighting), or when you are photographing a scene which consists largely of very dark or very light tones. Classic examples of the latter might be a black cat in a coal cellar, in which case the cat cannot be easily picked out against the predominantly black background, or a winter snow scene, in which the white-out effect of the snow negates any other colors in the scene.

In such circumstances, the camera cannot differentiate the subject from the similarly colored background and can only produce a photograph of average overall brightness. With the exposure skewed in this way, in the final image the black cat will come out in a kind of pale gray color, as will the winter snow scene in its entirety.

With experience, it is possible to predict when exposure errors will occur and adjust the camera settings accordingly. Often, though, you will only find out that there is a problem when you see the photo on your computer screen and when it appears to be too late to do anything about it. However, one of the great advantages of digital photography is that many exposure errors can be rectified very effectively using image editing software.

LEVELS

A poor, dark image of a wheel hub (above) is massively improved by adjusting the levels in image editing software (left).

The histogram in the Levels dialog box above demonstrates why this photo looks dark. The histogram tails off long before the right-hand end of the scale, which means that it has few light tones. The image is crying out for adjustment.

Moving the "white point" slider below the histogram so that it lines up with the end of the histogram, you can expand the photograph's tonal scale so that it has proper highlight tones.

You can also move the "midtone" slider to the left to increase the photograph's overall brightness. Now the colors and tones in the picture have been restored.

CURVES

This image of a statue (above) is enhanced through the use of Curves (left).

You can adjust Curves in Adobe Photoshop and some other image editing programs, and you do this when you want to adjust brightness, contrast, or both in a single action.

You can brighten this photograph by dragging the curve upward from somewhere near its center. This increases the brightness of the shadow areas and midtones.

If you drag the left-hand end of the curve down you will darken the shadows again, and this steepens the curve in the midtones. This increases contrast in the image.

BRIGHTNESS/CONTRAST

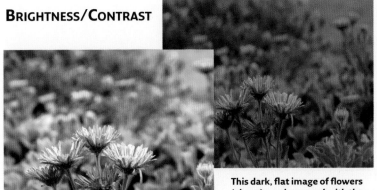

This dark, flat image of flowers (above) was improved with the Brightness and Contrast tools in the editing software (left).

This photo is quite dull and flat-looking. You can correct this using these simple Brightness and Contrast sliders, which work just like those on a television set or a computer monitor.

Begin by increasing the Contrast. This pushes the light and dark tones in the image farther apart. Be careful to avoid large areas of solid black shadow or washed-out highlights.

Increasing the Brightness value improves the photo still further. The disadvantage of the Brightness/Contrast controls, though, is that they tend to produce coarse shadows and highlight tones.

Dodging and Burning

Many traditional darkroom techniques can be duplicated using image editing software. One of these is "dodging and burning." Parts of the photograph can be lightened during the printing process by shading ("dodging") them during part of the print's exposure under the enlarger. Other parts can be darkened by giving them extra exposure ("burning in").

Both Adobe Photoshop and Elements and other manufacturers' image editing programs offer Dodge and Burn tools for recreating this darkroom effect digitally. You can match the sizes of the Dodge and Burn "brushes" to match the area you want to adjust, and also the strength of the effect, or its "exposure."

This sunset scene has a good sky but the beach in the foreground is too dark. By using Photoshop's Dodge tool you can lighten the beach by "brushing" over it. Using a large brush size ensures that the "dodged" area blends well with the rest.

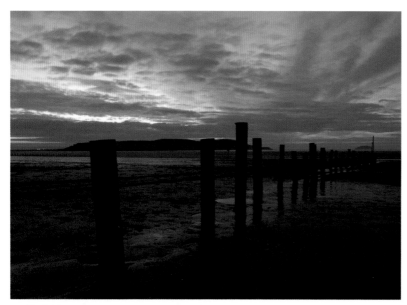

Before

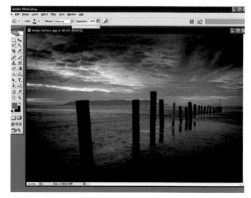

To focus attention on the center of the frame, use the Burn tool to darken the top of the sky and the bottom corners. The Exposure value here is set to 100 percent, but smaller values enable you to build up the effect more slowly.

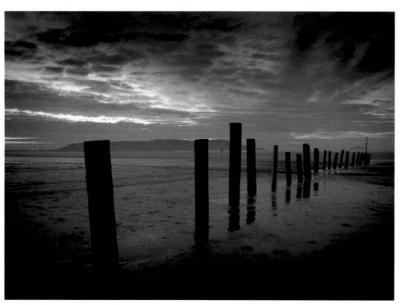

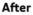
After

Photoshop and Elements also provide a "Sponge" tool. This can be set to add or reduce color saturation. Here, it has been used to intensify the colors in the sky and the wet sand on the beach.

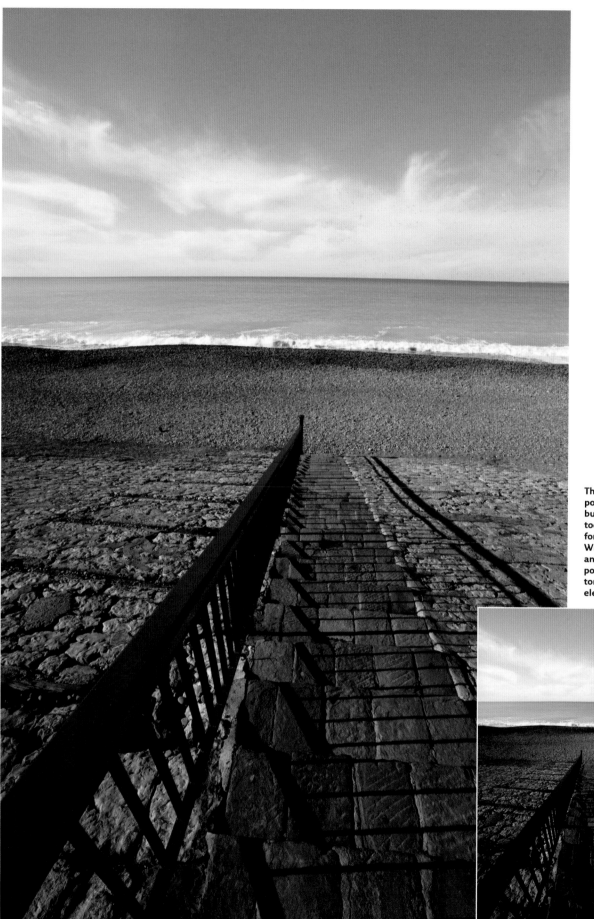

This picture showed potential (below), but the sky was too light and the foreground too dark. With careful dodging and burning it was possible to balance the tonality of the various elements (left).

Adjusting Color

One of the great advantages of image editing software is that it enables you to alter the colors in your digital images almost at will. However, it is always a good idea to keep a copy of the original image before you begin editing colors, as it can be very easy to go too far with this feature.

Why adjust the colors in your image?

You may wish to alter the colors in your digital photos for a number of reasons. It may be that the original colors in your images simply lack the intensity that you were hoping for. This can often happen when pictures have been taken in overcast lighting. Enhancing the exposure and contrast can often restore full intensity to the colors, but if this does not work you can increase the saturation of the image. In Adobe Photoshop and Elements, the Saturation slider is found in the Hue/Saturation dialog. You should avoid increasing the saturation value beyond 30–40, though, because this can introduce digital noise

(speckling) and artificial-looking solid areas of color in the adapted image.

Sometimes the colors in your photograph might just look "wrong." Digital cameras feature "auto white balance" systems which can analyze the color of the light and correct it to produce neutral colors. This gives digital cameras a major advantage over film cameras, because film has a fixed response to color and is more likely to show unwanted color casts. However, despite this extra flexibility, digital cameras do not always get it right. You will often find that portrait shots taken in shade or on overcast days have an unhealthy-looking blue cast, while photographs taken under artificial lighting may look very

Is this fire truck red or is it in fact blue? The following step-by-step sequence shows how you can create such a striking "before and after" effect.

In this step-by-step sequence we are using the Replace Color option in Photoshop. This is available in Photoshop Elements, as well. First, you need to click on the color you want to replace. This is the red cab of the truck.

Now, you adjust the Hue slider to change the color and, if necessary, the Lightness and the Saturation of the replacement color as well. Clearly, though, there are still some red areas visible in the truck.

The range of red tones currently selected is clearly not yet wide enough. There are two ways to put this right. You can shift-click on any remaining red patches to add them to the range selected, or you can increase the "Fuzziness" value.

This picture of traditional houses in Frankfurt, Germany, is pleasant enough, but because it was taken in the middle of a summer's day there is an unattractive blue cast over the entire image.

Using the "Color Balance" option removes the blue cast and brings it back to neutral—making the picture look much nicer and more natural.

yellow. Fortunately, color casts like these can be corrected in image editing software using color balance sliders, eyedroppers for clicking on objects which should be colored in a neutral tone, or with "white balance" sliders. The specific color correction tools available will depend on the software that you are using.

Finally, you may wish to change certain colors deliberately. For example, you could give your car an instant respray, or change the color of your partner's coat. These color "makeovers" can be fun, but there is a serious side to doing this sort of thing, also. This is because many shots are spoiled by clashing colors—such as bright clothing worn by a passerby in a landscape photo, for example, or a single out-of-place bloom in a vase of flowers. The good news is that, with its unsurpassed optical dexterity, digital image editing software enables you to fix nearly all problems like these quickly and easily on your computer.

Adding a little "warmth" suggests that the picture was taken later in the day (even though the shadows indicate otherwise), and overall it is a lot more pleasing to the eye.

Eliminating Unwanted Elements

You can remove unwanted objects from your photos using "cloning." In principle this is a fairly straightforward process, although it does require a fair amount of skill and practice, and there are limits to what can be achieved while still maintaining a successful image.

What is cloning?

Cloning is like copying one area of an image and pasting it down over another. However, rather than using cutting and pasting operations, cloning tools constantly copy pixels from one area (the clone "source") and paste them down over the area of the image that you are repairing.

Before you start, you must identify this clone "source" area. In Adobe Photoshop and Elements, you "Alt-click" where you want the pixels to be copied from.

Useful cloning tips

It is possible to clone over an area in the image with a single movement of the brush, but in practice this seldom gives the best results, especially if you are trying to clone over quite large areas.

In fact, it is better to "dab" with the brush or make quite small brush strokes and build up your repair slowly.

Now and again you should choose a new clone source. This will avoid the appearance of repeating patterns and details—one of the dangers of cloning.

Before: A nearly great image is spoiled by the lizard tail impeding the mid-ground.

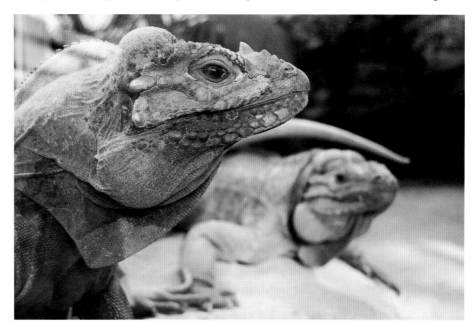

In this photograph of a lizard, the tail of another animal in the background appears below the lizard's jaw and is a distracting element. To improve the image, it would be a good idea to clone out this tail. You need to make sure that you do not clone over the jaw itself, though, and to avoid this you should place a selection over the precise area that you wish to repair.

Firstly, define the "clone source" by Alt-clicking" on an area of the background that you want to use for the repair. Now move the mouse pointer over the tail and start brushing it out. A set of crosshairs indicates the area of the background being used for the repair. The "source" crosshairs move in step with the brush, showing you exactly where you are making the repair.

You can clone right up to the jaw of the lizard, because your selection protects it from your clone brush. Elsewhere, you simply need to make sure that the clone brush does not get too near the out-of-focus lizard in the background. With just a few moments' work you can create a completely invisible repair. Just be careful not to inadvertently mess up any other part of the image as you make a repair like this.

Change the brush size

You may find it useful to change the size of the clone brush, also. A large, soft-edged brush is ideal when you are cloning over areas with even tone, or subtle tonal changes. Blue skies are a typical example. A small brush or one with a hard edge can leave a visible join between the repaired area and the rest of the photo, so be careful which size you select. On the other hand, when you are cloning over areas with strong textures or details, a soft-edged brush may introduce some overall softening that looks rather obvious once the repair is complete. In cases like this, a harder-edged brush will generally give better results.

After: Anyone viewing this amended version of the image would never have a clue that it was once ruined by an errant lizard's tail!

REMOVING DUST SPOTS

Dust can be a problem if you are scanning prints or negatives with a scanner that does not have built-in dust removal tools. It can show up as black specks on the photograph if you have scanned a print or a transparency, and as white specks when you have scanned negatives. You can also get dark spots on pictures taken with digital SLRs, caused by specks of dust on the sensor.

Fortunately, Adobe Photoshop and Elements have a Spot Healing Brush tool that makes removing dust spots easy, and other programs may offer something similar.

The Adobe Spot Healing Brush works by taking pixels from the area around the brush. You can simply "dab" on spots to remove them, or adopt a more subtle approach by brushing over hair marks or scratches. Usually, the repair is quite invisible.

Dust spots can be removed quickly with the Spot Healing Brush tool in Adobe Photoshop and Elements.

Sharpening

In most cases, a good image is a sharp image—one in which the various elements that make up the photograph are clearly delineated and crystal clear to the viewer's eye. However, sometimes unintended blurring can ruin an otherwise strong picture—unless it is corrected.

Going soft

Digital photographs can sometimes look a little "soft"—that is, the detail in them is not defined quite as crisply or as clearly as it should be. There can be a number of reasons for this. All cameras sharpen photographs as they process and save them to the memory card, but some models are very conservative and do not apply enough sharpening at this stage. Some photographs exhibit camera-shake or focusing errors, and these problems will also make them appear less sharp.

To sharpen or not to sharpen?

Some photographs are blurred beyond repair, and can never be sharpened up satisfactorily. With experience you will be able to distinguish between shots which can be improved and those which should simply be discarded.

All image editing programs offer sharpening tools, and usually more than one. The panel below explains the differences and which one is best for specific circumstances.

It can be quite difficult to pick the right degree of sharpening, and the process itself can produce some undesirable side effects which reduce the overall picture quality. Side effects of sharpening include visible edge "halos" (white outlines) around objects and an increase in digital "noise" (speckling). Keeping the side effects to a minimum is one of the skills needed for effective image sharpening.

You apply sharpening settings using dialogs displayed on the screen; however, your monitor is not necessarily the best guide to how much sharpening you need. This is because you will often find that the settings needed to produce really crisp-looking prints can look too strong on the screen. Do some test prints to get a better idea of the settings to use with particular cameras and print sizes.

SHARPENING TOOLS

All image editing programs include sharpening tools, and usually more than one. The choice can be confusing, and so can the terminology. The main tools are named as follows, offering a variety of different features:

- The "Sharpen" filter found in Adobe Photoshop, Elements, and other programs is the most basic image sharpening tool. This has no settings, applying the same sharpening process to all images. It is particularly effective at adding a bit more "bite" to images from a digital camera.

- The "Unsharp Mask" filter is more complicated to use, but it also offers more control over the sharpening process and its side effects.

- The "Amount" slider adjusts the overall strength of the sharpening.

- The "Radius" slider controls how far either side of an edge the sharpening process is applied (this is related to edge "halos").

- The "Threshold" value can be used to control any increase in noise.

The right amount of sharpening results in a picture that is crisp and detailed but not overly so. If it looks *too* sharp, it probably is. Don't overdo this technique.

Sharpen None

This photograph looks a little "soft." It was taken indoors at a high ISO and a slow shutter speed that has produced a little camera-shake. However, the degree of blur is minor, and it can be disguised very effectively with the Unsharp Mask filter.

Sharpen Too Little

These settings have slightly improved the sharpness of the photo and it does look sharper on the computer screen. However, the sharpening is too mild, and if you print this photo out it will not look very much sharper than it did in the first place.

Sharpen Too Much

It is just as easy to oversharpen photos as it is to undersharpen them. Here, the high Radius setting has produced a stronger sharpening effect, but it has also produced prominent edge "halos." These have been made worse by the high Amount value.

Sharpen Just Right

For successful sharpening you have achieved enough sharpening to produce crisp-looking prints but without harming the image quality. Here, a Radius value of 1.6 pixels and an Amount value of 250 percent is just about right, and the Threshold value of 3 limits any increase in digital noise.

Converting to Mono

Black-and-white photography remains popular, despite the fact that color is much more "real" to look at. The enduring appeal of black and white in photography may be due to a number of factors.

Why shoot in monochrome?

Many people like black-and-white—or "monochrome"—photography because it has a timeless quality. Black and white photos often have an aged look about them that makes them feel like real mementos, even if they were only taken last week! Additionally, black-and-white images have a powerful, graphic simplicity that is much more difficult to achieve with color. Finally, black-and-white photographs are obviously more "disconnected" from literal reality, and this can make it easier to produce more meaningful and thought-provoking pictures.

Converting color into grayscale

Turning a color shot into a black-and-white image is very simple indeed. All image editing programs have a "grayscale" mode which converts colors into shades of gray. This generally works well, though the results can sometimes look a little flat and lifeless.

Some photographers reduce the saturation value of the photograph instead, effectively eliminating all the color information and simply leaving shades of gray. The results are subtly different from those you get from converting the image to a standard grayscale. The saturation-reduction conversion is generally more sophisticated and can separate colors into different tones a little more effectively.

There is a third option for conversion from color to black-and-white which is available in Photoshop and some other image editing programs, but not Photoshop Elements. This is the Channel Mixer, which enables you to mix together the three color "channels" in the photo—Red, Green, and Blue—as the image is converted to black

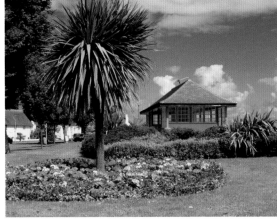

RIGHT: The original picture, from which we want to create the best possible black-and-white image.

FAR RIGHT: The end result—a monochrome image with a full range of tones.

The Channel Mixer dialog is used to adjust the relative strengths of the red, green, and blue components of the photograph. To produce a black-and-white image you need to check the "Monochrome" box at the bottom left.

This produces the effect of a strong red filter in black-and-white photography. It dramatically darkens blue skies, but it is a little strong for landscape shots like this one. Instead, try increasing the Green and Red percentages simultaneously. This is similar in effect to a yellow/green "landscape" filter.

Ideally, the percentages of the Red, Green, and Blue should add up to around 100 percent, or you may find that the highlights are "muddy" or bleached out. Here, values of 70 percent for both Red and Green have been used, together with a negative value for the Blue to bring the overall brightness back under control.

and white. This means you can replicate the effect of the red, yellow, and green "contrast" filters once used for black-and-white photography.

In the guide to the Channel Mixer found on the opposite page, you are shown how this feature can be used to subtly darken a blue sky while lightening green vegetation. This produces a much more pleasing balance between the tones in the foreground and the sky than you would get from a simple grayscale conversion.

TOP LEFT: A low-contrast tonality provides maximum detail but the image lacks power.
TOP RIGHT: Increasing contrast slightly adds depth. The eyes in particular stand out more.
BOTTOM LEFT: When there is a full range of tones, from black to white, pictures have plenty of "bite."
BOTTOM RIGHT: Cranking up the contrast gives plenty of impact—but highlight and detail begin to get lost.

PAGES 218–19: Black-and-white photography enables you to create amazing tonal effects and contrast in your images when used on the right subjects.

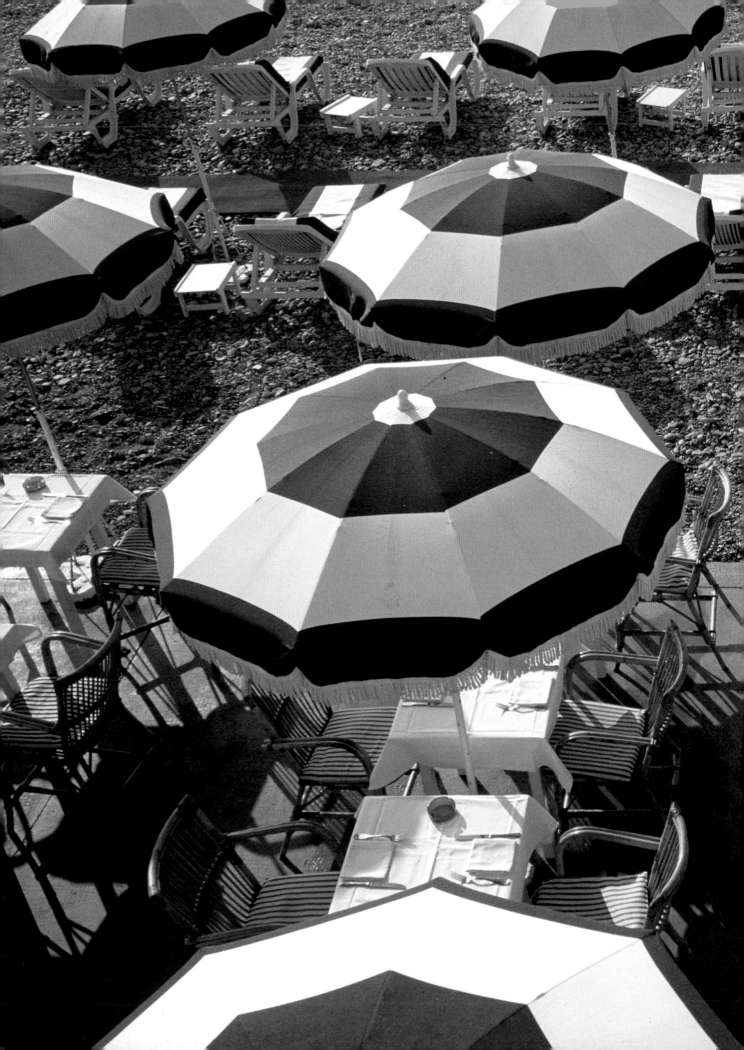

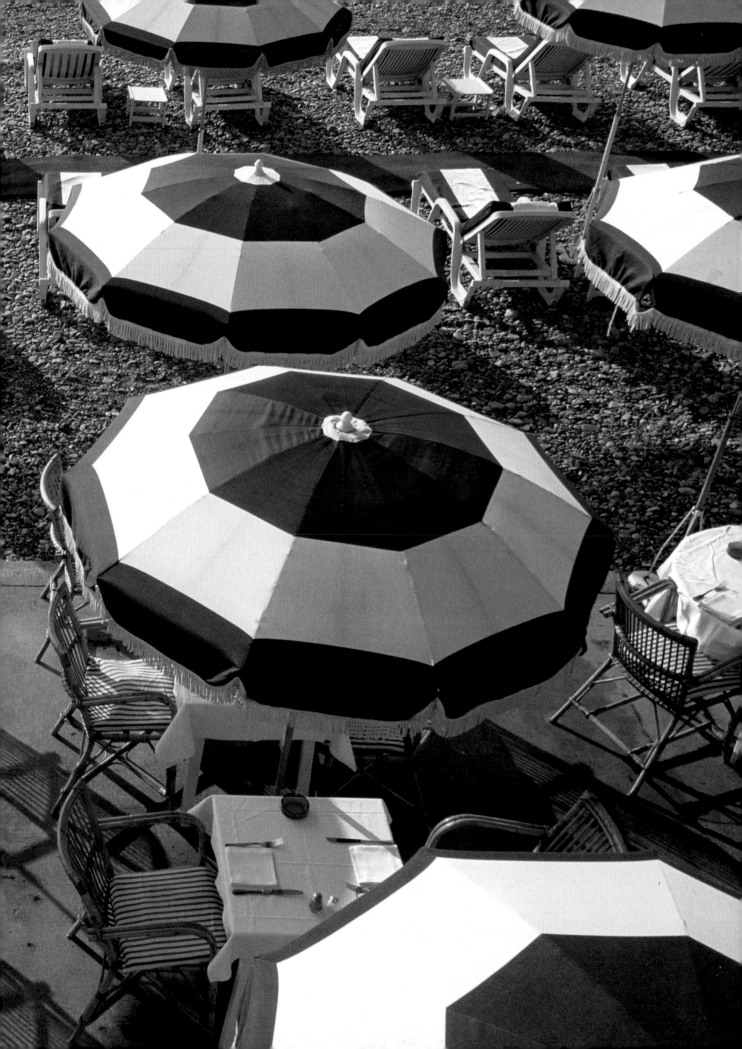

Toning (Sepia/Duotone)

Black-and-white photographers have long used "toning" to improve both the appearance and the longevity of black-and-white prints. Toners may be used to add warmth to portrait shots or nostalgic landscapes. The classic example is sepia toning, which gives a characteristic brown, "aged" look. "Cold" scenes such as winter landscapes may benefit from blue toning to emphasize the feeling of cold.

"Wet" toning in the traditional black-and-white darkroom can be a messy and complex process involving a variety of chemicals. However, digital images can be toned in just a few moments using an image editing program.

The easiest way to do this in Photoshop and Elements is to use the Hue/Saturation dialog. You need to start from a full-color image rather than a grayscale photo. If you are starting with a grayscale image, you will need to convert it to RGB mode.

In the Hue/Saturation dialog, check the "Colorize" box. Now move the Hue slider to try out different colors. A value of 32 will give you a realistic-looking sepia tone, while a value of around 225 will produce a good blue tone.

You can increase the Saturation value, but toning effects rely on subtle coloration, so using the Saturation slider to excess will usually do more harm than good to your image.

Tritones are easy to control and to create. CLOCKWISE FROM BOTTOM LEFT: The original shot in full color. Converted to monochrome. Given a green duotone treatment. The Tritone effect, using black, blue, and orange.

PRODUCING DUOTONES

Duotones are used by the printing industry to both "colorize" photos and to lend them an extra depth and richness—this comes from using an additional ink to supplement the black ink. In Adobe Photoshop you create duotones from grayscale images via the Image > Mode menu. You are prompted to specify an additional "Pantone" ink color. Pantone inks are standardized within the print industry.

Understanding how Pantone inks work is not necessary if you simply wish to recreate a toning effect—instead, simply choose a suitable color from the drop-down Pantone menu. The black and the extra "ink" are mixed to produce the toned image. The default mixture values are generally about right, but you can tune them by clicking the Duotone Curve box to the left of the "ink" you want to modify. Dragging the center of the curve downward will weaken the ink's effect, while dragging it upward will intensify it.

In Photoshop you can select the color in duotone options and adjust the curve to change the ink usage.

CLOCKWISE FROM TOP LEFT:
This is an appealing
monochrome image—
but what else could be
done with it? Adding
blue gives a cool feel.
Going sepia gives the
image an "olde-world"
appearance. Any color
is possible, and
whether you like it or
not is simply a matter
of personal taste.

Blurring the Background

Photographers make so much fuss about sharpness and definition in their images that it might seem strange to talk about deliberate blurring. The fact is, though, that many photographic effects rely on contrast, and your main subject will appear all the sharper if it is set against an out-of-focus background.

Deliberate blurring

A blurred effect is not always easy to achieve at the time you take the photograph, but you can apply one relatively easily later on in your image editing program on your computer.

The key to the process is to make sure that only parts of the image are blurred and not the main subject itself; you can do this by using the selection tools. Alternatively, it may be easier to select the main subject and then "Inverse" the selection. When your subject has a clear outline, the Polygonal Lasso tool in Adobe Photoshop and Elements is the most effective accessory to use.

It is not always necessary to be precise with selections, and after all these can sometimes produce hard and obvious "joins" in the adjusted photograph. Instead, make a rough selection with the Freehand Lasso tool and apply a "Feather" of around 50 pixels to soften the selection edge and "fade in" the blurring effect over a larger area.

Once the area you want to blur is selected, you can then use the Gaussian Blur filter. The strength of the blur is adjusted with the Radius slider. A value of five pixels is about right if you want the background to be blurred but still more or less recognizable.

Although the main subject in this picture (top right) was strong, the background was too sharp and distracting. Selecting it and applying blur (bottom right) results in an image where the person really stands out (opposite page).

MOTION BLUR

You can also blur pictures in a single direction to create the impression of movement. For example, you can suggest the speed of a race car by selecting its background and applying "motion blur" in the direction of the car's travel. You can find the Motion Blur filter on the Filter > Blur menu in Adobe Photoshop and Elements. Again, the amount of blur is entered in pixels, but there is also a control for adjusting the angle, or direction, of the blur.

However, even this method is not convincing for rotating objects, like wheels, or the kind of blur produced by an object moving toward the camera. To create these effects you need the Radial Blur filter. This has two modes: Spin and Zoom. Use the Spin mode to blur the edges of a spinning wheel and the Zoom mode when you want to make it look as if your subject is rushing toward or away from the camera.

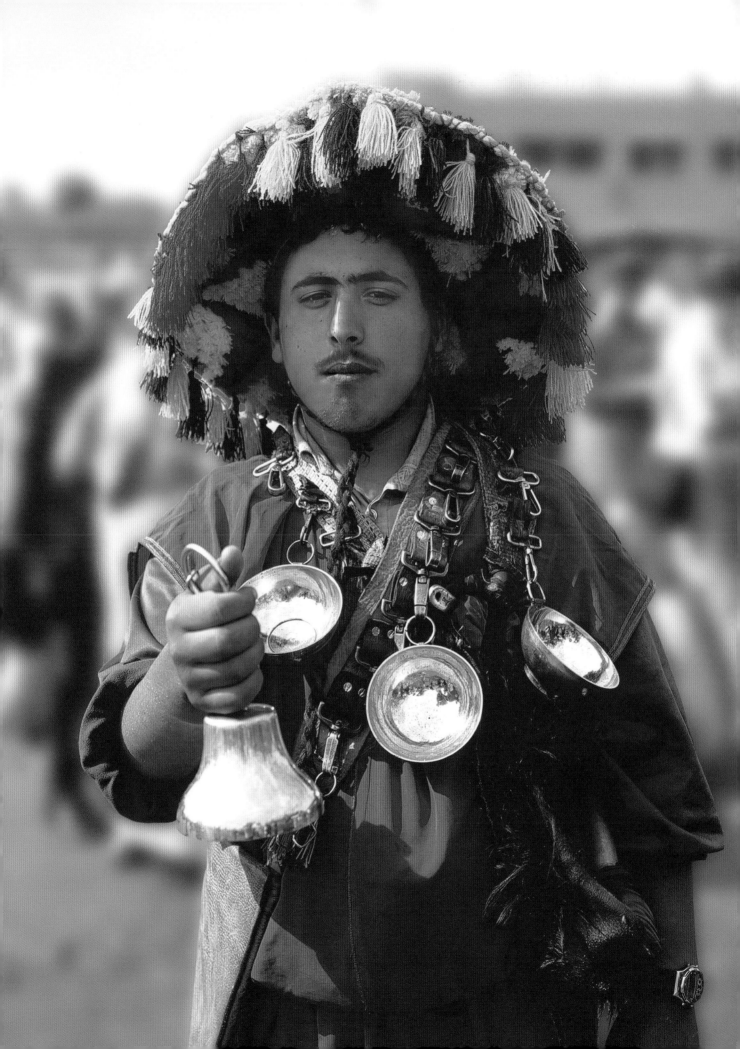

Traditional Photo Effects

Digital photography does not have a monopoly on special effects. Many traditional darkroom effects are just as striking and effective today as they have always been. In fact, it can be difficult to reproduce these effects digitally in a way that is convincing.

Solarization

Solarization produces photographs that look like a mixture of positive and negative images. Darker areas and midtones have a normal appearance, but lighter areas and highlights are darkened. Solarized images have a brooding, theatrical, unreal look that is very compelling. This effect is achieved by briefly re-exposing the film or the print (usually the print) partway through the development process.

Lith

Lith prints exhibit high contrast, dense shadows, and soft, ethereal highlights. Their look is unique, captivating, and quite difficult to repeat consistently. Lith prints are made by overexposing a conventional print and then using a special "lith" developer.

Infrared

Infrared film comes in both black-and-white and color versions, but most infrared photographers choose black and white. Differences in the infrared part of the spectrum mean that blue skies darken to near-black, while vegetation takes on a white, ethereal glow. Infrared film is tricky to handle and shoot with, but the results can be mesmerizing.

Sabattier

This effect was first described by Armand Sabattier in 1862 and is named after him. It is very similar in nature to solarization. The effect is accomplished by re-exposing the film or print to light during the development process, then continuing development in the dark. The re-exposure to light causes a reversal of some of the image tones and the deposit of silver along those lines where strong areas of white meet strong black areas.

Cross-processing

Cross-processing is the deliberate use of the "wrong" chemicals to develop a film. Typically, color negative chemicals might be used to process or color slide film, or slide chemicals used for color negative film. Cross-processed films have characteristically distorted colors and often feature high contrast, also. The effects vary according to the films and chemicals used.

Reticulation

Reticulation is a coarse, grain-like effect or, in extreme cases, a fine "cracked" pattern. It is caused when the temperature of the chemicals changes abruptly during processing—for example, when using excessively hot water or cold water to wash the film after development.

It's easy to replicate traditional photo techniques on the computer in your image editing software. We used this attractive portrait of a young woman as a starting point.

Increasing the contrast and saturation, and playing with the curves control, gives a "cross-processing" kind of effect.

Adding grain only takes a few seconds, but replicates the effect of using a high-speed black-and-white film.

Using the Solarize filter produces a dramatic effect —though it may not be entirely to everyone's taste.

Moving the Contrast and Brightness sliders to remove intermediate shades of gray produces a dramatic "Lith" effect.

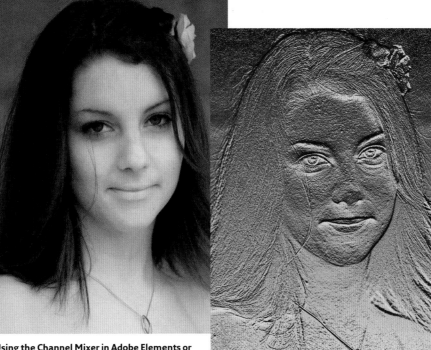

Using the Channel Mixer in Adobe Elements or Photoshop allows you to increase the "red" in the mix to give a pseudo-infrared effect.

This unusual embossed effect is called Bas-Relief. It was difficult, if possible, to achieve using film.

Changing Backgrounds

Cutting the subject of a picture and placing it against a new background is nothing new—but in the days of film you had to use scissors or a scalpel, and it was pretty obvious you had done it. However, nowadays with digital imaging it is relatively easy, and the results can look extremely convincing.

Digital wins again

Image editing software enables you to produce much better cutouts of your images. It still requires a certain amount of skill and practice, but with the right subject matter and the right technique, you can get rid of unwanted backgrounds and place objects against a completely new backdrop. This is made possible by the use of Layers and Selections—features which are available on most imaging programs.

Using various selection tools you can precisely delineate a subject and then erase the background. Having placed the resulting "cut-out" subject on one layer, you can then add another, on a different layer.

To be successful in bringing elements together in this way you need to follow a few simple rules. Firstly, make sure that the resolution of each image is the same—many people use 300dpi, which is the standard resolution for printing books and magazines.

You should also choose images in which the lighting direction is the same, if you want the end result to appear realistic. Finally, you should "feather" the main subject, so that the edges do not stand out starkly from the background. The series of images opposite will give you an idea of what can be achieved.

Once you get the hang of cutting the subject out from the background you will be able to make changes relatively quickly. However, if you plan to do this kind of work regularly, it might be worth investing in dedicated software, such as Corel Knockout, which helps to automate this particular task.

The girl's expression on the original picture was great, but the background of the image was rather dull. Using the lasso tool to trace carefully around her body, a "cut-out" was produced that could be placed on a separate layer.

The cut-out image on the separate layer was then combined with other existing images to create a range of background effects, from balloons to jelly beans and roses.

Artistic Filter Effects

Never learned to paint when you were at school? No problem. Image manipulation software lets you express your artistic side at the click of a mouse. There is a plethora of tricks and effects you can apply to your images, and nearly all of them are easy to learn.

PAGES 230–31: Most image processing/ manipulation programs feature a range of filters that enable you to transform regular photographs into works of art at the click of a mouse.

Ever wanted to have a go at watercolor painting but never got around to it? Now you can do it quickly and easily in the computer, using a photograph as your starting point. And the results can be spectacular. Most popular image editing programs feature a wide range of "filters" that enable you to enhance your images artistically. Some are subtle, others more dramatic.

The effects shown here are just a small sample of what is available—so you will never get bored. There is bound to be something that suits any image you have. You can even combine filter effects on the same image —as many as you like—to produce something utterly unique to you. The only danger in the whole process is getting overly carried away and making the effect more important than the content of the picture itself.

Total control

Getting the result you want could not be easier. Most of the filters in your image editing software will offer an enormous amount of control, so you can adjust the effect until it is just right. If you take a wrong turn and decide you do not like what you have just done, you can simply undo it and try something else.

When you first start using filters, you may feel like a kid in a candy store—you want to try everything. However, after a period of experimentation it is likely that you will find certain filters that you like, and come back to them time after time. Many people only ever use a tiny percentage of the techniques that are available to them in what is increasingly sophisticated computer software.

This is the original image, without an artistic filter applied. This is the same image, with a Watercolor filter applied.

In this version, a Conté Crayon filter has been applied.

In this case, a Glowing Edges filter has been applied.

For a very grainy effect, here a Craquelure filter has been applied.

Finally, in this version of the image a Glass filter has been applied.

Combining Images

Placing objects against a new background is just one of the tricks you can use in image editing software. In fact, you can go a lot further than this, combining any number of images in much more subtle ways to produce very striking images.

Layer masks and blend modes

This is all made possible by image layers, and the many different ways in which these layers can be combined. Two features in particular make layers as powerful as they are: layer masks and blend modes.

You can hide parts of a layer simply by selecting the unwanted area and then deleting it. However, this is a one-way process that cannot be modified later. With a layer mask, you do not actually delete any part of the layer. What the mask does is identify the parts of the image that you want to hide, and masks can be modified later. Bear in mind that not all image editing programs offer layer masks; Adobe's Photoshop does, but the more basic version, Photoshop Elements, does not.

In the composite image on this page, a layer mask was used to hide the blue sky in the layer containing the tower so that a different sky on the layer below showed through.

Blend modes control the way that an image layer interacts with the layer beneath it. In the default "Normal" mode, the layer simply covers up the one below. However, in the "Color Burn" mode, the layer becomes transparent but, at the same time, it modifies the colors of the layer below.

This effect has been used in the composite image below. The top layer is a photograph of a cracked rock surface. The Color Burn blend mode has superimposed the rock texture on the image below and, at the same time, intensified its colors.

Three separate photographs were used to make this composite image. A layer mask hides the blue sky in the shot of the tower, while the Color Burn blend mode superimposes the rock texture in the top layer over the rest of the image.

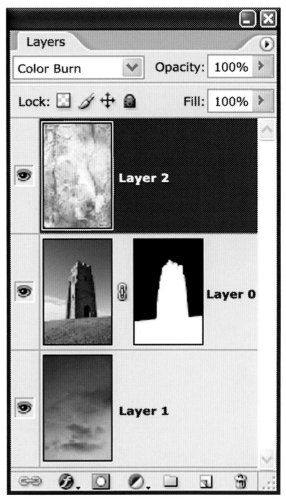

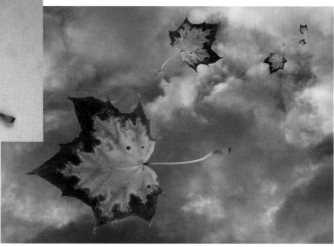

In order to combine the two images at the top left and center of this page, firstly the two photographs must be "layered." In Photoshop and Elements, this means opening both at the same time and then dragging one on to the other. Now, the "leaf" image has become a new layer on top of the "sky" picture. At the moment it obscures it completely.

Our next job is to select and delete the leaf's background. Because it has a clear, sharp outline, the Magnetic Lasso tool is the best tool for the job. Once the whole leaf is selected, the selection must be "inverted" so that now it is the background that is selected.

When the background is deleted, the sky shows through and the leaf appears to be floating in mid-air. We can duplicate the "leaf" layer any number of times and use the "transform" tools to rotate the copies and change their sizes and positions so that it appears there are many leaves falling from the sky. This creates a stunning visual effect remarkably quickly and easily.

TOP TIPS FOR COMBINING IMAGES

- Collect useful backgrounds and textures such as skies, wood grain, rocks, and fabrics. These can add texture and richness to composite images.
- Experiment with the selection tools when deleting backgrounds or cutting out objects. Each tool has its own strengths and weaknesses.
- Use layer masks to cut out shapes if your image editing software offers them. Layer masks can be modified or deleted at any time, giving you valuable flexibility later on.
- Try out the different blend modes when combining image layers. Many fantastic digital effects have been discovered by accident.
- Save your layered images in your image editor's own file format (the .PSD format for Photoshop, for example), so that you can return later and experiment with different effects.
- Keep notes about how you achieved an effect you are especially pleased with. If you do not, you can be sure you will soon forget how you did it!

Printing Digital Images

These days you can produce superb, high-quality prints from a desktop photo printer in your own home or office. And yet there are still many main-street and online photo laboratories which will offer to produce prints for you. Which should you use?

Home or away?

The choice comes down to cost and convenience. Home printers are much more convenient because you can produce prints immediately. You can also check the quality of the output and precisely control the print size and how the photograph is cropped. All in the familiar surroundings of your own study or home office.

Printers come in several sizes. The smallest produce 6" x 4" snapshots. Most photographers choose larger letter-size printers, though, because they are more flexible and no more expensive. Tabloid-paper-size printers usually cost more than twice as much, so they are usually selected only by enthusiasts.

Desktop photo printers can be expensive to run, and if you have a large number of photos that you want printed—from a vacation abroad, for example—using an online service or a street photo lab will prove a much cheaper option.

Another advantage of photo laboratories is that they can offer bigger prints than even a tabloid-paper-size desktop printer can provide, including special "panoramic" print sizes and textured paper types that it would be uneconomical to buy for occasional home use.

COLOR MANAGEMENT

One of the most common complaints made by photographers is that the colors produced by their printer do not match those displayed on the screen.

Each monitor and each printer will tend to reproduce colors in its own characteristic and subtly different way. This is simply a reflection of the different manufacturing processes, components, and designs in use. Surprisingly, perhaps, it is usually computer monitors rather than printers that are the weak link in the chain. Having said that, it is possible to calibrate your monitor so that it produces the correct colors.

Color calibration can be effected using a software program such as Adobe Gamma, which is installed automatically with Photoshop or Elements. With Gamma, you visually compare colors on the screen to produce a "profile" for correcting the monitor's color.

Hardware calibration kits offer an even more accurate option. In this case, a color-measuring instrument is placed on the monitor during the calibration process. Again, a color "profile" is produced to correct the monitor's colors.

PAPER TYPES

If you have your photos printed commercially, you can leave it to the lab to choose the appropriate type of paper. However, if you are printing at home, it is important to understand the various choices of paper on offer. In order to produce top-quality photos, printers need to use specially designed "photo" paper. This is because ordinary paper cannot absorb enough ink or control the spread of the ink properly, which is why photo prints on plain paper lack contrast, saturation, and definition.

Printer manufacturers also supply photo papers. These are specially "tuned" to the characteristics of the printer and can be relied on to give good results. However, you will get a wider choice of papers from third-party manufacturers, and the results can be just as good. Photo paper comes in several finishes. "Glossy" is the most popular, but "Matt" and "Satin" papers can work well with different kinds of images. Some paper makers can also supply textured "art" papers.

When it comes to choosing inkjet paper there is a tremendous range available—everything from glossy to textured, in a variety of different weights and thicknesses.

ABOVE, LEFT AND RIGHT: There are various color management systems on the market which allow you to match what you see on the screen with what comes out of your printer.

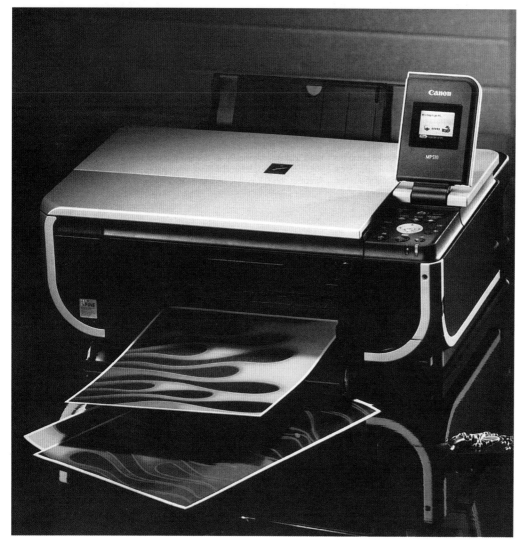

Sophisticated inkjet printers are now available that enable you to produce photographic-quality prints without the need either to go to a processing outlet or even to have to spend exorbitant amounts of money on ink and specialist papers, as in the past.

Developing and Printing Film

If you are serious about your photography, at some point you will doubtless wish to experiment with film as well as taking digital images. While of course it is still possible to have films developed and printed at photo laboratories everywhere, it is far more fulfilling to do it yourself.

Developing

Developing films is easier than you may think. Black-and-white films need just two chemicals— a "developer" and a "fixer"—and these can be used at room temperature. One of the best things about developing your own black-and-white films is that you can choose a developer that provides exactly the balance of results you want in your pictures— whether you make your choice for finer grain, better sharpness, or more pleasing tonality. This contrasts with the average commercial development laboratory, which will offer only a series of standard development settings with little or no choice.

In the past, color film development was more complicated, but newer kits for hobbyists reduce the number of chemicals that are needed. The chief difference between black-and-white and color film development is that color films need to be developed at a higher temperature—around 100 degrees Fahrenheit—and that it is more important

HOW TO DEVELOP FILMS

1) Load the film into the developing tank. This needs to be done in complete darkness, so use a photographer's "changing bag."

2) Prepare the chemicals by making up solutions at the required strengths and get them to the recommended temperature.

3) The first chemical to apply is the Developer. With color slide films, this is followed by a Color Developer solution.

4) Once the film is rinsed it must be treated immediately with a Fixer (black and white) or Bleach/Fixer (color film).

5) The film now needs to be rinsed thoroughly. Color films may also require a Stabilizer solution to ensure the best results.

6) A "wetting agent" can be useful for preventing water droplets on the film from leaving drying marks. Choose a still, dust-free place to hang the film to dry.

HOW TO CREATE PRINTS FROM FILM

1) First, you need to insert the negative into the enlarger's negative carrier, then focus the image on the paper easel below the enlarger head.

2) Now switch off the enlarger, fetch a sheet of paper, and place it in the enlarging easel.

3) The enlarger lamp is now switched on for the required length of time to expose the paper correctly.

4) The paper must now be developed to turn the latent image produced by the enlarger into a visible image on the paper.

5) This is followed by a rinse and then a Fixer (Bleach Fix, or Blix, for color). Color print chemicals can be used at room temperature.

6) Wash the prints. You can do this with running water, if available, in your darkroom, or you can collect prints in a large tray and wash them later.

to control the temperature precisely during the processing. It is possible to get thermostatically-controlled water baths which provide a constant temperature for your chemicals, but many photographers manage perfectly well by using an unheated water bath prepared at exactly the correct temperature.

Printing

To make prints from your film you need a darkroom. You can fabricate home-made shutters to cover up windows and fit foam seals to doors. Most rooms can be made light-proof in this way. For black-and-white printing you can now use a "safelight," a dim red lamp of a color which does not affect black-and-white printing paper (the paper is designed with this in mind). For color printing you need a special "color safelight," since color paper is sensitive to a much wider spectrum than black-and-white paper. The other equipment you need is an enlarger, a set of developing trays, and the chemicals needed to process the prints.

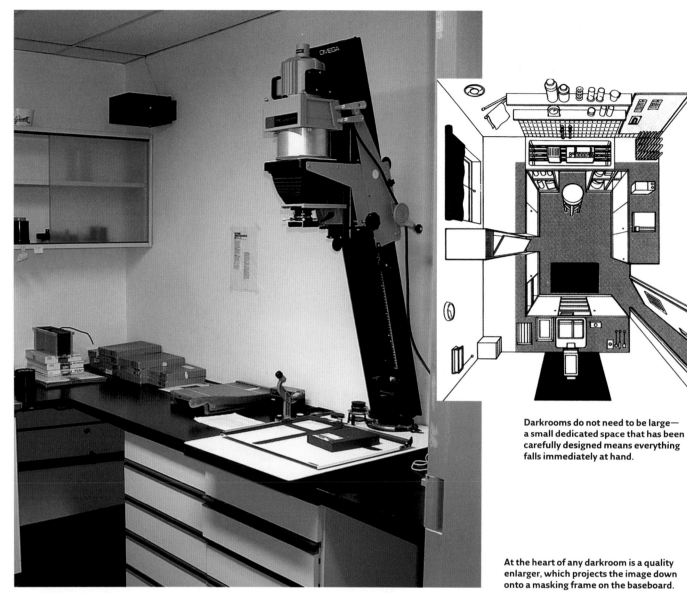

Darkrooms do not need to be large—a small dedicated space that has been carefully designed means everything falls immediately at hand.

At the heart of any darkroom is a quality enlarger, which projects the image down onto a masking frame on the baseboard.

It is relatively easy, and quite a lot of fun, to produce black-and-white prints at home in a darkroom. Printing color images, though, can be more of a challenge, and requires more equipment.

Organizing and Storing Images

The more photographs you collect, the more you will need a proper filing system. There are a number of photographic filing systems on the market—see the panel below for more information and advice.

Filing digital images

When it comes to organization and storage, digital images pose special problems. This is largely because of our habits rather than any intrinsic failing in the medium itself. It is very easy to transfer batches of photos from a digital camera to a computer and then leave these folders scattered on the desktop and within other folders in a haphazard fashion; this can make it difficult or impossible to find the photos you want later on.

Consequently, it is important to establish a logical system when organizing digital images—a system that works for you and which you will adhere to over a period of time. Your computer probably has a Pictures folder, which is where most image transfer programs will put new batches of photos. Ideally, you should use this folder or create another specifically for your growing picture collection.

Digital photos can be transferred in batches, in much the same way that film comes in "rolls." Make sure you give each folder a unique name, based either on the date or an index number, so that as you add batches of images the folder names reflect the chronological order.

Your digital camera will assign a unique filename to each digital photo, but you can rename photos according to your own filing system. For example, you could use "foldername"-"indexno," so that a specific photo might have the filename "Batch36-003."

It is tempting to type in descriptive names for folders and the photos within them, but this makes it difficult to maintain any kind of chronological organization, and you will soon run out of unique names if you regularly take pictures of the same subject.

Once you have a filing system in place, you can use an image cataloging program to help you browse through your photo collection and find specific images quickly. Programs like Picasa and the Photoshop Elements Organizer can catalog tens of thousands of images. Another advantage of these dedicated programs is that they also come with powerful search tools.

The "File Browser" which is built into Adobe Photoshop makes it easy to check the contents of a folder, but does not create a permanent record. This is a very useful tool when you need to find a particular image quickly.

PHYSICAL IMAGE STORAGE SOLUTIONS

Slides and negatives can be stored in loose-leaved sleeves in ring binders, and each film can be labeled with the data, a unique index number, or a system of your own choosing. A second number can be added to identify each unique frame on the film. Contact sheets, or the "index prints" supplied by photo labs, can help you locate and identify pictures quickly.

Prints take up more space, of course. It is possible to buy loose-leaf print storage systems, or you could use conventional photo albums. Whichever you use, make sure you label each print with the unique negative number. This means that if you want to have more prints made, you can find the right negative immediately.

When you are choosing a filing system, look out for those specifically designed for photographic materials, and designed for "archival" storage. Ordinary materials may contain chemicals which cause degradation in the negatives, or which trap humidity and cause fungal growth.

iView is yet another image browsing and cataloging system that offers several useful tools. Check these browsers out on the Internet before buying, so that you can be sure you acquire the one that has the right features for you.

Special programs such as Extensis Portfolio and iView make it easy to catalog your images, so you can find exactly what you are looking for immediately.

_DOG2593.NEF

▶ **Media Info**

▼ **Photo EXIF**

Capture Date	5/4/06 18:05:10
Aperture	f11.0
Shutter Speed	1/20 sec
Exposure Bias	+0.0
Exposure Program	Aperture Priority
Focal Length	75.0 mm
Sensing	One-chip color area sensor
Light Source	Daylight
Flash	OFF
Metering	Pattern
ISO Speed	200
Noise Reduction	OFF
Sharpness	None
Focus Mode	AF-S
Lens	24-120 mm

▶ **Annotations**

Gone are the days of having to record the settings you used when taking a picture—now this information is stored automatically.

Optimizing Images for Email and Internet Usage

When you print a photograph, it is scaled to fit the size of the print that you have selected. In the case of digital photos or scans, the pixels in the digital image are scaled up or down according to the print size, but the number of pixels remains the same.

Resizing images

If you wish your photograph to be displayed on a computer screen, either on a Web page or as an email attachment, the picture will need to be resized. This is because the pixels on the computer screen correspond exactly with the pixels in the photo. A photograph from a digital camera might measure 3000 pixels by 2000 pixels, which is far too large for any computer screen. Most have a resolution of around 1024 pixels by 768 pixels.

What you need to do in cases like this is to "resample" the digital photo so that its pixel dimensions match those of computer displays. When doing this, it is important to work on a copy of the photograph, because resampling reduces the detail in the picture and, once this has been done, there is no way back to the higher-resolution original.

On-screen image display

For on-screen display, you need pixel dimensions of around 640 x 480 pixels, or 900 x 600, depending on the size of the screen the pictures will be displayed upon. (Photographs displayed on Web pages or in e-mails need to be smaller than the actual screen size because the program interface takes up much of the space available.)

It is possible to resample photos manually using a program such as Photoshop or Elements. However, many image editing programs can automatically resize photographs for on-screen use.

When emailing large files it is important to compress them. If not, download speeds can be excessive, even with broadband. This 20.5Mb TIFF file was reduced to an 800Kb JPEG for attachment to a message.

INTERNET FILE FORMATS

The pictures, or "graphics," you see on web pages fall into two or three categories. Firstly, movies and animations use special file formats such as QuickTime, MPEG, or Flash, which we need not concern ourselves with here. Secondly, diagrams, illustrations, and logos commonly use the GIF format. This produces crisp, clean-looking graphics that download quickly, but they are restricted to 256 colors and this format is therefore unsuitable for photographs. Instead, you need to use the JPEG format, which compresses photos so that they download quickly, but still produces good quality.

You can choose various different JPEG compression ratios:

- "High" quality produces better-looking photos but also larger files.

- "Medium" quality may be a good compromise with larger photos to make sure they download quickly.

- You may encounter the "progressive JPEG" format. This is a special type of JPEG file which will display quickly in a web browser but only in a low-resolution form. The full resolution builds up as the rest of the image is downloaded. This is a way of displaying a full image immediately, rather than one which builds slowly from the top down.

Images for the Web need to be small enough to download quickly but have sufficient resolution to look sharp and clear on screen. You can either work this out by simple trial and error or do it more systematically. Some programs, such as Photoshop, offer a "Save for Web" feature that allows you to compare the quality of the image at different resolutions before you upload it to the Web. Here, four different resolutions are being compared side-by-side.

Glossary

Photography is a highly technological subject which is constantly evolving and changing. Consequently, there are many technical terms associated with the medium which you need to understand at least in simple terms if you are to get the best out of your equipment and become a better photographer.

AEB Auto Exposure Bracketing.

AE-Lock Facility that allows the exposure to be locked. Useful in difficult lighting situations to ensure accurate exposure.

Ambient light Any form of constant—as opposed to flash—illumination. Examples include sunlight, moonlight, tungsten bulbs, firelight.

Angle-of-view How much of the scene a lens can see. Wide-angle lenses have a large angle-of-view, telephoto lenses a very narrow angle-of-view.

Aperture An adjustable hole formed by the lens diaphragm to control the amount of light that reaches the film.

Aperture-priority mode A shooting mode in which the photographer chooses the lens aperture and the meter provides the complementary shutter speed.

Array An arrangement of imaging sensors.

Attachment file A digital image, or other attachment, sent with an e-mail.

Auto zoom A handy feature on some strobes on which the head moves in and out to ensure the flash coverage matches the angle-of-view of the lens.

Available light *See* Ambient light

Backlighting A situation in which the main illumination comes from behind the subject, creating a silhouette. If this is not desired, flash can be used to add light to the subject.

Back projection System in which a transparency is projected onto a translucent screen to create a backdrop.

Barn doors Set of four flaps that fit over the front of a light and can be adjusted to control the spill of the light.

Bas-relief Artistic technique available as a filter in some image editing computer programs.

Batch processing Automated function in some programs that allows you to make the same set of changes for a series of images.

Boom Long arm fitted with a counterweight which allows heads to be positioned above the subject.

Bounce flash A flash technique whereby the light from a strobe is bounced off a reflective surface such as a white wall or ceiling. Bounce flash creates a soft, gentle lighting and eliminates the risk of red eye.

Bounce head A flash head that can be tilted and rotated to allow bounce flash photography while the strobe is mounted on the camera.

Brush image Computer software image editing tool that is used to apply different effects.

Built-in flash The pop-up flash unit built into the camera.

Bulb A shutter speed setting available in Manual. When this is set, the shutter remains open for as long as the shutter button is held down.

Burn Selectively darken parts of the image using the Burn tool.

Byte Small unit of computer memory. *See* Megabyte and Gigabyte.

Camera-shake Lack of image sharpness caused by movement of the photographer's hand.

Capacitor An electrical component that builds up and stores electricity. Used to create the high voltages needed to fire an electronic flash.

Catchlight A sparkle of light in a subject's eyes.

CCD Stands for charge-coupled device—the sensor in a digital camera that creates the digital image.

Center-weighted average metering A metering system that takes a light reading from the whole image, but with an emphasis on the central area.

Clone stamp Tool that allows the user to copy part of the image to somewhere else.

Close-up lenses Simple optical accessories that provide an inexpensive entry to the world of close-up photography.

Close-up mode A Subject Program Selection mode for photographing near objects.

Closest-focusing distance The nearest distance at which a lens can focus.

CMYK Cyan, Magenta, Yellow, and Black (K)—combinations of which produce color images on the printed page.

Color management The process of controlling the color of an image through different stages—from capture to print.

Color temperature The color of a light source measured in degrees Kelvin.

CompactFlash One of a number of removable and reusable "digital film" cards.

Compression Process that reduces the size of a digital image so that it requires less storage space, transmits more quickly by e-mail, or downloads faster from the Internet (*see* JPEG).

Contrast The difference between the lightest and darkest parts of the image.

Coverage angle The angle that the light from a flash spreads. Ideally, this should be the same as, or greater than, the angle-of-view of the camera lens.

CPU Central Processing Unit, another word for Microprocessor.

Crop To cut away parts of the image not required.

Dedicated strobe A flash that is electronically linked to the camera to facilitate exposure control. Early systems merely set film speed on the flash and provided a ready light in the viewfinder.

Depth-of-field How much of the finished picture will appear acceptably sharp. This varies in size and depends principally upon the aperture, lens setting, and camera-to-subject distance (see image below).

Diffuser A material positioned over the flash head to soften the light.

Digitize How a digital image is created—normally by means of a scanner or digital camera.

Dioptric correction lens A viewfinder adjustment that corrects for a range of eyesight deficiencies.

Direct flash A technique where the flash is pointed directly at the subject. Often results in harsh, flat lighting and red eye.

Dodge tool A tool which allows you to selectively lighten areas of the image.

Download Receive a file/image from a remote computer, often via the internet, and generally using a modem (opposite of upload).

Depth-of-field is one of the most important creative tools under the photographer's control.

DPI Dots Per Inch—an indication of the resolution of a computer monitor, scanner, or printer. The higher the resolution the better the quality.

Duotone A mode that simulates printing with two different colored inks.

Dynamic range A measure of the spread that can be captured or reproduced by a scanner or printer.

Electronic strobe A lighting system that uses a capacitor and a gas-filled tube to create a bright flash of light.

Element Individual lens, several of which are combined in groups to produce lenses capable of taking pictures.

Enhancement Improving an image by adjusting contrast, sharpness, colors, and so on.

Existing light *See* Ambient light.

Exposure bias Term used in respect to exposure modes, based on whether they give small or large apertures or fast or long shutter speeds.

Exposure compensation A feature of some Minolta cameras that allows the exposure to be increased or decreased by a chosen amount.

Exposure Value (EV) A unit of measurement of light, used as an alternative to shutter speed and aperture. For instance, EV 10 is equivalent to 1/30 sec at f/8.

A flash meter will give you accurate and invaluable light readings.

File format The way in which the image is stored (*See* TIFF, JPEG, and GIF.)

Fill-in flash A flash technique used to illuminate shadow areas of a scene already lit by ambient light.

Fill-in Ratio Control A feature on some strobes that allows the balance of the ambient and flash exposures to be altered (see image above). Also called Flash Exposure Compensation.

Film scanner A scanner which is designed to digitize film transparencies and negatives.

Filter Software option for image enhancement.

FireWire High speed computer connection system.

First curtain sync The standard way a flash is synchronized to the camera shutter. The flash fires immediately when the shutter is fully open. *See also* Second Curtain Sync.

Fish fryer An extremely large softbox.

Flare Image fault caused by light scattering inside a lens—most often occurring when shooting toward the light.

Flash duration The length of a flash emitted from a strobe (see image opposite).

Many digital SLR cameras now feature high-powered built-in strobes, like this Nikon.

Flash Exposure Compensation A feature on some cameras and strobes that allows the balance of the

ambient and flash exposures to be altered. Also called Fill-in Ratio Control (see image opposite).

Flash tube A gas-filled glass tube that emits a bright light when a high voltage passes through it. The light source of all electronic strobes.

Flatbed scanner Scanner designed to digitize flat artwork, such as prints and drawings.

Fluorescent light Continuous light source which often produces a green cast with daylight balanced film—though neutral tubes are also available.

Focal length The optical length of a lens.

Focus lock Action of the shutter release in which focus is locked while it is held down. Allows accurate focusing with off-center subjects.

Focusing ring The ring found on some cameras that allows manual focusing when the lens is set to manual focus.

Frame grabber Device that allows you to "grab" an image from a video, camcorder, etc.

Full auto A simple-to-use shooting mode that handles everything for the user.

Gamut The range of colors that can be displayed on a screen or printed on media.

GIF Graphical Interchange Format, used to display images on the net. JPEG is better for photographs, as GIF is limited to 256 colors.

Gigabyte 1024 megabytes, or 1,048,576 bytes, often written as "Gb."

Grain The individual silver particles that make up a film image. A grain effect can be added to digital images in the computer.

Grayscale Image consisting of only black and white tones with no color (see image above, right).

Guide number An indication of the power of a strobe. By dividing by the flash-to-subject distance, it is possible to calculate the aperture to set for a correct exposure during manual flash photography. Can be quoted in either feet or meters and normally assumes the use of an ISO100 setting.

A grayscale image is made up only of shades of black and white.

Hard disk/hard drive Computer hardware that is used for storing images and other files. Some hard disks are built-in, some separate, others removable.

Histogram Graph that shows the tonal distribution of pixels within a digital image.

Honeycomb Grid that fits over a lighting head producing illumination that is harsher and more directional.

Hotshoe A fitting on top of a camera that accepts a strobe or other accessory.

Image editing software Computer program which can be used to acquire, manipulate, and store digital images.

Incident reading Exposure reading of the light falling onto the subject.

Inkjet printer Popular type of color printer capable of producing photo-quality prints (see image on page 246).

Interpolation Process in digital imaging that uses software to add new pixels to an image by analyzing adjacent pixels and creating new ones to go between them. This process can reduce quality.

ISO International Standards Organization—sensitivity rating system.

Inkjet printers are now capable of producing color photographic prints of an extremely high quality.

Joule Measure of the output of flash units, equivalent to one watt-second.

JPEG Stands for Joint Photographic Expert Group—the most popular, and useful, image compression format.

Kelvin A unit of measurement of color temperature.

Key light The main light source.

Landscape mode A Subject Program Selection mode for photographing scenery.

Layers An aspect of most image editing programs which allows you to work on different parts of the image independently.

LCD *See* liquid crystal display.

Light A visible radiated energy with wavelengths including the colors of the spectrum.

Light source The origin of any type of light used for photographic purposes, including the sun, reflectors, and strobes.

Liquid crystal display (LCD) An electronic device that becomes black when an electronic charge is passed through it. The LCD panel on many cameras displays information about camera settings.

Lith Image in which there are only black and white tones—no colors.

Mac Popular name for Apple Macintosh computers.

Macro lens Technically speaking, a lens which provides a magnification ration of 1:1 (life-size) or greater.

Magic wand Image editing tool which automatically selects areas of similar colored pixels.

Manual flash A setting on strobes that gives a fixed-output flash with no TTL control.

Manual focusing Focusing option in which the lens is adjusted by hand—usually with confirmation provided by the viewfinder display.

Manual mode A shooting mode that leaves the photographer to set both the aperture and the shutter speed.

Marquee Tool for selecting part of the image.

Maximum aperture The largest aperture available on a lens, usually indicated by its designation. On most 50mm f/1.8 lenses, for instance, the maximum aperture is f/1.8.

Megabyte 1024 kilobytes, often written as "Mb."

Megapixel One million pixels.

Microprocessor The "brain" of the computer, measured in megahertz.

Minimum aperture The smallest aperture available on a lens—typically f/22, f/27, or f/32.

Mixed lighting Combination of different colored light sources, such as flash, tungsten, or fluorescent.

Mode Way of working—but most commonly indicating exposure mode, the way in which the aperture and shutter speed are selected.

Modeling light Tungsten lamp on a flash head which gives an indication of where the illumination will fall.

Monobloc Self-contained flash head that plugs directly into the mains (unlike flash units, which run from a power pack).

Multiple exposures A feature on some cameras that allows more than one exposure to be made on a single frame of film.

Off-camera flash A technique using a strobe not mounted on the camera hotshoe.

Optical viewfinder Direct viewing system found on some digital cameras.

Palette A set of tools presented in a small window in computer image editing software.

Partial metering A metering system that takes a light reading from just a small, central part of the image area.

Pixel Short for Picture Element, a tiny square of digital data containing details about resolution, color, and tonal range.

Pixelation Unwanted (usually) effect in which the pixels become so large they are visible to the naked eye.

PL-C Circular polarizing filter which increases subject contrast by controlling light from non-metallic surfaces.

Portrait mode A Subject Program Selection mode for photographing people.

Predictive AF Sophisticated focusing system which anticipates the direction and speed of a moving subject and sets the focus at the moment of exposure to give a sharp result.

Preflash A small flash emitted by some strobes to determine the flash-to-subject distance. During direct flash photography the preflash comes from a near-infrared emitter.

Primary color One of the colors red, blue, and green to which the human eye is especially sensitive.

Prime lens One which has a fixed focal length. The opposite of a zoom lens.

Printer Computer peripheral for making hard-copy prints.

Program mode A shooting mode in which the camera sets both the shutter speed and the aperture, but the photographer can override some settings.

RAM Random Access Memory.

Ready lamp A light on the back of most strobes that indicates when the flash is recharged ready to fire.

Recycling time The period after a flash fires during which the capacitor recharges ready for the next flash.

Red-eye A distinctive effect caused by light from a direct flash entering a subject's eyes and bouncing off red blood vessels behind the retina.

Red-eye reduction A light shone at the subject by some cameras during built-in flash photography. It helps to reduce the risk of red eye.

Reflector Any surface that light can be bounced off. Also, a silver surround in the flash head that backs the flash tube.

Resolution Key indicator of the quality of an image, defined by multiplying the number of pixels down by the number of pixels across.

RGB Red, green, and blue—the three primary colors used to display images on a computer monitor.

Ringflash Circular flash tube which fits around the lens and produces a characteristic shadowless lighting (see image below).

If you want to create images using flash which will definitely not feature shadows, then you need a ringflash.

Scanner Item of hardware used to digitize images, with types available for use with prints, slides, and negatives.

Second Curtain Sync A setting on some strobes that causes the flash to fire just before the shutter closes, instead of immediately when the shutter is fully open.

Self-timer A setting on many cameras that delays the firing of the shutter for a few seconds after pressing the shutter button.

Shutter A blind in the camera that opens for a pre-set time to allow light to reach the film.

Shutter-priority mode A shooting mode that allows the photographer to choose the shutter speed.

Shutter release The button pressed to take a photograph.

Shutter speed The time the shutter is open. Most digital cameras have a shutter speed range from around 1 second to 1/1000sec—some wider.

Slave unit A device that senses one flash firing and simultaneously fires a second flash to which it is attached. Does not allow dedicated flash control.

Slow sync flash A technique that combines a flash exposure with a long shutter speed.

SLR Acronym of Single Lens Reflex. In SLR cameras, a mirror and prism deflect light passing through the lens to the focusing screen so that what you see in the viewfinder is the same image that the film is exposed to when the shutter button is pressed.

Softbox Popular lighting accessory producing extremely soft light. Various sizes and shapes are available—the larger they are the more diffuse the light.

Sports mode A Subject Program Selection mode for photographing action.

Spot meter Meter capable of reading from a small area of the subject—typically 1-3°.

Standard lens Lens with a focal length of 50mm.

Standard zoom Lens with a variable focal length around 50mm, typically covering the range from 28/35mm up to 70/80/105mm.

Strobe flash A series of flashes in quick succession, used to record movement. Strobe is short for stroboscopic, not to be confused with the term for electronic flash.

Sync speed The maximum shutter speed that can be used for flash photography on a camera with a focal plane shutter.

Synchronization The method of ensuring that the flash fires when the camera shutter is fully open.

Telephoto lens Lens with a focal length greater than 70mm.

Telezoom Zoom lens whose shortest focal length is 70mm or greater.

Through-the-lens *See* TTL.

Thumbnail Low-resolution image found on digital software and the Internet which mirrors the high-resolution files.

TIFF Tagged Image File Format, a popular and high-quality file format.

Transparency More formal name for slide film, which is designed to be illuminated from behind.

Transparency adaptor Accessory that allows transparencies to be scanned on a flatbed scanner.

TTL metering Short for Through-The-Lens metering. A meter inside the camera body measures light that has passed through the lens.

TV An abbreviation of Time Value, and most often used as TV Mode. Indicates Shutter-priority exposure mode.

Tungsten Continuous light source.

TWAIN Cross-platform interface for acquiring images from scanners.

Umbrella Inexpensive, versatile, and portable lighting accessory. Available in white (soft), silver (harsher light), gold (for warming), and blue (for tungsten sources). The larger the umbrella, the softer the light.

Wide-angle lenses are ideal for capturing dramatic images of large structures like the building in this image.

USB Abbreviation of Universal Serial Bus, a computer connectivity system that allows many peripherals to be connected to a computer and swapped without the need to "power down."

USM "Unsharp masking" image editing process which improves the apparent sharpness of an image.

UV Ultra-violet filters used to protect the front lens element.

Viewfinder The eyepiece at the back of some SLR cameras that you look through to see the image.

White balance Camera facility which automatically adjusts the color balance of the picture to compensate for different lighting sources, such as tungsten and fluorescent.

Wide-angle lens Lens with a focal length of 35mm or shorter—for instance 28mm and 24mm.

Zoom Lens on which the focal length can be varied.

Index

Architectural photography can be challenging—especially in terms of angles and lighting—but also very rewarding.

Small is beautiful—and a macro lens enables you to make it big.

For great landscape shots, ideally you need a wide-angle lens.

Acknowledgments and Picture Credits

I would like to thank everyone who contributed in any way to this book, including my co-writers and the photographers whose pictures are published here. In particular I would like to express my appreciation for the unfailing professionalism and good humor of Guy Croton and Diarmuid Moloney at Focus Publishing, who have done a magnificent job of putting the book together.

Steve Bavister, Consultant Editor

Picture credits

Most of the images in this book are © Steve Bavister. Equipment pictures are reproduced courtesy of the manufacturer. The following images are by other photographers: p4 Tim Sandall (flowers); p11 Lee Frost (railroad tracks); pp12–13 courtesy of Kodak; p19 Marek Czarnecki (bottles); p26 Helen Bavister (dog); p41 Tim Sandall; pp46–7 Lee Frost; p69 Lee Frost; pp98–9 courtesy of Kodak (bride), courtesy of Agfa (pale girl/red eyes); pp118–19 Lee Frost (sand and castle), Ronnie Bennett (man on bench); p121 Lee Frost (wall); p123 Lee Frost (lifebuoy), Gerry Coe (sand); p124 Ronnie Bennett (shadow); pp128–9 Lee Frost; p142 Ronnie Bennett (black and white portrait); p144–5 Ronnie Bennett (black and white couple), Phil Chisholm (two men); p151 Len Dance (beach palms); 158–9 Lee Frost (tree and misty landscape); pp160–1 Lee Frost; p162 Lee Frost (sunset); pp174–5 Marek Czarnecki; pp 176–7 Marek Czarnecki; p182 Neil Warren; p183 Nick Hill; pp184–5 Odd Furenes; pp186–7 Chris Rout; pp188–9, pp190–1 Simon John; pp196–7 Anna Wiskin (baby), Marek Czarnecki (pen); pp198–9 Ronnie Bennett; pp206–7 Rod Lawton; p208 Rod Lawton (sunset); p210 Rod Lawton (fire truck); pp212–13 Rod Lawton; p215 Rod Lawton (flowers); p216 Rod Lawton (gardens); pp232–3 Rod Lawton; p243 Marek Czarnecki.

Where appropriate, the locations of the chapter opener photographs are as follows: pp12–13 Trinity College, Cambridge; pp46–7 Tower Bridge, London; pp72–3 Wren Library, Trinity College, Cambridge.

Steve Bavister, Consultant Editor.

The Canon EOS5 digital SLR camera. Many of the photographs in this book were taken with this model.